AESTHETICS AND PAINTING

AESTHETICS AND PAINTING

JASON GAIGER

continuum

Continuum International Publishing Group
The Tower Building, 11 York Road, London, SE1 7NX
80 Maiden Lane, Suite 704, New York, NY 10038

www.continuumbooks.com

British Library Cataloguing-in-Publication Data
A catalogue record for this book is available from the British Library.

ISBN 10: HB: 0826485200
PB: 0826485219
ISBN 13: HB: 9780826485205
PB: 9780826485212

Library of Congress Cataloging-in-Publication Data

Gaiger, Jason.
 Aesthetics and painting/Jason Gaiger.
 p. cm.
 ISBN 978-0-8264-8520-5
 ISBN 978-0-8264-8521-2
 1. Painting–Philosophy. 2. Aesthetics. I. Title.

 ND1140.G343 2008
 750.1--dc22

2008016672

Typeset by Newgen Imaging Systems Pvt Ltd, Chennai, India
Printed and bound in Great Britain by MPG Books Ltd, Bodmin, Cornwall

CONTENTS

CONTENTS

LIST OF ILLUSTRATIONS

Colour Plates

Figures

ACKNOWLEDGEMENTS

I would like to thank Katerina Deligiorgi, Andy Hamilton, Charles Harrison, Derek Matravers and Paul Wood for their advice, encouragement and support in producing this book. Special thanks are due to Andy and Katerina, who read and commented on every chapter, and whose detailed criticisms and suggestions helped to shape my ideas and sustained me in the belief that it is possible to reconcile the twin imperatives of writing about philosophy and art.

I would also like to thank the British Academy for the award of a research grant to cover the costs of the illustrations.

CHAPTER I

PAINTING AND PHILOSOPHY

THE RELEVANCE OF PHILOSOPHY

Philosophy is said to begin in wonder.[1] But it also begins in perplexity, doubt, curiosity and a stubborn insistence on asking difficult questions, including questions about the nature and purpose of philosophy itself. This book is a study in philosophy, more precisely, that particular branch of the discipline that has come to be termed aesthetics. It is therefore important to start by asking what, if anything, philosophy can tell us about painting and why painting should be considered an appropriate subject for philosophical enquiry. Although directed at the same underlying issue, these two questions tend in different directions. The first asks whether philosophy can reveal something about painting that might otherwise remain obscure or hidden: in what ways might it deepen our understanding and how does it differ from other forms of writing and thinking about art such as art history and art criticism? The second question asks why philosophers should be interested in painting in the first place. Does painting raise a distinctive set of problems in aesthetics that are not already addressed within other areas of philosophy? And might reflection on these problems cast light on more abstract philosophical concerns, such as the distinction between appearance and reality or the status of representations?

Painting is a non-discursive art form whose effects are realized through the arrangement of shapes and colours on a material support. A painting does not depend on axioms or chains of inference, nor, even in the most extended sense, can it be said to raise a claim or defend a position. It is therefore far from obvious that a discipline that is primarily concerned with abstract reasoning and logical argument is equipped to provide special insight into a creative practice that operates through images rather than words. Although we might criticize a painting on the grounds of artificiality or insincerity, we cannot assess it in terms of its truth or falsity. Such an approach surely rests on a category mistake. But that we cannot argue *with* a painting does not mean that we cannot argue *about* it.

One of the reasons why painting has been a source of enduring fascination to philosophers is that it is irreducible to verbal description. It is not merely that words are inadequate to capture the full visual content of a painting – an idea that finds popular expression in the cliché 'a picture is worth a thousand words'. Rather, linguistic description and pictorial representation appear to provide two radically different means of communication and expression.

To describe something is to place a series of abstract symbols – letters, words, phrases, sentences – in an ordered sequence. As has frequently been noted, neither the symbols themselves nor the order in which they are presented need bear any resemblance to what they stand for or represent. The sentence 'A woman is peeling apples' does not look like a woman peeling apples, nor does the word 'apple' look like an apple. Different languages, of course, have different words for the same objects, so even if we were tempted to look for some common feature, we would also have to find a way of accounting for the differences between the French word *pomme*, the Italian word *mela*, the German word *Apfel* and so forth. It is therefore widely agreed that the relation between words and what they represent is fixed by convention rather than the possession of a set of shared characteristics. To understand a language we need to know not only a sufficient number of words but also the specific rules that govern their combination into meaningful sequences. By contrast – or at least, so it might first seem – when we look at a representational painting such as Pieter de Hooch's *A Woman Peeling Apples* of c. 1663 (Plate 1) we do not need to possess any such prior knowledge. Unlike a verbal description, the painting provides us with an experience that is similar in certain respects to the experience of looking at the depicted scene: in this case, the sunlit interior of a house in which a seated woman hands a length of apple peel to a waiting child. The intuitive, or prephilosophical, way of accounting for this is to say that, unlike a sentence, a picture looks like or resembles what it represents.

As we shall see, however, the idea that pictures resemble their subjects is potentially misleading and surprisingly difficult to articulate in a coherent theoretical form. This recognition has led some philosophers to reject our intuitive assumptions and to argue that pictures are, after all, best understood on the model of language. The existence of such conflicting views is testament to the considerable complexity of explaining how pictures work. We can broadly distinguish two different approaches to depiction. The first, perceptualist approach, contends that pictures are to be explained in terms of the psychological effects that they produce in

the viewer: to understand the nature of pictorial representation we need to study the underlying psychological and perceptual processes that allow us to see an apple in a picture of an apple. By contrast, adherents of the symbol-based approach argue that pictures, like language, depend on the correlation of a set of marks with a field of reference, and that pictures are to be analysed as complex symbol systems. More recently, philosophers have sought to produce hybrid theories that combine the strengths of both approaches.

What Ernst Gombrich termed the 'psychology of pictorial representation' in the subtitle to his book *Art and Illusion* in 1960 has proved a rich and fertile field of enquiry.[2] Although Gombrich's ideas are currently out of fashion among art historians, they have been taken up, revised, challenged and extended by analytic philosophers, who have used his work as a starting point to develop their own accounts of the nature of pictorial representation. Remarkably, Gombrich's importance is acknowledged not only by advocates of the perceptualist approach, but also by the principal exponent of the symbol theory of depiction, Nelson Goodman.[3] Gombrich's stated goal in *Art and Illusion* is to 'restore our sense of wonder at man's capacity to conjure up by forms, lines, shades, or colours those mysterious phantoms of visual reality we call "pictures".'[4] How is it that a pattern of marks upon a flat surface is able to provide a convincing representation of a scene or object that is not physically present before us? Are the same perceptual processes at work when we see an object represented in a painting as when we see it in everyday experience? How can something static and two-dimensional succeed in conveying spatial relations or the appearance of movement? What is the role of the viewer's imagination in filling out and completing partially occluded or foreshortened objects? And are there standards of correctness against which different forms of representation can be measured?

These questions are of intrinsic significance and connect in a variety of ways with larger issues in the philosophy of mind. However, it is clear even from this short list that the analysis of pictorial representation intersects with but does not exhaust the philosophical interest of painting. First, not all painting is figurative. The emergence of fully abstract painting in the early years of the twentieth century showed that painting can dispense with the depiction of recognizable objects, scenes and events without forfeiting its claim on our attention. A central aim of this book is to show that representational content is only one aspect of painting as an art and that equal importance needs to be given to internal or 'configurational' properties, including properties of form and design. Second,

although most paintings are pictures, not all pictures are paintings. Stick figures, maps, heads on coins, architectural plans, cartoons, billboard advertisements, newspaper illustrations and computer-generated imagery are all pictures of one sort or another. Despite the high aesthetic value that is traditionally ascribed to painting, its very complexity as an art form and the many different functions it has been made to fulfil make it difficult to accommodate within any single explanatory framework. The more sophisticated or original an artist's work, and the more remote from our contemporary concerns, the more recalcitrant it is likely to prove as an example for philosophical analysis.

One response to this problem has been to argue that 'demotic' forms of representation should be taken as fundamental: just as philosophers of language begin by studying basic propositional sentences rather than elaborate verbal conceits or the highly compressed and metaphorical language of poetry, so philosophers who are interested in depiction should start by analysing images that are 'a product of the people rather than the art world'.[5] Only once we have understood how these putatively more basic representations work will we be in a position to address the greater challenges posed by paintings that are artworks. Although this approach has clear advantages for the construction of a general theory of depiction, it is based on the assumption that the communicative and referential function of pictures should be given primacy. As a result, it risks severing philosophical enquiry into painting from the motivating interests of artists, viewers and critics. Many of the core problems of pictorial representation are studied by other disciplines for quite different purposes. To give just one example, the development of visual recognition software that allows computers and other machines to process visual data is frequently modelled on an analysis of information processing in the brain, including the way in which we are able to read two-dimensional surfaces as containing representations of spatial depth. It is not unusual for there to be an overlap between philosophical enquiry and scientific research and there is no doubt that philosophy has much to learn from developments in science and technology. However, the isolation of a discrete set of technical problems cannot do justice to the full complexity of the issues that are raised by painting. The claim that 'pictures are at bottom vehicles for the storage, manipulation, and communication of information' may hold true as the basis for a general theory of visual representation, but it is tendentious when extended to works of art, for it relegates aesthetic considerations to secondary status.[6]

THE PRACTICE OF PAINTING

In a panel discussion held in 1952 on the subject of 'Aesthetics and the Artist', the American painter Barnett Newman made an observation that has passed into the folklore of twentieth-century art. Responding to Susanne Langer's suggestion that the research she and her colleagues were carrying out in aesthetics might be of interest to contemporary artists, he replied: 'I have never met an ornithologist who ever thought that ornithology is for the birds.'[7] Newman's remark captures in witty and memorable form the view that the philosophy of art is external to what it describes and thus has no significance for artists, who are motivated by different interests and concerns. This claim needs to be assessed on its own terms, independently of the circumstances in which it was voiced. However, it is worth noting that at the same time as he was developing his characteristic 'signature style' of vertical stripes against a coloured ground, which he first explored in his painting *Onement I* (1948, Museum of Modern Art, New York), Newman was also writing and publishing essays in avant-garde periodicals.[8] His theoretical reflections on topics such as 'primitivism' and the concept of the sublime do not provide an explanation of his work at this time, but they do suggest that his search for a type of painting that was appropriate to the age in which he lived was not carried out in isolation from ideas about the place and purpose of art. Indeed, writing and thinking about art seems to have played an important role in his recognition that *Onement I* constituted a significant breakthrough rather than a failed experiment.[9]

Newman is not the only artist to have suggested that aesthetics is irrelevant to art. Wyndham Lewis told the critic and philosopher T.E. Hulme, 'I do it, and you say it.' More brutally, Picasso once retorted to someone who was trying to explain his work: 'Don't speak to the driver!'[10] What lies behind these remarks is the belief that the artist is always one step ahead of the philosopher, who frequently arrives too late on the scene and whose efforts at comprehension never quite live up to the originality and excitement of the creative process. The opposing point of view – that without philosophy to interpret it art remains 'mute' – is forcefully expressed by the German philosopher Theodor W. Adorno in his book *Aesthetic Theory*, which was published posthumously in 1970.[11] Adorno's position is difficult to summarize without distortion, but his central idea is that since the meaning of an artwork is necessarily indeterminate, it needs philosophy to disclose its

full significance. Unlike, for example, a propositional sentence, whose content is intended to be directly communicable, a work of art does not explicitly declare its meaning. It is this very indeterminacy that makes art different from – and potentially richer – than conceptual thought. Philosophy has need of art, since art expresses something that cannot be fully captured through rational argument. However, without interpretation by philosophy, that is to say, without critical reflection upon its meaning and significance, art remains incomplete. The two therefore stand in a reciprocal relation in which each is dependent the other.

The problem with both of these approaches – represented on the one hand by Newman's dismissive attitude towards philosophy and on the other by Adorno's insistence on its indispensability – is that they rely on a forced opposition between theory and practice in which philosophy and painting are treated as wholly distinct forms of activity. The relation between painting and philosophy cannot be reduced to that between 'doing' and 'saying', as if painting were an unreflective process carried out by individuals who are unaware of the significance of their work. The French expression *bête comme un peintre*, which means 'stupid as a painter', or more literally, 'a beast or dumb creature like a painter', reminds us that painters were once derided as mere craftsmen or skilled labourers, involved in the physical activity of mixing and applying paint. The artist Marcel Duchamp, who is perhaps best known for having 'abandoned painting' in favour of presenting found objects as works of art – including the notorious act of exhibiting an upside down urinal in his *Fountain* of 1917 – claimed to have been motivated by a desire to get away from this conception of the artist.[12] Rejecting what he described as the merely 'retinal' satisfactions of oil painting, he sought to produce works of art that were addressed to the mind rather than to the senses. Duchamp's belief that painting had become obsolete led to him to explore new forms of artistic activity, but the opposition between art as a mere craft or technical skill and art as a vehicle for the presentation of ideas goes back to some of the oldest disputes about painting.

Rather than accepting these divisions at face value, it makes more sense to recognize that painting and philosophy are *independently* valuable modes of enquiry. Newman is perhaps unusual in having published theoretical essays at the same time as producing major works of art, but advanced art practice has always been characterized by a high degree of critical self-reflection. There have, of course, been 'learned' painters, such as the French artist Nicolas Poussin, who was praised by his contemporaries for his erudition and classical knowledge. And

there are other examples of artists such as Newman who have written in a highly insightful – and sometimes highly misleading – way about the ideas behind their work. However, the majority of artists have expressed their thoughts about art through the practice of painting. Painting has its own internal complexity, a complexity that is largely worked out in and through painting itself rather than by means of manifestos and statements about art. This is the moment of truth in Adorno's observation that without interpretation artworks remain silent.

While the writings of artists are clearly important, they do not provide an infallible guide to the meaning of their work: there is no necessary connection between agency and philosophical understanding. This can be seen by considering the analogous case of moral action. If we want to understand why someone acted in a certain way, it makes sense to enquire into her motives and to consider what may have led her to behave in the way she did. However, we do not assume that because someone engages in moral deliberation she is therefore in a position to provide a coherent account of moral action or to give a rationally defensible explanation of the meaning of terms such as 'right' and 'wrong'. Philosophy asks questions that are both more general and more abstract than the ones we wrestle with in everyday life. Precisely because of its distance from concrete decision-making, philosophers are able to investigate the implicit assumptions that sometimes guide our actions without our being aware of it. They also aim at a degree of clarity in the use of concepts and the presentation of arguments that would otherwise be hard to sustain. Similarly, even though artistic activity involves a wide range of practical and theoretical decision-making, artists are not necessarily in a privileged position to account for, say, the nature of pictorial representation or to analyse the meaning of key terms such as resemblance and denotation. The questions that philosophers ask touch upon but do not coincide with the questions that artists address through their work. One of the challenges in writing about painting is to remain sufficiently attentive to the specific goals that have motivated artists at different historical periods while at the same time addressing fundamental questions that pertain not just to this or that artist's work but to painting as such.

The real provocation behind Newman's remark lies in the suggestion that art has nothing to learn from philosophy. Most of us would, I think, be willing to agree that moral philosophy can help us to clarify our moral intuitions and that critical reflection on our most basic ethical commitments is an important and worthwhile activity, even if it does not necessarily make us better human beings. (Few moral philosophers

would hold themselves up as paragons of moral virtue even though they spend much of their working lives thinking about the subject.) Similarly, we do not need to share Adorno's view that art is somehow incomplete without philosophy to recognize that aesthetics has a valuable role to play in elucidating the nature and purpose of art. The idea that art can learn from philosophy is itself, perhaps, based on the mistaken assumption that philosophy should fulfil a prescriptive rather than a merely explanatory role. Aesthetics, in its modern guise at least, does not aim to provide a set of rules or instructions that can serve as a guide for artistic practice. Nor does it offer a set of principles for judgement that can enable us to evaluate the relative merits of different works of art. It is therefore to be distinguished from both art criticism and art appreciation, though it may contribute to both. The distinction between a descriptive and a normative theory of art has not always proved easy to sustain. Nonetheless, it is important to distinguish between these two goals. Whereas a normative theory seeks to *justify* a particular type of artistic practice or a particular set of aesthetic preferences, a descriptive theory seeks to *explain* these phenomena, either by showing how they come about or by analysing their constitutive elements.

A PRELIMINARY DEFINITION

If asked to give an example of a painting, most readers of this book would probably choose a work that falls under the category of easel painting: a work that is executed on a portable support such as wood, paper or canvas. Since it is not tied to a specific location, an easel painting can be framed and transported, as well as traded, bought and sold. This type of painting is mentioned by Pliny the Elder in his *Natural History*, which dates from the first century AD, but evidence of its existence goes back even further to the ancient Egyptians. From the thirteenth century onwards it gradually rose in importance and, in the West at least, it is what most of us now think of under the rubric of painting as an art. The rise to prominence of easel painting is closely connected to the emergence of the idea of aesthetic autonomy: the belief that art is intrinsically valuable and that it is, or should be, free of any determinate social function. The very portability of an easel painting – its physical independence from the site at which it was made – allows it to be treated as a discrete object of aesthetic appreciation. A painting that is hung on a wall can be moved from room to room, or from building to building, without

this affecting the work itself. It therefore seems natural to us to assume that the internal relations between the various parts of a painting are more important than the external relations that connect it to a particular location. To see that this was not always the case, we need to remind ourselves that an altarpiece would have been painted for a particular church, that a portrait of a monarch or high court official would have been designed for display where it could convey a sense of the individual's power and prestige, and that prior to modern technology a mosaic or fresco would have been physically inseparable from the wall, floor or ceiling of the building of which it formed a part.

The dominance of easel painting can lead us to overlook the plurality of functions that painting has traditionally fulfilled and to assume that the meanings we attribute to the practice of painting are timeless rather than socially and historically conditioned. Despite the unprecedented availability in museums and through reproductions of many thousands of years of art belonging to a wide diversity of cultures and traditions the art of painting remains elusive and enigmatic. Once we become aware of the variety of circumstances in which paintings have been produced and the range of purposes for which they have been made – ceremonial, religious, decorative, commemorative and so on – we are forced to question the assumption that a single concept of art can be used to accommodate such divergent practices. Some philosophers hold that any systematic study of the arts must rest on the firm foundations of definition and classification. Others have countered that the attempt to identify universal and necessary conditions for a practice such as art, which is not only socially and historically variable but, by its very nature, subject to revision and transformation, is both fruitless and potentially misleading.[13] Without attempting to offer a strict definition of painting – an achievement that would potentially impede rather than further our enquiries – a provisional investigation into the meaning of the term and the range of objects that it is taken to designate is necessary if we are to grasp what is distinctive to painting as an art.

One of the earliest stories about the origins of painting is told by Pliny the Elder in his *Natural History*.[14] There he relates how a Corinthian maid, despairing at the prospect of her lover's imminent departure, drew the outline of his face on a wall by tracing the shadow thrown from a lamp. Fanciful as this story may be, it already contains the basic elements of an account of painting: the purposive marking of a surface through direct bodily movement to create a visual image. Let us consider each of these elements in turn. I have described the making of marks as purpo-

9

sive in order to distinguish painting from naturally occurring shapes and patterns. It is possible for us to see the stains left on a wall by a burst pipe or the shape of a cloud blown by the wind as resembling the outline of a face, but it is unlikely that we would be prepared to describe either of these as paintings. (I shall discuss the reasons for this in chapter 3.) Second, painting requires the modification of a surface through the making of marks. This part of the description helps to distinguish painting from other art forms such as music, which operates through the medium of sound, and sculpture, which is an art of three-dimensions rather than two. As we shall see, however, there are many different ways in which a surface can be marked or modified and for this reason I have intentionally kept the terms broad. Third, the observation that the marks are made through direct bodily movement provides a way of distinguishing the humanly constructed character of painting from merely mechanical processes. One way of thinking about this is to note that Pliny locates the origin of painting not in the shadow cast by the lamp, but in the drawing of the shadow by the maid. If this is right, then, we need to rule out not only the temporary images created by optical devices such as the camera obscura, but also the more permanent record provided by photography, film and digital media. Finally, I have described the marks as resulting in a visual image to distinguish painting from writing, which can also be characterized as the purposive marking of a surface through direct bodily movement. This part of the description also serves to exclude non-artistic forms of painting, such as painting a wall or a chair where the goal is to protect the object and perhaps to make it more beautiful, but not to create a pattern of marks that has meaning.

The fluid yet more or less viscous substance that we term paint is normally put on with a brush, but it can also be worked with a palette knife or, as in the case of the late Titian, applied directly with the fingers. Oil paint can be built up in thick layers so that it is encrusted on the surface. A striking example is provided by Rembrandt's *Man with a Golden Helmet* (c. 1650/55, Gemäldegalerie, Berlin) in which the gleaming surface of the soldier's headpiece is built up out of layers of pigment that stand proud of the rest of the canvas. At the other extreme, twentieth-century colour field painters such as Morris Louis used heavily thinned oil paint to soak into and stain unsized and unprimed duck-weave canvas, a technique that was first employed by Helen Frankenthaler in *Mountains and Sea* (1952, National Gallery of Art, Washington D.C.). This method of applying paint so that it is absorbed into and becomes one with the surface rather than sitting on top of it is also used in

watercolour and in fresco, in which pigment is applied directly onto wet lime or gypsum plaster. Paint can also be sprayed, dripped or thrown, as in Jackson Pollock's all-over drip and splatter paintings, which required laying the canvas flat on the floor rather than propping it up on an easel (for an example, see Plate 15: *Silver over Black, White, Yellow and Red*, 1948). Different types of paint such as oil, enamel, acrylic and watercolour have different properties as do different types of support such as paper, wood, copper and plaster. While most painting involves the use of variously coloured pigments, some techniques limit the palette to monochrome. Examples include grisaille, which is restricted to various shades of grey, and sepia, which employs the warm range of browns that can be produced from cuttlefish ink.

The account of painting that I have derived from Pliny's story of the Corinthian maid – the purposive marking of a surface through direct bodily movement to create a meaningful visual image – is too loose to serve as a strict, philosophical definition. With sufficient determination it is possible to find examples of paintings that it fails to cover. Thus, for example, Damien Hirst's so-called 'spin paintings' rely on the centrifugal force created by a revolving table to create randomly coloured circles. The deliberate cultivation of chance effects is intended to undermine the connection between the finished work and what I have termed the purposive marking of its surface. It is also possible to find examples of visual images that meet the requirements I have identified but which do not aspire to aesthetic interest. A good example would be the illustrations that accompany the instructions for flat-pack furniture. Nonetheless, this provisional attempt to identify the determining features of painting does provide a useful way of thinking about what distinguishes a painting from other objects and artefacts. In particular, it helps us to see that although the term painting is frequently used in a restrictive sense to refer to works of art made using oil paint, acrylic, gouache, ink or some other viscous medium, the specific substance through which the marks are made does not seem to play a central role. If this is right, then we may need to expand the scope of our enquiry to include a broader class of objects.

I want to endorse this suggestion by considering the example of mosaic, an ancient method of creating images and decorative designs that has been used for over five thousand years. A mosaic is constructed by embedding small, uniformly shaped particles called tesserae into a mortar or cement base. Tesserae can be made from a wide range of natural and man-made materials, including stone, shells, terracotta and

glass. Plate 2 shows a mosaic dating from the second century BC that was found in the Villa of Cicero at Pompeii, but which has now been relocated to the National Archaeological Museum in Naples. Signed by Dioskourides of Samos, it is thought to show a scene from a Roman comedy play in which the stage is occupied by a group of masked street musicians. The work is sufficiently detailed that anyone who is interested in ancient theatre or music-making can learn a great deal about Roman costumes and instruments. What lifts it into the realm of artistic rather than merely documentary interest is the vivid impression of life and movement and the way in which the masked figures are individualized through their actions and postures. These are not mere ciphers, but players and dancers, whose weighted bodies cast shadows on the stage and who interact with one another in a remarkably convincing and life-like image. Part of our admiration for the work surely consists in the felt contrast between the laborious and time-consuming process of its construction and the freedom and liveliness of the resulting image. However, the fact that it has been made by cementing coloured pieces of stone rather than applying dabs of paint has little bearing on its status as a work of art. Despite the difference in the manner of its execution, this mosaic surely deserves consideration under the heading aesthetics and painting.

The English language lacks a suitable generic term that groups together all and only these art forms that meet the requirements that I have laid down for painting. The term 'visual arts' is too broad, since it is normally taken to include sculpture, film and architecture. The same problem arises with the term 'graphic arts', which derives from the Greek word for writing (*graphē*) and embraces calligraphy and typography as well as painting and drawing. The term 'pictorial arts' suffers from the opposite problem insofar as it gives undue weight to picturing or figurative representation. I therefore propose to go against conventional linguistic usage by employing the term 'painting' to describe a wide range of different methods of making images and abstract designs, including not only drawing, etching, engraving, lithography and other forms of print-making, but also mosaic, intarsia (inlaid wood), embroidery, tapestry and collage. This is standard practice among philosophers who take the nature of pictorial representation to be central to the philosophy of painting, but it re-opens the question, treated somewhat summarily at the start of this section, whether photography should be included in the present enquiry. There I suggested that since painting is a product of direct bodily movement, we could rule out photography, film, digital media

and other forms of image-making that depend upon mechanical processes. However, the distinction between human action and mechanical processes starts to break down when we consider the role played in photography by the artist's choice of subject matter, viewpoint, exposure and so forth, together with the possibilities for subsequent manipulation of the resulting image, whether this be a photographic plate in the darkroom or a pixellated image uploaded onto a computer. Although photography depends upon automated, causal processes in a way that painting does not, human decision-making and intervention also play a crucial role.

I should therefore concede from the outset that the decision not to make photography central to the present enquiry is, in part, a matter of convenience. Photography, film and digital media raise a number of distinct philosophical questions that do not coincide with those raised by painting. Since painting pre-dates the invention of photography by several millennia, many of the core issues concerning, say, the nature of pictorial representation or the relation of surface and subject, can be addressed without considering the impact of modern technologies of visual imaging. The richness and complexity of these issues provides ample material for the present study without extending the enquiry further. Nonetheless, the development of painting from the mid-nineteenth century onwards has partially been shaped by its relation to photography and to this extent photography does form part of the subject matter of this book. It is arguable, for example, that photography's ability to fulfil many of the traditional functions of painting played a key role in the turn towards abstraction in the early twentieth century. These issues come to the fore in the final chapter in which I examine how artists such as Gerhard Richter have responded to the success and ubiquity of the photographic image by incorporating elements of photography into the practice of painting. However, my focus will remain on painting as it is influenced by photography rather than on photography as an independent art form.

TWO REQUIREMENTS

I would like to conclude these preliminary remarks by establishing two requirements on a theory of painting. These play an important role in what follows since many of the rival theories of painting that I discuss in this book, while helping to illuminate key features of painting as an art, fail to satisfy one or both. The first requirement, which bears on the relation between the marks that make up the surface of a painting and

what those marks are taken to stand for or represent, is widely acknowledged among philosophers working in the analytic tradition. However, the second requirement, which bears on the historicality of painting, has received less attention and is potentially more controversial. I shall offer a brief account of these requirements here, but their full significance will emerge as the book progresses.

To look at a painting as a work of art is to attend both to what can be seen in the painting – what it depicts or shows – and to the structure and organization of the painting itself. Whereas mimetic theories give primacy to a painting's representational content, formalist theories give primacy to its design, treating features such as line, shape and colour as independently significant pictorial elements. In their strong versions, both of these theories fail to acknowledge that the marks on the surface of the canvas and what those marks are taken to represent stand in a relation of reciprocal tension and enhancement. The attentive viewer responds not only to the subject or content of the painting and to its painted surface but also to the way in which the one is sustained in and through the other. It is a requirement on a theory of painting that it acknowledge the complexity of this relation and that it be able to account for the interaction of both representational and configurational elements in a single, dynamic experience.

Painting is an historical practice in which artists respond to the work of other artists as well as to wider social and cultural developments. We cannot therefore examine a painting in isolation as if its full meaning were somehow distilled into its visible properties, which simply await sufficiently close scrutiny in order to disclose their content. Our responses to art are tractable in relation to external knowledge and information. Without some attempt to identify the differences between the culture in which a painting was produced and the governing assumptions of our own age, we run the risk of simply imposing our own prejudices and assumptions. However, the task of historical recuperation is potentially endless since it requires not only that we seek to make intelligible other cultures that are temporally and geographically remote from our own, but also that we try to reconstruct the complex motivations that may have guided the work of individual artists. To what extent is philosophy bound by the results of historical scholarship? And how are we to understand the differences in approach that distinguish the philosophy of art from art history? Such questions are easier to raise than to answer. It is clear that philosophy cannot hope to match the level of historical knowledge

that art history is able to provide, but it is enormously to its benefit to be able to draw on the information that specialist studies make available.

The demand for historical understanding raises the spectre of relativism: the abandonment of a unified theory of painting in favour of merely descriptive account of a plurality of different practices. Philosophers are understandably anxious to identify a coherent set of problems that are amenable to analysis and to avoid the fragmentation that results from the piecemeal study of individual cases. Nonetheless, questions concerning art's historical character cannot be treated as marginal or secondary to aesthetics. The distinction between the philosophy of art and the philosophy of art history – a curiously cumbersome designation that equates reflection on art's changing character with reflection on the academic discipline that describes those changes – is unworkable. The second requirement on a theory of painting, then, is that it sustain the connection between painting and historical knowledge. At a minimum, this means opening up the field of investigation to include what Michael Podro terms the 'changing pressures and possibilities of pictorial imagining'.[15] This is vital, not only for understanding the art of the past, but also for understanding the specific conditions under which painting is practised today. The strategy that I pursue in this book is to start out from debates that are internal to philosophy and then to show that these debates can be opened up to broader social and historical considerations. The opening chapters are primarily 'analytic' in orientation insofar as they are concerned with the most basic features of pictorial representation. As the book progresses, this account is deepened and extended to include questions concerning the historical development of art and the role of historical explanation. These questions are particularly germane to the practice of painting in the late nineteenth and early twentieth century, which is characterized by the emergence of an historically self-conscious avant-garde, and, of course, to our own time, in which the status of painting has been challenged by the emergence of new visual technologies and new forms of art.

CHAPTER 2

A WINDOW ONTO THE WORLD

ART AND IMITATION

When the French art theorist Roger de Piles, writing at the end of the seventeenth century, defined painting as 'an art, which by means of drawing and colour imitates on a flat surface all visible objects', he could confidently claim 'this is how all those who have spoken of painting have defined it and no one has yet found it necessary to alter this definition'.[1] By contrast, contemporary philosophers have been less sanguine about the success of this definition, finding it easy to show that any attempt to define painting in terms of imitation is to fall prey to counter-examples. If the purpose of a definition is to identify all and only those objects that belong to a particular category or class, the definition fails since the class of things that are paintings and the class of things that are imitations are not co-extensive: an abstract painting is still a painting even if it does not imitate 'visible objects'. As George Dickie has pointed out, a successful definition needs to specify two conditions rather than one, each of which is necessary and both of which are jointly sufficient.[2] Although the definition of art as imitation goes back to the Ancient Greeks, its compliance class is too broad for it to serve any useful purpose: a definition that stipulates just one condition posits a relation of identity between two different terms and so is unable to pick out the relevant set of objects.

Contrary to the convictions of some analytic philosophers, this piece of philosophical good-housekeeping does not carry us very far. Rather than clarifying the connection between art and imitation, it renders the relation between them deeply mysterious. Dickie goes on to argue that:

> for over two thousand years . . . the view that art is imitation was around in a thoughtless kind of way as a slogan definition. The persistence of this implausible theory was due to a lack of interest in the philosophy of art; philosophers just never bothered to examine the view.[3]

Dickie's suggestion is more implausible than the view it purports to replace: it is highly unlikely that a definition of art would have remained in circulation for so long, simply because philosophers never got round to demonstrating its inadequacy. Instead, we should ask what purpose or function the definition was intended to fulfil. For someone writing in the seventeenth century, with its comparatively secure terms of reference, there would have been little point in providing a means of identifying all and only those things that can be categorized as paintings. I would like to suggest that de Piles's remarks are best understood as specifying the central end or goal of painting, and thus as fulfilling an elucidatory function. While this conception of art is open to challenge, it is not inherently confused. Rather than rejecting de Piles' definition for failing to stipulate a set of jointly necessary and sufficient conditions, we can use it as starting point to investigate why the concept of imitation has played such a central role in the theory and practice of painting. Only once we have understood the different ways in which the concept has been employed will we be in a position to assess its usefulness for philosophers working today.

Delight in painting's capacity to represent the visible world has been an enduring feature of writing about art from the earliest recorded documents in Ancient Greece through until the present day. The highest praise that the Greeks could bestow upon a work of art was to call it life-like, and numerous stories have come down to us from antiquity that celebrate the painter's ability to create a convincing likeness. Perhaps the best known of these tells of a competition between the Greek painters Parrhasius and Zeuxis. This is how the story is recounted by Pliny is his *Natural History*:

> Parrhasius entered into a pictorial contest with Zeuxis, who represented some grapes, painted so naturally that birds flew towards the spot where the picture was exhibited. Parrhasius, on the other hand, exhibited a curtain, drawn with such singular truthfulness, that Zeuxis, elated with the judgment that had been passed upon his work by the birds, haughtily demanded that the curtain should be drawn aside to let the picture be seen. Upon finding his mistake, with a great degree of ingenuous candour he admitted that he had been surpassed, for whereas he himself had only deceived the birds, Parrhasius had deceived him, an artist.[4]

This story is no doubt as fanciful as that of the Corinthian maid, but it does succeed in capturing the Ancients' admiration for what Xenophon terms 'the appearance of life'.[5] The *Greek Anthology*, a collection of

epigrams put together from various sources, contains innumerable hymns of praise for artworks, many of which contain the stock phrase that a painting or a statue 'lacks only breath' or seems as if it is 'about to move'.[6]

Life-likeness or truth to nature also served as one of the principal measures of artistic value in the Renaissance. Alberti, whose ideas we will explore later in this chapter, observes that painting possesses 'a truly divine power' since it can 'make the absent present' and 'represent the dead to the living'.[7] The reader of Vasari's *Lives of the Artists* (1550–68) cannot fail to be struck by the importance he attaches to the realism with which painters can depict folds of drapery, the soft down of skin and hair, the glistening of a tear or the gleam of a weapon. Echoing the terms of praise that had been used by the Ancients, he extols Leonardo da Vinci for having 'painted figures that moved and breathed'. In his famous description of the *Mona Lisa* he declares that her mouth 'appeared to be living flesh rather than paint' and that 'at the pit of her throat one could swear that the pulses were beating'.[8] Vasari claims that the rebirth or 'renaissance' of painting began with Giotto's introduction of the technique of drawing from life, which enabled him to make 'a decisive break with the crude traditional Byzantine style', and that the progress of art to the state of 'complete perfection' it has reached in his own day was achieved by learning to 'exactly reproduce the truth of nature'.[9] Near the start of his life of Masaccio he offers in passing, and without according it any great weight, a definition of painting that is virtually identical to that provided by de Piles: 'painting is simply the imitation of all the living things of nature, with their colours and design just as they are in life'. He concludes that 'the best painters follow nature as closely as possible' and that those artists are most worthy of esteem who 'reflect in their work the glories of nature' and who produce work that is 'living, realistic, and natural'.[10]

Vasari's criticisms of Byzantine painting, which he condemns for its stiffness and artificiality, as well as for 'absurdities' such as feet pointing downwards, sharp hands and the absence of shadows, alert us to the fact that verisimilitude or truth to appearances has not always been given primacy. Vasari was unwilling to recognize that the features of earlier religious painting that he decries arose not from ineptitude, as he frequently claims, but from a different understanding of the role and purpose of art. As we shall see, the assumptions behind Vasari's account of artistic progress have been challenged by later philosophers and historians. However, the underlying conception of painting as an art of imitation is

so central to the development of Western art that it cannot be reduced to the views of any specific individual, no matter how influential their writings may have been. Later chapters will consider alternatives to the theory of imitation and examine the reasons why avant-garde artists working in the late nineteenth and early twentieth centuries came to reject the goal of 'truth to nature'. Georges Braque's pithy observation 'One must not imitate what one wishes to create' registers a general a shift away from the concept of imitation, which came to be associated with a slavish adherence to external appearances.[11] For artists such as Braque, a new frame of reference was needed if due weight was to be given to the conceptual and constructive dimension of artistic activity. It goes without saying, however, that the polemics of the avant-garde provide a highly unreliable guide to the art they sought to replace.

Vasari's *Lives* has a strong normative component. Not only does he promote the work of some artists over others, he also identifies the exact imitation of nature as a goal that artists ought to pursue if they are to produce work of the highest quality. The great store that earlier writers placed on art as imitation – even to the point of actually deceiving the viewer – is difficult for us to appreciate today when modern technologies such as television and digital photography provide us with a seemingly effortless superfluity of visual images. Nonetheless, when we look closely at specific examples there remains something compelling about the way in which artists have succeeded in using the limited means of coloured pigment upon a flat surface to represent not only the three-dimensionality of objects and spatial relations but also the most subtle textures and effects of light. Velázquez's *The Waterseller of Seville* of c. 1618–22 (Plate 3), begun when he was just nineteen years old, seems to have been intended as a demonstration piece to display his technical accomplishments as an artist. The painting shows a young boy receiving a glass of water from a street vendor, something that would have been a commonplace sight in the artist's native Seville. The two principal figures, whose hands meet on the stem of the glass, are curiously pensive and withdrawn, as if absorbed in thought. The solitary onlooker remains a shadowy presence in the background. The absence of dramatic action leaves the viewer free to take in details such as the rough cloth of the vendor's cloak and his crumpled shirt. Rather than being caught up in a narrative or invited to imagine the thoughts and feelings of the represented figures, the viewer is allowed to participate in a moment of suspended calm in which everyday objects gain in prominence through the stillness of the depicted scene.

Velázquez seems to have relished the challenge of using paint to convey the shape and texture of different types of objects. The large water jug in the foreground appears to push out of the picture plane into the space of the viewer, its rounded body contrasting with the dimpled surface of the small pitcher on the table behind. Such is the level of detail that we can make out the striations where it has been turned on the wheel and the slight unevenness with which it has been thrown. Beads of water glisten on its surface and leave behind marks where they have run down its side. The irregular shape of the pitcher allows Velázquez to create a subtle interplay of protrusion and recession. Perhaps the greatest opportunity for virtuosity is provided by the glass of water, for here the artist has not only represented the transparent sides of the glass, he has also depicted the transparency of the water that it contains, a double effect that is emphasized by the presence of a fig that can be seen at the bottom of the glass.

Painting's uncanny ability to capture the most subtle visual effects has persuaded many art theorists that there is an especially close relation between painting and imitation. The connection certainly seems stronger than for arts such as music and architecture. Although music can imitate bird song or the rhythm of a march, and architecture sometimes incorporates natural forms, such as branches or flowers, these are marginal cases. On the other hand, imitation clearly plays an important role in art forms such as sculpture and literature. This suggests that it is not imitation as such that is distinctive to painting, but the specific means that are at its disposal. But what does it mean to describe one thing as an imitation of another?

One of the principal obstacles to grasping what is meant by the concept of imitation as it relates to painting arises from the confusion between an imitation and what we might term a copy or a replica. Although a painting can imitate the look of an object, such as a jug, a curtain or a bunch of grapes, it does not reproduce its physical properties. This is the lesson that Zeuxis and the birds are supposed to have learned when they tried to reach out to what they believed was in front of them. The earliest formulation of this argument is to be found in the dialogue *Cratylus*, in which Plato draws attention to the distinction between an image of an object, such as a painter makes by imitating its outward form and colour, and a second instance of the object itself. If a god were to create another person identical to Cratylus, with his same features, body, inward organization, soul and mind, then we would have to say that there were two Cratyluses. However, if a painter makes a picture of Cratylus, we do not have another Cratylus but rather an image or a representation. Plato concludes that 'images are very far from having qualities which are the

exact counterpart of the realities that they represent' and that for this reason 'we must find some other principle of truth in images'.[12] Plato's metaphysical commitments lead him to cast doubt on the reliability of images, which, on his account, are less real than the objects they represent. I shall return to Plato's critique of art as a mere appearance or semblance when I discuss his notorious indictment of painting and the other 'imitative arts' in the *Republic*. However, it should already be clear that an account of painting as an art of imitation cannot be based exclusively on the likeness between a painting and its subject. It must also identify and explain those 'qualities' that belong to the painting but not to what it represents. This is the aim that I will pursue in the rest of this chapter.

ALBERTI'S *ON PAINTING*

I want to start by considering a key text of Renaissance art theory, Alberti's *On Painting*, whose composition in 1435 is widely recognized as marking the point of transition from medieval workshop practices to the modern, humanistic conception of painting. Alberti originally wrote the treatise in Latin, but he also produced an Italian version the following year, which he dedicated to the Florentine architect Brunelleschi. In the dedication he expresses his regret that none of the classical treatises on painting has survived and that so many of the artworks described by authors such as Pliny have been lost or destroyed, but he also affirms his belief that painting is once again returning to its former greatness and that in the hands of contemporaries such as Masaccio it is beginning to rival the achievements of Ancients. Although he frequently refers to Greek and Roman literary sources, his aim is not to reconstruct the views of his predecessors but to offer a new, systematic theory of painting grounded in the most recent advances of geometry and mathematics. The treatise is divided into three books, which move progressively from a theoretical discussion of painting through to its practical and pedagogical application:

> The first, which is entirely mathematical, shows how this noble and beautiful art arises from roots within Nature herself. The second puts the art into the hands of the artist, distinguishes its parts and explains them all. The third instructs the artist how he may and should attain complete mastery and understanding of the art of painting.[13]

Unlike the authors of medieval workshop manuals, Alberti locates the rudiments of painting not in practical skills such as the grinding of pigments or the selection of the appropriate brushes, but in a correct understanding of how the world reveals itself to sight. By starting out from geometry and mathematics, he seeks to substantiate his claim that painting requires expert knowledge of the sciences as well as of human character and action, and thus deserves to be ranked among the liberal arts.

On Painting contains the first written presentation of a theory of linear perspective. Although artists had been painting objects in perspective prior to Alberti's treatise, they seem to have relied on intuition and empirical judgement rather than following a scientifically grounded procedure. Techniques for representing certain types of objects were passed down between artists, but this knowledge was largely acquired through trial and error. What Alberti offers for the first time is a systematic theory of perspective construction, based on mathematical principles, that artists could employ irrespective of their chosen subject matter. Drawing on both medieval optics and Euclidean geometry, he starts out from a simplified analysis of visual perception according to which rays of light travel in straight lines from the surfaces of objects to the eye, thereby forming a visual cone or pyramid. Alberti's principal innovation is to suggest that the picture plane should be conceived as an imaginary intersection that cuts through the pyramid of light. What this means can quickly be grasped by looking at Figure 1, which is taken from an eighteenth-century text book on perspective. The illustration shows a viewer, a rather heavy painted board and a three-dimensional object – a cube. The lettered vectors represent rays of light as they travel from the surfaces of the cube through the painting to the viewer's eye. By tracing the points at which the light rays pass through the plane of the painting, it is possible to make an accurate representation of the visual appearance of the cube as it seen from a particular standpoint.

Objects will appear to be larger or smaller depending upon their distance from the eye, but because they remain proportional to one other within the visual pyramid they can be scaled relative to the viewer. Lines that are perpendicular to the imaginary picture plane will appear to converge on a 'centric point', or vanishing point. Since on Alberti's theory the stationary eye forms the fixed centre at which the rays of light are supposed to meet, he is obliged to discount both the binocularity of vision and the mobility of the viewer. His theory does not therefore accurately characterize the physiology of vision. Nonetheless, his account of the way light passes through an imaginary rectangle to the viewer's eye

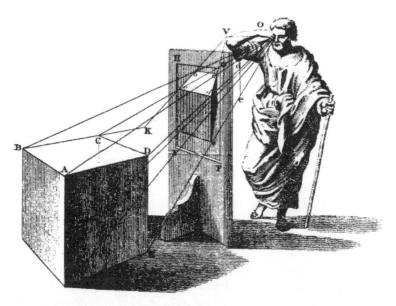

Figure 1 The visual cone, illustration from Brook Taylor, *New Principles of Linear Perspective*, London, 1715.

provides a highly effective means of describing the requirements of planar projection. We are to conceive the picture plane as a surface suspended between the viewer and the external world on which the artist fixes the visual appearances of objects with lines and colours. This proposal is fully consistent with the idea, expounded by later figures such as Vasari, that artists should seek to provide an exact imitation of the way things appear to sight.

The important point that I want to emphasize here is that Alberti's account of the geometry of vision does not seem to allow for any variation between the image that is produced by the painter on the rectangle of the canvas and the virtual rectangle that lies at the intersection of the 'rays of light'. In the second part of the treatise, in which he turns to the practical task of actually constructing a picture, he makes a telling analogy between the surface of a painting and a window onto the world:

> Up to now we have explained everything related to the power of sight and the understanding of the intersection. But as it is relevant to know, not simply what the intersection is and what it consists in, but also how it can be constructed, we must now explain the art of expressing the intersection in painting. Let me tell you what I do

when I am painting. First of all, on the surface on which I am going
to paint, I draw a rectangle of whatever size I want, which I regard
as an open window through which the subject is to be seen.[14]

This analogy vividly captures the idea that a painting is 'transparent' to
what it represents: just as we look through a window to the world
outside, so we look through a painting to the objects and figures that are
depicted. A painting that fulfilled this requirement would not only meet
the demand of verisimilitude or truth to nature, but it would also provide
an exact counterpart to our normal perception of objects as this is
described in the first part of the treatise.

For the modern reader, the central difficulty presented by Alberti's
treatise is how this thoroughly naturalistic conception of painting is to be
reconciled with his insistence on the importance of 'composition'
(*compositio*), which he defines as 'that procedure in painting whereby
the parts are composed together in the picture'.[15] It may well be, as
Thomas Puttfarken has argued, that Alberti's theory of composition has
more to do with the integrity of the representation of bodies on a two-
dimensional surface than with modern theories of pictorial composition.[16]
However, when read in conjunction with his claim that the 'great work'
of the painter is 'historia' (*istoria*), the ordering of figures in a dramatic
narrative in such a way that it can effectively communicate the attitudes
and feelings of the participants, it is clear that he is concerned with effects
that are produced by the internal ordering of the constituent elements of
the painting.[17] Much of the second book of the treatise is taken up with a
discussion of topics such as proportion, harmony, variety and decorum.
Alberti expresses his disapproval of 'those painters who, in their desire
to appear rich or to leave no space empty, follow no system of composi-
tion (*nullam sequuntur compositionem*), but scatter everything about in
random confusion with the result that their "historia" does not appear to
be doing anything but merely to be in a turmoil.'[18] These properly
aesthetic considerations presuppose a meaningful distinction between
the artwork as something that has its own internal structure and the arbi-
trary framing of a view from a window. If the artist is to 'hold the eyes of
the learned and unlearned spectator for a long while with a certain sense
of pleasure and emotion', as Alberti requires, he cannot base his work
simply on the accurate representation of a section through the visual
pyramid of normal vision.[19] Instead, he must consider questions of picto-
rial structure and unity, ordering the parts towards a desired effect that is
to be realized in the responses of the viewer.

There is, then, an unresolved tension between the conception of painting that is presupposed by Alberti's theory of perspective construction and the conception of painting that is presupposed by his theory of 'historia'. Since the resolution of this tension bears directly on the claim that painting is an art of imitation, it may be useful to stand back from Alberti's text and to consider the differences between them in a more abstract way. Let us call the first conception of painting P(1) and the second P(2):

P(1): A painting that is produced in accordance with the geometrical method of perspective construction provides an equivalent using marks and colours on a flat surface of an orthogonal slice through the pyramid of light that reaches the eye.

P(2): A painting that is produced in accordance with the requirements of 'historia' is structured by the artist to create pictorial unity and to maximize its effect upon the viewer.

Whereas P(1) is compatible with the belief that a painting is like a window, a transparent rectangle that arbitrarily crops a view of the visible world, P(2) identifies a painting as a composition, something that is ordered by the artist to fulfil a specific purpose. According to P(1) the framing edge is extrinsic to what is contained within it; but according to P(2) it marks the boundary between the real world and the pictorial world, to which a different set of principles apply. On this conception, the pictorial world is discontinuous with the real world, that is to say, the world as it presents itself to normal vision. This remains the case even if the artist has striven to arrive at the greatest possible verisimilitude in the representation of individual figures and objects and their spatial relations.

The difference between P(1) and P(2) also has important consequences for our understanding of the distinctive interests that a painting has for the viewer. According to P(1), a painting is simply a means of recreating on a flat surface a cross section of the pyramid of light that would have reached our eyes from the viewed objects. As the window analogy indicates, the painted surface is 'transparent', that is, it is not something of interest in its own right. This suggests that the viewer should look through or past the surface of the painting and its framing edge onto the depicted scene. According to P(2), however, a painting is purposively structured by the artist, both to create pictorial unity and to bring about certain effects. This suggests that the viewer should also direct her

attention to the way in which the artist has ordered the constituent elements of the painting. To recognize a painting as a composition is no longer to see it as a window onto the world. Instead, it is to recognize it as something *sui generis* that obeys its own laws and principles. This is reflected in Alberti's use of terms such as proportion, harmony, variety and decorum. Whereas P(1) assumes that the viewer looks at a painting as if it were continuous with ordinary experience, P(2) acknowledges that the viewer brings a different set of expectations to a painting, some of which are specifically pictorial.

We can examine the tension between these two conceptions of painting – and the way in which artists working within the naturalist tradition of Italian Renaissance art were able to exploit this tension for aesthetic effect – by considering a painting by Giovanni Bellini that was produced for the altarpiece in the church of San Zaccaria in Venice in 1505 (Plate 4). This late work, still housed in its original location, displays full mastery of the Albertian system of perspective construction, but it uses these techniques to depict an imaginary higher realm, in which the viewer is granted access to the Virgin and child, a music-playing angel and four contemplative saints. The ornamented columns and the entablature of the frame are repeated inside the pictorial space, creating visual continuity between the physical architecture of the building and the fictional architectural elements that are depicted in the painting. The sense of continuity between the real world and the pictorial world is further reinforced by the scale of the painting, which, at over four metres high, allows Bellini to paint the figures life-size. In the dim light of the church, the viewer is invited to imagine a celestial scene in which the figures are vividly present, occupying, albeit temporarily, the same architectural space as ourselves. Nonetheless, I think it would be wrong to suggest that we are meant to be deceived into believing that the Virgin and saints are physically present in the church. Leaving to one side the fact that beings such as these do not belong to the mundane world, and, with the exception of the violin-playing angel, are depicted as self-contained and inviolable, the painting is unmistakeably a 'composition' that has been ordered with the needs of the viewer in mind. The symmetrical organization of the figures around the central motif of the seated Virgin, and their arrangement in bands parallel to the picture plane, creates a sense of internal lawfulness in which there is a clear visual relationship between the constituent parts. The frontality of the composition is self-evidently 'addressed' to the prospective spectator, from whose standpoint in front of the altarpiece the painting is intended to be seen.

I suggested at the end of the previous section that an account of painting as an art of imitation cannot be based exclusively on the likeness between a painting and its subject, but must also identify and explain those 'qualities' that belong to a painting but not to what it represents. Another way of formulating this question is to ask: how does a painting differ from what it is a painting of? The foregoing discussion has shown that although Alberti characterizes painting as a window onto the world, he also identifies a number of *sui generis* features that distinguish a painting from an arbitrary view through a window. These features can broadly be gathered under the heading of 'composition' and point to an awareness of the way in which the constituent elements of a painting are selected and ordered in order to bring about certain effects in the viewer. The concept of pictorial order is incompatible with the idea of painting as a direct 'copy' of reality since it establishes conditions on painting that do not apply to everyday experience. In the final part of this chapter I shall return to Alberti's *On Painting* in order to show that, despite his attempt to ground the art of painting is the knowledge provided by geometry and mathematics, he succeeds in providing a positive account of painting's reliance on sensory experience. First, however, I want to consider the opposing view, which received its definitive articulation in Plato's critique of art as a mere semblance of reality. By identifying the reasons for Plato's notorious attack on the 'imitative' arts, we can prepare the ground for a positive re-evaluation of painting as an art of appearance.

PLATO'S THEORY OF MIMĒSIS

I have already discussed Plato's argument in the dialogue *Cratylus* that since a painting represents only the outward form and colour of an object it cannot be characterized as a direct copy or counterpart, and that we therefore need to find 'some other principle of truth in images'.[20] I now want to consider in more detail Plato's account of the nature of artistic representation, focussing in particular on his theory of mimēsis. The ancient Greek word *mimēsis* is a polysemic term, whose correct translation remains a source of considerable debate. Its origins have been traced back to the practice of 'miming' a person's character and movements and hence to the 'mime' as a form of dramatic performance, though this is still a matter of controversy.[21] The difficulty of finding a single English equivalent arises from its usage in a variety of different contexts, not all of which

refer to works of art. This problem is compounded by the lack of a single Greek term for our modern concept of art. As has frequently been noted, the Greek word *technē*, which is standardly translated as 'art', has a much broader meaning. It was used to describe any human skill or accomplishment, and thus encompassed not only those things that we would categorize as art – such as poetry, painting, sculpture, music and architecture – but also crafts and skills such as shoe-making and horse riding.[22] It seems that Plato was the first to identify the concept of mimēsis as the key to explaining the distinguishing features of painting and the other 'imitative arts', among which he includes drama and music. Near the start of book X of the *Republic* he has Socrates ask his interlocutor, Glaucon, 'Could you tell me in general what imitation (*mimēsis*) is?', and in the ensuing discussion he seeks to answer this question with special reference to art.[23] His use of the term decisively shaped subsequent attempts to understand the distinctive character of art, and it continues to inform the ideas of philosophers working today. Nonetheless, the problems of translating both *technē* and *mimēsis* need to be borne in mind as we proceed since Plato's distinctions do not always map neatly onto our own.

The claim that there is a 'principle of truth' that applies to images is puzzling and we are entitled to ask what Plato might mean by this suggestion. His basic thought seems to be that truth consists in a relation of correspondence or *homoisosis* between two things: something is a true or accurate representation if it is identical to what it stands for or represents in every respect. However, this conception of truth as correspondence is greatly complicated by Plato's theory of ideas, according to which the material objects that are presented to our senses are themselves imperfect instances or copies of pre-existing ideas or forms (*eidē*). This results in a threefold or tripartite distinction between ideas, material objects and representations, including both works of art and natural images, such as a reflection in a lake. In the *Republic* Plato elucidates the difference between these levels of reality by using the example of a couch or bed. Through his spokesperson Socrates he observes that although a carpenter makes the physical object that we term a couch, he does not make the 'idea' of a couch – the underlying form or concept that guides his actions and that is shared in common with other couches. According to Plato's metaphysics, it is the idea or form that should be considered the 'real couch', whereas the particular couch that is made by the carpenter is 'only a dim adumbration in comparison with reality'.[24] If an artist makes a painting of a couch, he produces something that is at yet a further remove, a mere copy of a copy, or what Plato terms a 'product three removes from

nature'.[25] Whereas the craftsman is guided by the idea of a couch, the painter imitates the appearance of a particular couch, depicting it as it is seen from a certain viewpoint, such as from the front or from the side. Plato concludes that since painting is not directed at 'reality as it is' (i.e., the underlying form or idea) but at an 'appearance as it appears', it possesses a lesser degree of truth.[26]

Anyone who does not endorse Plato's view that the highest level of reality is to found in the underlying forms or ideas is unlikely to be persuaded by this argument. His position rests on the claim that both material objects and artistic representations of material objects can be ranked in terms of their greater or lesser proximity to an abstract concept or idea – an idea, moreover, that can never be fully known. Even if we concede that a painter represents a couch as it is revealed to sight, and hence its 'superficial appearance', which varies according to the viewpoint from which it is seen, rather than its unchanging essence or 'form', nothing constrains us to privilege conceptual knowledge over sensory experience. Unless we are already committed to the belief that the idea of an object is more real than any of its material manifestations, we are not required to accept the conclusion that the representation of the visible appearance of an object belongs to a lower order of reality.

Fortunately, Plato also offers a second argument in support of his claim that 'mimetic art is far removed from the truth'. Whereas his first arguments rests on the identification of a hierarchy of different levels of reality – idea, material object and representation – the second rests on the identification of a hierarchy of skills belonging, respectively, to the user, the maker and the imitator of an object. The two hierarchies are not directly correlated with each other, but in each case artistic representation is situated at the lowest level. Plato develops his second argument by considering the example of an artist who paints the reins and bit that are used to guide a horse. Once again, he begins by observing that whereas the artist merely makes an image or representation of these objects, it is a craftsman who makes the actual reins and bit. This time, however, his argument turns on the type of knowledge that is required in each case. Plato maintains that since the artist only imitates the external appearance of the reins and bit, it is the maker rather than the imitator who has proper knowledge of their 'quality', by which he means knowledge of how they can be designed most effectively to guide a horse. The knowledge of a craftsman, while superior to that of an artist, is surpassed in turn by the knowledge of a rider who actually uses the reins and bit, for a craftsman is expected to adapt the work he produces in accordance with the rider's

report of how well they work. Plato concludes that since artists are able to paint reins and bit without any knowledge about their use in controlling a horse, 'the imitator knows nothing worth mentioning of the things he imitates'. Artistic 'imitation is a form of play, not to be taken seriously', which neither relies on nor provides 'genuine knowledge' (*epistemē*).[27]

Unlike the argument from different levels of reality, this argument possesses the virtue that it does not require prior acceptance of Plato's theory of ideas – it stands or falls independently of his larger metaphysical commitments. The principal challenge to which it is exposed is that the distinctions on which it rests are artificial: nothing precludes an artist from also being a horseman or a craftsman, and thus from having practical knowledge of the things that he represents. Plato is right to point out, however, that a painter does not *need* expert knowledge of how reins and bit function in order to make an accurate representation. If knowledge of this sort were essential to pictorial representation, painters would only be able to depict things that they also had experience of making or using. It therefore seems correct to say that painters are primarily concerned with the visual appearance of objects and that they do not draw on practical knowledge in the same way as actual makers of objects or those who use them. But this can only be used as an argument against painting if we believe that the value of painting depends on its relation to practical knowledge. An alternative strategy, which Plato does not consider, is to investigate whether painting has its own distinctive contribution to make, a contribution that cannot be assimilated to other forms of knowledge.

Plato's third argument against painting is that it exploits a 'confusion in our souls'. He singles out the technique of *skiagraphia*, or shadow painting, for particular censure, claiming that it 'falls nothing short of witchcraft'.[28] *Skiagraphia*, or what today we term chiaroscuro – the blending of light and dark tones to model the reflection of light on three-dimensional objects – is thought to have been introduced during Plato's youth by the Athenian painter Apollodorus, and was thus a comparatively recent discovery. When combined with established techniques such as foreshortening, it resulted in a more convincing representation of volume and depth, allowing figures and objects to appear to stand forth from the ground on which they were depicted. Plato argues that if we trust the deliverance of our senses rather than reason, we can easily be taken in by such 'illusions'. Citing familiar examples such as the way a stick appears to be bent when viewed through water, he contends that the senses provide an unreliable guide to reality. The path to true knowledge is to be found in practices such as measuring, weighing and numbering,

which are carried out by that part of the soul that reasons and calculates. By contrast, painting is addressed to the lower faculties of the mind and trades in deceptive semblances.

Although Plato develops these criticisms in relation to painting, his real target is tragic poetry, which carried great prestige in Athenian society. By associating poetry with the deception and trickery of painting, he aims to discredit its authority as a source of knowledge. His strategy is to show that tragic poetry also appeals to the inferior – or non-rational – part of the soul insofar as it arouses our emotions and inhibits our capacity for rational self-control. He claims that when we respond to a poem or a play, we are ruled by our feelings instead of ruling over them as we should through the exercise of reason and that 'after feeding fat the emotion of pity . . . it is not easy to restrain it in our own sufferings'.[29] The poet is 'the counterpart of the painter, for he resembles him in that his creations are inferior in respect of reality, and . . . his appeal is to the inferior part of the soul'.[30] With these observations in place, Plato moves quickly to his conclusion that since art 'stimulates and fosters [the lower] element in the soul, and by strengthening it tends to destroy the rational part', we are justified in excluding artists from the ideal state or, at the very least, subjecting their work to censorship.

Plato's unflinching condemnation of mimetic art as 'an inferior thing cohabiting with an inferior and engendering inferior offspring' needs to be understood in the context of the overall aim of the *Republic*, which is to prescribe the type of education that should be given to the guardians of an ideal state in order to ensure that they are fit to rule.[31] His primary concern is to demonstrate the deceptive character of art, both as a source of knowledge and as a guide to right action, and hence its potentially corrupting effect on those who have not yet arrived at true philosophical understanding. Although Plato's theory of art is clearly intended to subserve a broader political purpose, it can be assessed independently of the conclusions that he draws from it. I will therefore conclude this discussion by identifying what I believe are the two principal weaknesses of Plato's account of art as imitation. To do so, I want to turn to another of the dialogues that contains a substantial discussion of the concept of mimēsis: the *Sophist*. Here, too, the passages that are devoted to art also serve a larger purpose in that Plato's goal is to show that sophistry, like art, substitutes the making of semblances for the pursuit of knowledge and that its claims to truth are a mere 'shadow play of words'.[32]

Whereas the discussion of art in the *Republic* is framed by the question 'what is imitation?', the discussion in the *Sophist* is framed by the

question 'what is an image?'. In answering this question, Plato repeats an argument already familiar to us from the dialogue *Cratylus*. Although it makes sense to say that an image is 'another thing of the same sort, copied from the real thing', when we investigate what is meant by the phrase 'of the same sort' it becomes clear that an image is not simply another example of the object. An image has 'some sort of existence', but it combines the real and the unreal together in a 'perplexing way'.[33] Plato divides the art of making images into two kinds. The first, which he terms the making of a 'likeness' (*eikon*), involves producing an image that corresponds to the size, shape and colour of the original. This, however, is not what artists do, since rather than employing the real proportions of an object they change its dimensions in order make their work appear beautiful – by which he means both pleasing to the viewer and optically consistent. As an example, he draws attention to the way in which painters and sculptors, when they are producing a colossal figure, will increase the size of its upper parts so that it does not appear to diminish as it recedes. Plato terms this form of image-making, which he describes as '"appearing" or "seeming" without really "being"', the making of a 'semblance' (*phantasma*).[34] In a much-quoted phrase, he claims that just as nature produces semblances in the form of shadows, dreams, reflections and mirror-images, so the artist who makes a painting of a house rather than building an actual house produces 'a man-made dream for waking eyes'.[35]

In making the distinction between a 'likeness' and a 'semblance' Plato recognizes that an artistic image or representation differs in important respects from what it represents. Whereas a perfect copy would be identical to the original, a painting or sculpture contains an ineliminable moment of non-identity or difference.[36] The concept of mimēsis – although frequently rendered as imitation – cannot be understood in terms of a simple doubling or mirroring of the original. The question at issue is how this moment of difference is to be characterized. As we have seen, Plato's search for the 'principle of truth' that applies to images is guided by the belief that truth resides in the correspondence or identity between two things. As a result, he interprets the non-identity between an artwork and its model in nature as a misrepresentation: an imitation is always less than the thing that it imitates.

We can make this clear to ourselves by recalling the distinction between P(1) and P(2) that I introduced in the previous section. Plato's recognition that an artistic image is a 'semblance' of reality rather than a 'likeness' prevents him from falling into the mistake of treating a paint-

ing as if it were a window onto the world. He is therefore in a position to reject the assumptions behind P(1). However, his theory of truth as correspondence leads him to give an entirely negative account of the differences between a painting and its subject. P(2) requires that we acknowledge a work of art as a 'composition', that is to say, an internally structured whole in which the parts are selected and ordered by the artist in order to meet the demands of pictorial unity and to achieve a desired effect upon the viewer. Whereas on Plato's account a representational painting always falls short of its model in nature, P(2) points to the existence of *sui generis* features that help to explain the distinctive interest and value that we attach to art.

The second main weakness of Plato's theory of mimēsis as it relates to painting can be traced back to his rationalism and to his corresponding distrust of sensory experience. As we have seen, Plato claims that the highest level of reality is to found in the universal forms or ideas that underlie appearances rather than in the material world that is presented to our senses. Since painters represent things as they are revealed to sight, they are not concerned with things as they really are but as they appear, and so remain at the level of opinion and confusion. At best, painting, like the other mimetic arts, can be described as a form of play or diversion, whose purpose is give pleasure to the viewer by creating a semblance of reality.[37] More typically, in the *Republic* and some of the other dialogues, Plato emphasizes the deceptive character of art, insisting that its effects are potentially harmful and corrupting.

IDEAL FORM AND SENSORY KNOWLEDGE

Readers of Plato have long been struck by the discrepancy between his negative view of art and the degree of artistry, imagination and creativity that characterizes his own writings. What, after all, are the dialogues if not dramatic exchanges in which different individuals are given voice? And how is Plato's vivid use of metaphor and analogy – not to mention his frequent recourse to myths and stories to explain his ideas – to be reconciled with his insistence on the power of art to corrupt and to deceive? These reflections have inevitably led to a search for passages in the dialogues that reveal a more sympathetic understanding of art. Thus, for example, Plato's observation in the dialogue *Ion* that poets are able to compose only when they are 'inspired' by a divine power might be taken to prefigure the modern concept of artistic genius. However, when this

passage is read in context it becomes clear that Plato is drawing attention to the lack of critical reflection that accompanies inspiration: the poet is 'a light and winged thing', but he is also 'beside himself, and reason is longer in him'.[38]

A more subtle, and more complex, strategy has been to focus on Plato's account of beauty as a path to higher knowledge in dialogues such as *Phaedrus* and the *Symposium*. In a famous speech in the *Symposium*, Diotima argues that we can ascend from a love of human beauty to an appreciation of the beauty of human institutions and finally to an appreciation of 'pure beauty' or beauty as it is 'in itself', distinct from its mundane or merely individual manifestations.[39] From here it is but a short step to the claim that the beauty of works of art can serve as a guide to the beauty of the ideal forms, and that artists should strive to represent not the shifting world of appearances but the eternal and immutable forms themselves.

A large stumbling block lies in the way of this interpretation. For not only does Plato refuse any role to art in the ascent to 'pure beauty', he expressly denies that artists can represent or be guided by ideal forms. In book X of the *Republic*, he raises the question, 'To which is painting directed in every case, to the imitation of reality as it is or of appearance as it appears? Is it an imitation of a phantasm or of the truth?'[40] As we have seen, his unequivocal answer is that painting belongs to the realm of appearances and that it leads us away from rather than towards true knowledge. Nonetheless, Plato's theory of ideas, heavily mediated through the writings of Plotinus and the Neo-Platonists, was refashioned by later philosophers and art theorists, who promoted the contrary view that through divine inspiration artists are granted direct access to the realm of ideal forms. This formed an important current of thought in the Renaissance and was a mainstay of academic classicism throughout the late seventeenth and eighteenth centuries. Discoveries of important works of antique sculpture helped to reinforce this view, and it was widely held that the greatness of classical art derived from its realization of an ideal of perfection.[41] Aspiring artists were enjoined to correct nature and to overcome the 'imperfections' that might inhere in any one individual by comparing and synthesizing several different examples. This approach is given a typically robust formulation by Joshua Reynolds in his *Discourses on Art*:

> long, laborious comparison should be the first study of the painter, who aims at the greatest style. By this means, he acquires a just idea of beautiful forms; he corrects nature by herself, her imperfect state

by her more perfect. His eye being enabled to distinguish the accidental deficiencies, excrescences, and deformities of things, from their general figures, he makes out an abstract idea of their forms more perfect than any one original; and what may seem a paradox, he learns to design naturally by drawing his figures unlike to any one object. This idea of the perfect state of nature, which the Artist calls Ideal Beauty, is the great leading principle, by which works of genius are conducted.[42]

An early version of this argument is found in the third book of *On Painting*, in which Alberti recounts a story about the Greek painter Zeuxis that had been passed down in different forms by both Cicero and Pliny. When Zeuxis was asked to produce a painting of the mythical figure of Helen for a temple at Croton 'he chose from all the youth of the city five outstandingly beautiful girls, so that he might represent in his painting whatever features of feminine beauty were most praiseworthy in each of them'.[43] Contrasting Zeuxis's work with that of the painter Demetrius, who 'failed to obtain the highest praise because he was more devoted to representing the likeness of things than to beauty', Alberti concludes that Zeuxis 'acted wisely': 'excellent parts should be selected from the most beautiful bodies' since 'the merits of beauty are not all to be found in one place, but are dispersed here and there in many'.[44] The construction of an ideal type is not, of course, the same as being guided by the Platonic form or idea, which, according to Plato at least, is not so easily come by. Nonetheless, Alberti does not seem to have identified any conflict between his insistence on the accurate representation of the observable world through the use of linear perspective in book I and his acceptance of the theory of ideal beauty in book III. He takes it as given that unless the artist is able to provide a convincing representation of three-dimensional forms and non-planar spatial relations his work will appear awkward and unbalanced to the viewer. However, it does not follow from this that the artist should simply copy what lies before him. As we have seen, Alberti's theory of 'composition' requires that the painter submit his material to principles of visual ordering that are not found in nature. While the claim that the artist should improve nature by selecting and combining parts from different individuals takes this argument a step further, it is not inconsistent with his basic position.

Although a case can be made for Alberti's endorsement of the theory of ideal form, I shall argue that the main impetus of his thought tends in the opposing direction and that the abiding significance of *On Painting*

resides in its positive re-evaluation of painting's reliance on sensory knowledge. Like Plato, Alberti identifies a close link between painting as a specifically visual mode of representation and the realm of 'appearances', but – unburdened by Plato's metaphysical commitments – he recognizes that this is what gives painting its special interest and value. To see how he arrives at this position, we need to return to the distinction between mathematics and painting with which the treatise begins. The argument of book I is obscured by Alberti's insistence in the dedication to Brunelleschi that its contents are 'entirely mathematical'. This suggests that the abstract knowledge provided by mathematics provides the foundation on which the treatise as a whole is based and that the role of the subsequent books is to show how this knowledge can be 'applied' to the art of painting. However, in the main body of the text Alberti makes it clear that mathematics and painting have different objects: whereas mathematicians 'measure the shape and forms of things in the mind alone and divorced entirely from matter', the painter 'strives to represent only the things that are seen'.[45]

What Alberti means by this can be seen by considering his discussion of points and lines. For the mathematician, a point and a line are abstractions: a point is something that is indivisible into parts and a line is a something that can be divided along its length but not along its breadth. The painter, however, works not with mathematical concepts but with the physical marks and strokes that can be made with a brush. Rather than divorcing form from matter, the painter is concerned with matter's visible form. Similarly, Alberti argues that the surface of an object can be defined as 'the outer part of a body which is recognized not by depth but by width and length, and also by its properties'.[46] Considered in abstraction from the standpoint of a specific observer, the properties of a surface such as its outer edge and its local colour are fixed. They cannot be altered without altering the object itself. However, when seen from a particular viewpoint and under specific conditions of light, not only the size, but also the outline and the colour of an object are subject to modification. Thus, for example, a round coin seen from the side will have the shape of an ellipse and bright colours will appear darker when placed in the shade. Alberti observes that 'These matters are related to the power of vision; for with a change of position surfaces will appear larger, or of a completely different outline from before, or diminished in colour; all of which we judge by sight'.[47] Although the appearance of an object changes in accordance with the conditions of light and the position from which it is viewed, these changes are not arbitrary. Viewed from the side rather than

above, a coin will always take on the shape of an ellipse, just as the part of a coloured surface that is in shade will always appear darker than the part that is exposed to direct light.

If mathematics and geometry are concerned with the 'permanent qualities' that inhere in the object itself, including its actual size and its outline shape, then painting addresses the 'impermanent qualities' that change in accordance with the standpoint of the observer. The task of the artist is to learn the reasons for these changes and to employ the appropriate methods for representing the visible world through the medium of paint. This requires that he draw on the knowledge provided by mathematics and geometry, but he does so in the service of depicting appearances, that is to say, things as they are seen. Whereas Plato argues that we should use the intellectual knowledge provided by our rational faculties to correct the deception of the senses, Alberti seeks to bring sensory knowledge into the domain of science. Rather than privileging the realm of concepts and abstract ideas over the realm of appearances, he recognizes that painting has its own, unique claim on our attention – a claim that derives, at least in part, from its rootedness in sensory experience.

CHAPTER 3

SURFACE AND SUBJECT

TWO FORMS OF AWARENESS

One effect of a picture that shows someone absorbed in the act of looking is to draw attention to the viewer's own activity of looking. Adolph Menzel's *Lady with Opera Glasses* (Plate 5) depicts a woman at the theatre gazing intently at something that we cannot see. But what do we see when we look at Menzel's drawing? There are two different ways to answer this question, both of which are correct but insufficient on their own. The first is to insist, somewhat obtusely, that what we see is a small rectangular piece of paper overlain with coloured chalk – a flat surface marked by a configuration of marks and lines. We can describe the difference between the unmarked cinnamon coloured paper that serves as the ground and those areas where the grain has been used to hold traces of chalk. We can also describe the direction, density and pattern of the marks, perhaps focusing on the contrast between the opaque patches of red and the lighter, transparent touches of white, or the hatching where two sets of lines cross each other. We can look at these lines and marks *as* lines and marks, for that is what they are, perhaps even recognizing in them traces of the movement of the artist's hand, whose variations of pressure and direction have given rise to pronounced differences in weight and texture. We can do all this, however, without referring to the content of the drawing, that is to say, without saying what those marks and lines are made to represent.

The second way of answering the question is to observe, with equal justification, that what we see when we look at *Lady with Opera Glasses* is a picture of a seated woman looking through a pair of binoculars. We can make out the red shapes of the seat backs, the white dress that covers her back and shoulders, the jutting shape of the binoculars and even the parting in her hair. We can also describe the position from which we view her – looking down from above and at an angle – and note that this prevents us from seeing her left arm and her face. There is much, of course, that is not shown. We are aware, for example, both of the isolation

of the figure from her surroundings and of the incompletion of the lower part of her body. Just as the woman focuses her attention on what can be seen through the binoculars, so the artist has focused his attention on the seated woman to the exclusion of whatever – or whoever – else that he might have been able to see in the theatre. Rather than interpreting this omission as evidence that the work is unfinished we recognize it as continuous with the saliency of looking. We see what the artist saw, or, at least, what the artist retained in his memory, as is indicated by the German word *Erinnerung*, which is written across the bottom left hand corner.

The loose handling of *Lady with Opera Glasses* makes it comparatively easy to distinguish between these two forms of awareness: our awareness of the marked surface as a configuration of lines and shapes and our awareness of that surface as a representation of a woman holding a pair of binoculars. Both seem to be necessary to depiction. For unless you were aware that you were looking at a marked surface, you would not be aware that you were looking at a picture; and unless you were aware that the experience of looking at the picture is in some way like the experience of looking at its subject, you would not be aware of what it represents.[1] Once we have made this distinction, the question inevitably arises as to how these two ways of seeing the picture are related to one another: how does our visual awareness of the drawing as a physical object with a discrete set of properties enter into or inform our awareness of what it represents? Do we alternate between seeing the marked surface and seeing the subject of the picture? Or do we hold the two together in our mind as part of a single, composite experience? What enables us to see a pattern of marks as a representation of a woman with binoculars? And how does the experience of seeing someone (or something) in a picture differ from the experience of seeing someone (or something) face-to-face?

Current philosophical discussion of these questions takes its starting point from the work of Ernst Gombrich, who, more than any one else, succeeded in revitalizing interest in the relation between visual perception and pictorial representation. Gombrich trained as an art historian in Vienna at a time when the disciplinary boundaries between philosophy, psychology and art history were not yet rigidly established. In a groundbreaking series of books and articles from the 1930s through until his death in 2001, he carried out a wide-ranging interdisciplinary investigation into the historical development of art that brought together cognitive psychology, philosophical aesthetics and detailed historical research. Gombrich's own 'illusion theory' of depiction has found few supporters,

but many of the core arguments that he brings to bear in its favour have been taken up by others, often in markedly conflicting ways. As we saw in Chapter 1, both of the two main rival strategies for explaining the distinctive nature of visual representation derive inspiration from his work. Whereas the perceptualist approach is grounded in his account of the psychological effect that pictures bring about in the mind of the viewer, the symbol-based approach draws on his analysis of the role of conventions in different representational systems. I shall examine the perceptualist approach in this chapter, reserving discussion of the symbol-based approach until Chapter 4.

One reason why Gombrich's ideas have proved so fertile – or so I shall argue – is that he succeeded in demonstrating the inadequacy of narrowly mimetic theories of art without producing a satisfactory alternative theory. In shaking loose the underlying assumptions that had dominated thought on the topic since the time of Plato, he revealed the need for a new explanatory framework. However, the clarity and effectiveness of this critique removed what common ground had previously been shared and opened the way for a range of competing positions. The fiercest debates have focused on whether, as Gombrich claims, recognition of the subjectivity of vision still allows for 'objective standards of representational accuracy' or whether we are forced to accept the relativist conclusion that no system of representation is able to represent reality more accurately than any another.[2] I shall return to these disputes in the next chapter. First, I want to examine the presuppositions behind Gombrich's own 'illusion theory' of depiction and to show how this theory arises out of his root and branch rejection of the concept of mimesis.

SUSTAINING ILLUSION

The title of Gombrich's book *Art and Illusion: A Study in the Psychology of Pictorial Representation* (1960) forewarns the reader that its scope extends beyond the Western canon of fine art to include a wide assortment of pictures and images – including not only posters, signs and advertisements, but also the 'optical illusions' that are employed by psychologists to analyse visual perception. Gombrich's use of the term 'illusion' also points back to a much earlier tradition of enquiry, finding an important counterpart in Plato's characterization of art as a 'semblance' or 'phantasm'. Whereas Plato criticizes mimetic art as a form of

deception that is directed at the 'lower reaches of the soul', Gombrich's avowed goal is to 'recapture the thrill and shock which the first illusionist images must have caused when shown on the stage or on the walls of Greek houses'.[3] He acknowledges that realistic representation is now a commonplace, mastered by the skilled amateur and the corporate designer alike – 'even the crude coloured renderings we find on a box of breakfast cereal would have made Giotto's contemporaries gasp' – but he insists that the simultaneous 'victory and vulgarization of representational skills' presents an obstacle to understanding the nature of visual depiction.[4] The very facility with which these skills are now deployed prevents us from recognizing that they were acquired only through a lengthy process of study and investigation. Because we stand at the end of this process, it is easy for us to assume that these hard-won techniques have always been available and that anyone who seeks to record what she sees by making marks on paper will follow the same self-evident methods of representation. Gombrich pursues two separate lines of thought in order to break the hold of this assumption: the first is captured in his claim that the artist 'cannot transcribe what he sees; he can only translate it into the terms of his medium'; the second is captured in his oft-repeated slogan that 'making comes before matching'.[5] Let us consider each of these ideas in turn.

The materials out of which art is made become a medium when they are used in the service of communication. A line of chalk can be made to represent the outline of a shoulder, just as a row of tesserae can be made to represent the edge of a stage or a translucent glaze of paint a bead of water on a jug. But the medium also imposes constraints upon the artist. The coarse lines left by a piece of chalk allow the artist to explore a different range of effects from the thin lines of a pencil, just as the blending of oil-based pigments allows the painter to evoke subtleties of tone that must elude even the most patient mosaicist. Once we are aware of these differences we find ourselves hard pressed to say which offers the more faithful representation of nature. For the world as it reveals itself to sight no more looks like a soft residue of chalk than it does a hard line of graphite and the difference between the painter's brushstroke and the mosaicist's pieces of stone is a difference of degree rather than of kind. The artist cannot duplicate what he sees with the resources of his medium since – apart from some rare exceptions such as the use of gold leaf to represent gold – the medium and what it is used to represent are radically dissimilar. The world we see extends in depth, alters its colour with the modification of light and is animated with motion, but a picture offers us

only a still, two-dimensional surface marked with a configuration of pigmented substance. How, then, are we to explain the fact that some pictures are able to provide us with visual experiences similar to those that would be provided by the depicted scene were we actually to see it? In other words, how is it that pictures are able to generate the 'illusion' of seeing something that is not actually there?

In raising this question, Gombrich returns to a problem with which Plato had wrestled in the dialogues. Like Plato he acknowledges that 'images are very far from having qualities which are the exact counterpart of the realities that they represent' and that we must therefore seek 'some other principle of truth in images'.[6] The innovative character of Gombrich's solution derives from a pivotal transformation in the terms in which the problem is formulated. Instead of enquiring whether a work of art 'looks like' or resembles its model in nature – and hence whether it offers a more or less accurate copy of the original – he focuses on the type of *response* that each is able to elicit. Rather than comparing art with nature, he compares the different psychological effects that the two produce in the mind of the viewer. Although a still, two-dimensional surface does not share the same physical properties as the three-dimensional moving world it can nonetheless be made to trigger the same perceptual responses. Since these responses are largely involuntary they can be directed and manipulated by providing the appropriate visual cues. Recalling Alberti's famous analogy, Gombrich observes that:

> What may make a painting like a distant view through a window is not the fact that the two can be as indistinguishable as a facsimile from the original: it is the similarity between the mental activities both can arouse.[7]

Artists do not learn to 'copy' what they see: they discover ways of mobilizing the viewer's recognitional responses through the resources of their medium. This can only be achieved by experimenting with different arrangements of marks and observing their effect on the viewer. However, once successful techniques such as occlusion, diminution, foreshortening and shading have been developed, they can be deployed by other artists. In a vivid metaphor, Gombrich claims that the history of art 'may be described as the forging of the master keys for opening the mysterious locks of our senses to which only nature herself originally held the key'.[8] We have no direct access to the inner mechanism but once we know how to spring the lock this knowledge can be passed from artist to artist.

On this view, a picture that purports to offer an accurate representation of a particular scene or object can be tested against experience and modified accordingly. But since a picture is not a direct copy of nature the artist must start out with some basic design or motif that can serve as a basis for investigation. 'Making' comes before 'matching' in the sense that artists are only able to discover whether certain techniques will elicit the appropriate response through a process of trial and error. Analyses of a range of different types of artworks – from humble woodblock prints to the most ambitious Renaissance altarpiece – have shown that artists frequently rely on forms and compositional structures that have been derived from the work of earlier artists.[9] In emphasizing the extent to which 'the familiar will always remain the likely starting point for the rendering of the unfamiliar', Gombrich's goal is not merely to show that artists learn from each other as well as from their own experience: he seeks to undermine the misleading assumption that the process of artistic creation begins with a pure visual impression that is then 'transcribed' as a visual representation.[10] In short, there is no perception without conception: seeing and knowing are inextricably bound up with one another through the 'expectations' that structure experience. The information that reaches us through the senses is so abundant and so varied that we must first impose a means of selection and organization. 'Making' therefore also comes before 'matching' in the sense that pictorial representation depends on a prior conceptual schema through which the artist can seize hold of, and give order to, the flux of experience. Gombrich concludes that 'All art originates in the human mind, in our reactions to the world rather than in the visible world itself.'[11]

Gombrich likens the interplay of schema and correction to the role played by hypothesis and evidence in the formation of scientific knowledge. Once artists have set themselves the task of producing a convincing representation of the visible world, they can test the effectiveness of a particular design or schema against the deliverances of the senses and use the results to develop ever more effective means of triggering the appropriate responses. The evolution of naturalism as this took place first in Ancient Greece and then in the Renaissance is the progressive 'conquest of appearances' through a process of making and matching.[12] As Gombrich recognizes, the question that this account leaves begging is why some cultures but not others have pursued the goal of producing 'life-like' images in the sense in which he uses this term. One of the central aims of *Art and Illusion* is to explain why 'different ages and different nations have represented the visible world in such different ways'.[13]

There are two components of Gombrich's answer that are directly relevant to our present concerns. The first is his claim that what counts as artistic progress is closely tied to the purpose or function that art is intended to fulfil. During the Byzantine period, for example, the emphasis on didactic clarity resulted in images that were clearly legible and that could establish direct contact with the viewer. There was no requirement that the artist provide a coherent representation of three-dimensional space or that the figures stand in recognizable spatial relations to one another. Instead, 'the sacred event was told in clear and simple hieroglyphs which make us understand rather than visualize it'.[14] Pursuing the same line of thought, Gombrich argues that the rise of naturalism in Renaissance art should be traced back not to a general desire to imitate nature as such but to 'a specific demand for the plausible narration of sacred events'. The very success with which artists such as Giotto were able to satisfy this requirement allowed viewers to ask questions such as 'What does this onlooker feel?'; 'What sort of fabric is his cloak?'; 'Why does he throw no shadow?'[15] These questions – together with the corresponding technical interest in the accurate representation of appearances – became relevant only when pictures were treated not as emblems or symbols but as vivid representations of biblical scenes as they might have been perceived by an eye witness.

The second component of Gombrich's answer is to be found in his claim that the development of ancient Greek and Renaissance art is distinguished from that of other historical periods by the 'admixture of science'.[16] By this he means not merely that artists were able to draw on – and in some cases, contribute to – related fields of enquiry, such as anatomy, optics and projective geometry, but that the investigation into the underlying mechanisms through which artists could produce a realistic image was carried out in a scientific spirit. The work of Renaissance artists such as Alberti and Brunelleschi clearly fits this model, but Gombrich also wishes to include artists such as John Constable, who were scientific in their method rather than in their training. Citing Constable's remark that 'Painting is a science and should be pursued as an inquiry into the laws of nature,' Gombrich concludes that 'In the Western tradition, painting has indeed been pursued as a science. All the works of this tradition that we see displayed in our great collections apply discoveries that are the result of ceaseless experimentation'.[17]

Though this account has many virtues, it remains unmistakeably Whiggish. Gombrich too readily assimilates the problem 'why representation should have a history' to the problem 'why it should have taken

mankind so long to arrive at a plausible rendering of visual effects that create the illusion of life-likeness'.[18] He thereby downplays or overlooks the genuine diversity of visual art that has been produced in different cultures and at different historical periods in favour of a single, unified narrative that culminates in the development of fully-fledged naturalism. Even within the confines of the specific European traditions on which Gombrich focuses, it is far from clear that naturalism has been the main or even a primary goal that artists have pursued. It is only on the implausible assumption that the artists he discusses shared the same set of motivations and that they were attempting to find a solution to a problem that they all formulated in the same way that his theory of 'making and matching' can fulfil an explanatory role.

I shall return to these issues in Chapter 5, in which I investigate in more detail Gombrich's claims concerning the historical development of art. However, even this brief discussion allows us to see that Gombrich's account of pictorial representation is severely circumscribed. His so-called 'illusion theory' of depiction is exclusively concerned with naturalistic works of art in which the artist creates a convincing 'illusion' of reality by activating the mechanisms of perception.[19] The artist, like the scientist or conjuror, is an 'experienced manipulator', who 'has been able to find out how to predict and trigger certain non-veridical visual experiences through the arousal of visual sensations'.[20] It follows from Gombrich's equation of naturalism with the pursuit of illusionistic effects that the complete 'conquest of appearances' would be a painting that the viewer was unable to distinguish from reality: so effectively would the artist be able to simulate the clues we rely on in ordinary vision that the viewer's experience of the painting would be indistinguishable from her experience of the scene or object that it depicts. Gombrich concedes that this can be achieved, if at all, only under highly artificial conditions, such as requiring the viewer to look through two boxes with peepholes, one of which opens onto the painting and the other onto a reconstruction of the motif.[21] Without such devices, including the imposition of strictly controlled lighting conditions, the 'illusion' that she is looking at a real scene would be dispelled by her awareness of the picture's framing edge and the wall or bench against which it is displayed. Moreover, if she were allowed to move her eyes relative to the picture, she would notice that, unlike in the real world, the objects in the picture do not change their perspective profiles relative to the viewpoint of the observer. (You can confirm this for yourself by looking at the illustration of Bellini's *San Zaccaria Altarpiece* and noting how when you move your head a foot to

the right, everything else in your field of vision shifts but the figures in the painting retain the same outline shape and stay in the same spatial relations).

Some philosophers have argued that these considerations alone provide sufficient grounds to reject Gombrich's position. Goodman, for example, argues that:

> deception under such nonstandard conditions is no test of realism; for with enough staging, even the most unrealistic picture can deceive. Deception counts less as a method of realism than as evidence of magicianship, and is a highly atypical mishap. In looking at the most realistic picture, I seldom suppose that I can reach into the distance, slice the tomato, or beat the drum.[22]

Gombrich's response to this objection is to insist that it is the eye not the mind that the painter sets out to deceive and that being taken in by an illusion is not the same as holding a false belief. We do not need to believe that we are actually looking at the Madonna surrounded by saints to have a visual experience as of the scene depicted. The core of Gombrich's illusion theory of depiction resides in the claim that 'certain perceptual configurations can "trigger" specific reactions' and that these reactions are beyond our volitional control.[23] This, in turn, is buttressed by the much stronger claim that although we can alternate between looking at the marked surface of a picture and experiencing it as a realistic depiction, we cannot do both concurrently. Gombrich concludes that it is *impossible* for the viewer simultaneously to be aware of the painting as a flat surface containing a configuration of lines and marks and of what it is that those lines and marks represent. For as soon as we direct our attention to the painting as a physical object that possesses its own material reality the illusion that the artist has so carefully crafted will disappear.

AMBIGUITY AND PICTORIAL REPRESENTATION

The drawing that is reproduced as Figure 2 has proved a remarkably fertile stimulus for philosophers. It first appeared in the German satirical magazine *Fliegende Blätter* in 1892, but discussion of its significance, among philosophers at least, dates from Ludwig Wittgenstein's inclusion of a simplified line-drawing version in his *Philosophical Investigations* (published posthumously in 1953). The German original carries the

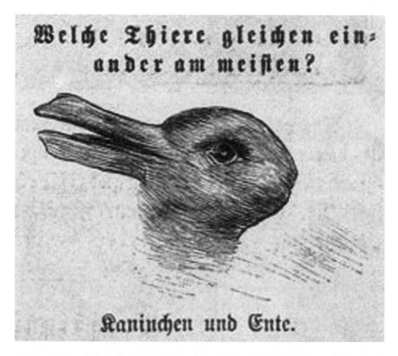

Figure 2 Duck-rabbit (*Kaninchen und Ente*), illustration from *Fliegende Blätter*, vol. 97, no. 2465, 23 October 1892.

inscription, 'Which animals are most like each other?' and is labelled at the bottom 'Rabbit and Duck'. The drawing is an example of an ambiguous or reversible figure. If you allow your interpretation of the drawing to be guided by the idea of duck, the image resolves itself into a duck's head with its bill pointing to the left (as you look at the picture); however, if you allow yourself to be guided by the thought of a rabbit, the image resolves itself into a rabbit's head facing to the right, with two protruding ears sticking out behind. When we move from seeing the drawing as a duck to seeing it as a rabbit the drawing itself does not change but we see it differently. Wittgenstein calls this kind of change in the way of seeing something 'noticing an aspect'.[24] He is interested in characterizing the change that takes place when we see the drawing first one way, then another, at least in part, because it provides a means of showing that concepts play a role in perceptual experience.[25] We do not have a prior, purely visual experience that we interpret in two different ways. Rather, interpretation enters into or informs the way in which we actually see the object: 'we *see* it as we *interpret* it'.[26] This line of thought is also central

to the argument of *Art and Illusion*, but Gombrich has another reason for giving such prominence to the duck-rabbit drawing, which, he claims, offers 'the key to the whole problem of image reading'.[27]

Like Wittgenstein, Gombrich employs the duck-rabbit drawing to elucidate the role of projection in visual experience. Throughout the book he emphasizes the 'beholder's share' in interpreting an image: successful representation depends upon the viewer's ability to make connections and to draw on the store of patterns and images that she holds in her mind. By showing that one and the same set of marks can be read in two different ways he is able to undermine the claim that there is a one-to-one correspondence between the distribution of marks on a flat surface and the scene or object those marks are intended to depict. However, the duck-rabbit drawing also fulfils a second, and more problematic function in Gombrich's theory of depiction. As well as using the drawing to explore the flexibility of our interpretations, he also uses it to demonstrate what he terms their 'exclusiveness'.[28] He points out that if we attend carefully to what happens when we look at the drawing, we can observe the shift between seeing it as a depiction of duck and seeing it a depiction of a rabbit, but no amount of effort will allow us to sustain both readings at the same time. We can train ourselves to oscillate between the two with increasing rapidity, and we can hold in mind or 'remember' the duck while we see the rabbit, but we cannot see the drawing simultaneously as both a duck and as a rabbit. Gombrich concludes that 'though we may be intellectually aware of the fact that any given experience *must* be an illusion, we cannot strictly speaking, watch ourselves having an illusion'.[29]

The very simplicity of the drawing makes perspicuous something that we normally overlook: the impossibility of direct visual awareness of the ambiguity through which an illusion is sustained. Although this demonstration is undeniably effective, few readers are likely to be convinced that a simple trick drawing can provide the key to understanding what happens when we look at a work of art. For this reason, Gombrich adduces a second example, taken from the writings of Kenneth Clark, in which the art historian describes his attempt to 'stalk' the illusion created by Velázquez's painting *Las Meniñas* [The Maids of Honour] (Plate 6). This is how Clark himself recounts his struggle to discover the mysterious process by which the artist has succeed in transforming 'appearances into paint':

one cannot look for long at *Las Meniñas* without wanting to find out how it is done . . . I would start from as far away as I could, when the illusion was complete, and come gradually nearer, until

suddenly what had been a hand, and a ribbon, and a piece of velvet, dissolved into a salad of beautiful brush strokes. I thought I might learn something if I could catch the moment at which this transformation took place, but it proved to be as elusive as the moment between waking and sleeping.[30]

The experience that Clark describes is one with which every gallery visitor is familiar. Curious as to how the artist has succeeded in conveying the texture and design of a piece of fabric or the pulse of life in a human hand, we approach the painting ever more closely only to discover that all we can see are patches and marks. To prevent the image from breaking up into its constituent elements we are forced to step further back. At a certain point the marks resolve into a meaningful shape, but then the image regains its hold on us and we find ourselves once again in the position from which we started out.

Taken together these two examples appear to offer conclusive evidence in support of Gombrich's argument for the 'inherent ambiguity of all images'.[31] As we have seen, the illusion theory of depiction issues in the claim that it is impossible for the viewer both to attend to the marked surface and to enter into the illusion that it sustains. To see something as a picture is to be aware either of the depicted content or of the lines and shapes out of which the picture is made: we can alternate between these two different forms of awareness, but we cannot simultaneously be aware of the marked surface and of what that surface represents. The first of Gombrich's examples is intended to show that we are unable directly to experience the visual ambiguity on which illusion depends, while the second is meant to establish the relevance of this simplified demonstration to the experience of looking at works of art. Despite the initial persuasiveness of this strategy, closer scrutiny shows that there are important differences between the two examples and that neither singly nor collectively can they can bear the weight that Gombrich places upon them.

Let us start with the duck-rabbit figure. There are two separate problems here. First, as a number of readers have pointed out, Gombrich misidentifies the source of the picture's ambiguity.[32] The viewer who sees the drawing first as a rabbit and then as a duck shifts from one interpretation to another. But this is not the same as the shift from seeing the drawing as a set of marks to seeing it as an image. The drawing is ambiguous in respect of its representational content not in respect of the relation between surface and subject. Gombrich incorrectly assumes that the disjunction – rabbit/duck – corresponds to the disjunction – surface/

subject. That there is a slippage from the one to the other is made explicit when he claims that 'instead of playing "rabbit or duck" [artists] had to invent the game of "canvas or nature", played with a configuration of coloured earth which – at a distance at least – might result in illusion'.[33] Gombrich's argument for the impossibility of sustaining simultaneous attention to both the surface and the subject rests on a false analogy: to see the drawing either as a rabbit or as a duck is not analogous to seeing it either as a picture or as a set of marks. Equally damaging is his failure to recognize that the duck-rabbit drawing possesses a special characteristic that is not necessarily shared by other representations.[34] As a reversible or bistable figure the drawing allows of two mutually exclusive interpretations. Since we cannot hold two incompatible interpretations at one and the same time, we are obliged to switch from the one to the other. However, nothing that Gombrich has said shows that we cannot concurrently sustain different interpretations. A separate argument is needed to show that our awareness of the marks used to make a picture is incompatible with our awareness of its representational content.

Few viewers experience any difficulty perceiving the duck-rabbit figure at one and the same time as a drawing, that is to say, as a pattern of marks on a flat surface, and as an image. However, it could be argued that in the case of more complex representations, such as Velázquez's *Las Meniñas*, we are unable to sustain this dual awareness. This would seem to be the appropriate conclusion to draw from Clark's account of his inability to capture the moment at which the 'salad' of brushstrokes transforms itself into a convincing representation of a hand, a ribbon or a piece of velvet. To see that the example does not licence this conclusion, we need to examine more closely the nature of the experience that Clark describes. By his own admission, Clark sets out to discover the secret behind Velázquez's painting. He does so by going right up to the picture's surface until all he can see are individual strokes of paint. But from this distance he can no longer view the painting as it is meant to be viewed. There is an optimum distance for viewing a painting or a drawing – a distance that varies from work to work. If we stand too far away, we are unable to make out sufficient detail; if we approach too close, all we see are marks and patches. Like any complex unity, the whole cannot be grasped by isolating its individual parts. Adorno describes this phenomenon with characteristic flair:

> When artworks are viewed under the closest scrutiny, the most objectivated paintings metamorphose into a swarming mass and

texts splinter into words. As soon as one imagines having a firm grasp on the details of an artwork, it dissolves into the indeterminate and the undifferentiated . . . Under micrological study, the particular – the artwork's vital element – is volatilized; its concretion vanishes.[35]

Just as a painting can be dissolved back into a welter of brushstrokes, so a novel can be reduced to words, or a piece of music to a sequence of sounds. Clark's attempt to 'stalk' the illusion of *Las Meniñas* reveals how hard it is to isolate and objectify the transformation of paint into appearances. But it does not allow us to draw conclusions about what takes place under normal viewing conditions, that is to say, when the painting is viewed from the appropriate distance.

The most powerful objection to Gombrich's theory of depiction is that it misdescribes what takes place when we look at a picture under normal viewing conditions. Even before an artwork as large and ambitious as Velázquez's *Las Meniñas* we do not experience the illusion of looking at an actual scene. This not merely due to the complex structure of the painting, with its three different centres of focus, or to the insistent gaze of the figures who look out of the picture towards the imaginary spectator. Nor can it be attributed to the prosaic fact that we have no first-hand experience of the court of King Phillip II and so are unlikely to enter into the illusion that we are seeing the infanta Margarita and her maids of honour. Any possibility that we might overlook the work's constructed character is forestalled by the inclusion of the artist himself, brush in hand, at work on a painting whose content is hidden from our view. Velázquez also leaves the viewer uncertain whether the framed image of the King and Queen on the rear wall is a reflection in a mirror or a painted portrait, creating an irresolvable visual ambiguity at the centre of the painting. The artist's intentions have been variously interpreted but there is a broad consensus that the painting thematizes the uncertainties of visual representation and that it is intended to make the viewer aware of the exigencies of looking.[36] It is therefore curious that Gombrich elects to employ this of all paintings in support of his illusion theory of depiction. However, since he takes his cue from Clark, we should, perhaps, focus our attention not on the complex structure of the image as whole but on the depiction of a single figure, such as the infanta Margarita. If Gombrich is right, we should be forced to oscillate between seeing the young princess and seeing the painted surface, but it is clear that nothing prevents us from seeing both the marks on the surface and what those

marks represent. Unless we were able to sustain simultaneous awareness of the subject of the painting and of the medium of representation, we would be unable, for example, to admire the facility with which the artist has used thick slabs of colour to capture the elaborate finery of the infanta's dress and the splendour of her broach, or the different range of effects through which he evokes the pale gold of her hair.

I started this chapter by drawing a distinction between two different forms of awareness: our awareness of a marked surface as a configuration of lines and marks and our awareness of that surface as a representation of something that is not physically present. We are now in a position to see that these two forms of awareness are not only mutually compatible but mutually sustaining: far from excluding one another, our awareness of the lines and marks *as* lines and marks and our awareness of what those marks represent can come together in a single composite experience. This can be confirmed by returning once again to Menzel's *Lady with Opera Glasses*. Consider, for example, the way in which we follow the direction of a line as it is drawn across the paper while at the same time becoming aware of the way in which that line circumscribes the outline of a shoulder or the curved back of a chair. Rather than switching from the one to the other, we look for continuities between the subject of the picture and the shapes and patterns formed by the lines and marks, whose variations in texture, direction and density take on meaning once recruited in the service of representation. The most cursory indications of light and shade or the partial outline of an object can elicit recognition even as we remain aware that we are actively engaged in filling out and completing highly abbreviated visual clues. We see the hatching of black lines both as chalk marks that have been drawn in different directions and as a suggestion of shadow. So adept are we at these transitions that we can look through the white chalk to the surface of the paper while also seeing this as a means of representing the woman's back as it is revealed through the material of her dress. Even the parts of the paper that have been left unmarked by the artist can function both as a flat, undifferentiated surface and as means of suggesting spatial depth. Far from being troubled by the incompletion of the figure and her surroundings, we remain aware that at a certain point the drawing simply stops. What gives the picture its sense of rightness is the correspondence between the selectivity that is imposed by the procedure of drawing, which omits and emphasizes in accordance with the work's own internal structure and order, and the selectivity of vision itself, which isolates and gives prominence to certain features of the visual field.

REPRESENTATIONAL SEEING

The fullest and most insightful analysis of the way in which these two forms of awareness interact and reciprocally transform one another in the experience of works of visual art is to be found in the writings of Michael Podro.[37] Through a wide range of examples, extending from Donatello's relief sculptures through to Hogarth's engravings and Chardin's oil paintings, Podro has traced the 'thread of recognition' that connects the viewer's awareness of the materiality of the medium with her awareness of the depicted subject. These case studies carry their own philosophical weight insofar as they provide an effective and persuasive means of elucidating the distinctive characteristics of 'pictorial looking'. The reader who finds her understanding of art deepened and extended by Podro's account is unlikely to ask for further clarification; confirmation, if it is needed, is to be found in the paintings and drawings themselves, that is to say, it is to be found in the viewer's own first-hand experience. Nonetheless, it is important to examine in detail the philosophical commitments entailed by this approach, for it is only after the alternative to Gombrich's illusion theory of depiction is formulated as an independent thesis that its strengths and weaknesses become apparent. For this reason, I now want to turn to the work of Richard Wollheim, whose theory of 'twofoldness' is widely recognized as the most robust and philosophically sophisticated defence of the view that simultaneous awareness of the subject and the surface of a painting is not merely consistent with, but essential to, pictorial experience. Wollheim's theory has evolved over time and been presented in a number of different versions, but its basic lineaments remain unchanged. From his inaugural lecture 'On drawing an object' through to his book *Painting as an Art*, where it forms part of a broader and more comprehensive theory of pictorial representation, he has sought to provide a coherent philosophical analysis of 'the strange duality – of seeing the marked surface, and of seeing something in the surface – which [he calls] *twofoldness*'.[38]

Wollheim pursues two different strategies, both of which are designed to show that the visual experience of looking at a picture has a distinctive phenomenology that is irreducible to other forms of experience. The first strategy, which he adopts in *Art and its Objects*, is to examine the most basic form of pictorial representation – the making of a single mark upon a blank canvas – to show that what he terms 'representational seeing' can be distinguished from 'straightforward perception'.[39] Drawing on a teaching strategy employed by the abstract painter Hans Hofmann,

Wollheim observes that a black mark placed on white canvas will appear to sit in front of the surface, while a blue mark will appear to sit behind it. To see the black as in front of the white surface or the blue as behind it is to see something other than their physical properties: the relation 'behind' and 'in front of' need not correspond to the physical relation between the mark and the surface. Wollheim contends that these examples 'give us in elementary form the notion of what it is to see something as a representation, or for something to have representational properties'.[40] The minimum requirement for representational seeing – and thus for successful representation – is the recognition of figure-ground relations. The viewer who identifies a mark or shape as lying in front of or behind the surface on which it sits sees not only a flat, patterned surface but also the non-planar spatial relations that belong to the 'virtual' space of the picture. (Even a page of printed text, such as the one you are now reading, can be viewed representationally. If you abstract from the meaning of the words and view the text as a set of black marks against a white ground, the dark shapes of the letters will appear to float in front of the surface of the paper.) Representation is, therefore, to be distinguished from figuration – the depiction of recognizable objects, scenes or persons. All that representation requires 'is that we see in the marked surface things three-dimensionally related'.[41]

One important consequence of this approach is that it extends the notion of representational seeing to include abstract as well as figurative painting. Wollheim gives as an example Hofmann's *Pompeii* (1959, Tate Gallery, London), a large abstract painting that exploits the 'push and pull' effect created by the juxtaposition of differently coloured rectangles against a variegated ground. By finely tuning the saturation and intensity of the colours, Hofmann creates a dynamic relation between the different areas of the painting, which appear to press forward or to recede within a shallow pictorial space. Despite the absence of figurative content, this painting therefore satisfies Wollheim's minimum requirement for representational seeing since it 'manifestly . . . requires that we see some planes of colour in front of other planes, or that we see something in the surface'.[42] For the moment, I want to leave open the question whether *all* abstract paintings are representational in Wollheim's sense of the term or whether some non-figurative paintings do not allow for representational seeing. The answer to this question bears directly on his claim that twofoldness is essential to the experience of a picture. To see why this is the case, we need to examine the relevant sections of *Painting*

as an Art in which he both elaborates and refines the thesis that representational seeing requires simultaneous awareness of the surface and the subject of a painting.

In *Painting as an Art* Wollheim adopts a new strategy. This time he starts out not from a single mark on a blank canvas but from a special kind of perceptual experience, which, he claims, is both logically and historically prior to representation: the experience of seeing something such as a fighting horseman or the figure of a boy in a wall stained by damp or in rough and uneven stones. He characterizes 'seeing-in' as follows:

> Seeing-in is a distinctive kind of perception, and it is triggered off by the presence within the field of vision of a differentiated surface . . . when seeing-in occurs, two things happen: I am visually aware of the surface I look at, and I discern something standing out in front of, or (in certain cases) receding behind, something else.[43]

Seeing-in is logically prior to representation since it can be exercised on surfaces or objects, such as clouds or rocky crags, that are not representations. However, Wollheim also maintains that 'seeing-in is prior to representation historically in that surely our remotest ancestors engaged in these exercises long before they thought to decorate their caves with images of the animals they hunted'.[44] These two levels of description, the logical and the historical, are both operative in Wollheim's claim that pictorial representation 'arrives' when someone purposively marks a surface with the intention that others are able to see something in it – such as, for example, a bison or a seated woman. Wollheim concludes that representation imposes on seeing-in something that it otherwise lacks: a 'standard of correctness and incorrectness'. Unlike the generic capacity for seeing-in, there is a right or wrong way of seeing a representation, and this is 'set – set for each painting – by the intentions of the artist in so far as they are fulfilled'.[45]

Wollheim's claim that there is a correct way of seeing a representation, and that this is determined by the intentions of the artist, can only properly be understood in the context of his theory of the 'spectator in the picture'. According to this theory, the artist is not only an agent, who alters and corrects his work to his own satisfaction, but at the same time and as part of this process, he also adopts the role of an imaginary spectator, whose responses he both anticipates and seeks to direct. To see a

painting correctly, the viewer must occupy the position of the imagined spectator, that is to say, she must see it as the artist intended it to be seen. As Wollheim explains:

> On this account, what a painting means rests upon the experience induced in an adequately sensitive, adequately informed, spectator by looking at the surface of the painting as the intentions of the artist led him to mark it. The marked surface must be the conduit along which the mental state of the artist makes itself felt within the mind of the spectator if the result is to be that the spectator grasps the meaning of the picture.[46]

Fortunately, Wollheim's theory of representational seeing does not depend upon this controversial argument. All he needs to establish is the difference between an open-ended process of seeing-in, akin to reverie and free association, in which there are no constraints on interpretation, and the type of looking appropriate to painting, in which the viewer takes into account 'the traditions, usages and purposes of the painter'.[47] Thus, for example, the knowledge that *Pompeii* is a work by a major abstract artist might count as a reason not to identify the rectangles of colour as a representation of the façade of a building. But there is no single correct way to see the painting, whose dynamic pictorial relations are set in motion rather than strictly controlled by the intentions of the artist. Even in the case of a figurative painting, such as Velázquez's *Las Meniñas*, the meaning of the work cannot simply be identified with, or reduced to, the intentions of the artist. Someone who failed to recognize the marks at the centre of the painting as a depiction of a young girl could be said to have failed to see the painting correctly, but this minimal level of identificatory accuracy is only one component of the viewer's understanding of its meaning.

The strategy that Wollheim pursues in *Painting as an Art* is potentially misleading insofar as it is designed to establish a close link between intention and pictorial content that is not entailed by the theory of twofoldness. However, he also makes an important refinement to the theory that helps to clarify the difference between his position and Gombrich's illusion theory of depiction. In *Art and its Objects* Wollheim had characterized twofoldness in terms of the viewer's simultaneous awareness of two different phenomena: the surface of the picture and the representation of pictorial depth. He thereby simply inverted Gombrich's claim that the viewer's awareness of the picture's material surface and her awareness of

what that surface represents are mutually effacing. But in *Painting as an Art* he abandons the underlying dichotomy of 'nature or canvas' by reconceiving twofoldness as the simultaneous awareness of two different aspects of one and the same experience. The first of these is the recognitional aspect: the viewer's awareness of what is represented, the content or subject of the picture. The second is the configurational aspect: the viewer's awareness of the design properties of the picture, including its shape or format, the visibility and disposition of the marks on the surface, the relative contrasts between light and dark, and, in the case of figurative painting, the viewpoint from which the subject is represented. Although these two aspects are 'distinguishable', they are also 'inseparable':

> They are two aspects of a single experience, they are not two experiences. They are neither two separate simultaneous experiences, which I somehow hold in the mind at once, nor two separate alternating experiences, between which I oscillate – though it is true that each aspect of the single experience is capable of being described as analogous to a separate experience.[48]

Wollheim's analysis of the distinctive phenomenology of the experience of looking at a picture is intended to rectify one of the central weaknesses of the illusion theory of depiction: its inability to characterize what takes place when we look at a picture under normal viewing conditions. By showing that representational seeing allows the viewer to attend both to what is represented and to the way in which it is represented he aims to provide a more satisfactory account of pictorial recognition.

The theory of twofoldness is also intended to make good a second major defect of the illusion theory of depiction: its failure to accommodate the distinctive pleasure and interest that we derive from looking at pictures. In his review of *Art and Illusion*, which appeared in 1961, shortly after the book was first published, Wollheim observed that Gombrich's conception of naturalism is not only 'false to our ordinary attitude to paintings', it also 'conceals or distorts the kind of admiration we feel for them'.[49] Unless twofoldness were possible, or so Wollheim argues, we would be unable to recognize 'a characteristic virtue that we find and admire in great representational painting: in Titian, in Vermeer, in Manet we are led to marvel endlessly at the way in which a line or brushstroke or expanse of colour is exploited to render effects or to establish analogies that can only be identified representationally'.[50] The aesthetic pleasure of looking at a painting or drawing derives at least in

part from the interplay of recognitional and configurational aspects: we are concerned not merely with what is depicted but with the way in which the artist has represented it. Although it is theoretically possible to recognize the 'how' of depiction by alternating attention between the marked surface and the picture's content or subject matter, this would make admiration of the artistry of depiction external to pictorial recognition.[51] One of the great strengths of Wollheim's account is that it shows how aesthetic appreciation is sustained in and through the process of looking.

STRONG TWOFOLDNESS

What I have identified as a major strength of Wollheim's theory also leaves it exposed to a potential objection. Dominic Lopes claims that Wollheim 'invalidly generalizes from what is required of one class of pictures to all pictures: [his theory] takes art pictures – indeed, art pictures of a particular "painterly" style – as paradigmatic'.[52] Similarly, Jerrold Levinson argues:

> Plausibly *not* all seeing-in or registering of pictorial content is aesthetic in character, or even informed by the awareness of pictures as pictures; for instance, that directed to or had in connection with postcards, passport photos, magazine illustrations, comic strips, television shows, or movies. Thus, any view that builds aesthetic character, or even awareness of pictures as pictures, directly into seeing-in would seem to have something amiss.[53]

In its simplest form, the objection is that although twofoldness may be essential for the *aesthetic appreciation* of a picture, it is not essential for the *experience* of a picture.[54] If sound, this objection would undermine a central feature of Wollheim's account. For although he initially couches the twofoldness thesis in permissive terms, he is committed to the view that twofoldness is a necessary condition of seeing something as a representation: 'if I look at a representation as a representation, then it is not just permitted to, but required of, me that I attend simultaneously to object and medium.'[55]

In light of Wollheim's attempt to make good the shortcomings of the illusion theory of depiction it is ironic that criticism of his position has tended to focus on his account of *trompe l'oeil* paintings, that is, paintings that are designed to 'trick the eye' through the use of illusion-

istic devices. However, given Wollheim's residual indebtedness to Gombrich's perceptualist starting point, it is perhaps unsurprising that the generation of pictorial 'illusions' creates difficulties for his theory of twofoldness. Like Gombrich, Wollheim maintains that when we look at a painting 'visions of things not present . . . come about through looking at things present'.[56] Indeed, Wollheim's distinction between 'straightforward perception', defined as 'the capacity of perceiving things present to the senses', and 'representational seeing', which 'allows us to have perceptual experiences of things that are not present to the senses', is intended to capture in its most elementary form the contrast between reality and appearance that Gombrich describes as the indispensable tool of naturalistic art.[57] The core of the theory of twofoldness is contained in the claim that the viewer is simultaneously aware both of the marked surface and of what that surface represents. However, in *Painting as an Art* Wollheim concedes that the experience of looking at a *trompe l'oeil* painting is *not* characterized by twofoldness, since, if successful, it will forestall the viewer's efforts to focus on the marks out of which it is made. Wollheim claims that *trompe l'oeil* paintings, such as those made by the French artist Leroy de Barde (Plate 7), are 'non-representational . . . because they do not invoke, indeed they repel, attention to the marked surface.[58] He also contends that although most abstract paintings suggest pictorial space some are intended to be seen merely as a pattern arrayed across a two-dimensional plane and that when perceived correctly, that is, when perceived in conformity with the artist's intentions, an abstract painting of this type fails to count as a representation for the complementary reason: the viewer sees the marks arranged on the surface, but she does not have an awareness of depth.

These concessions severely weaken Wollheim's position. Only by defending the counter-intuitive claim that two widely recognized genres of painting are non-representational is he able to maintain that two-foldness is essential to the experience of pictures. Moreover, his argument threatens to descend into a vicious circle: twofoldness cannot be used to explain pictorial representation without begging the question for he has already defined what it is to be a picture in terms of the experience of twofoldness. The problem that these two cases generate for Wollheim's account has led some philosophers to argue that he has no option but to abandon both the strong twofoldness thesis – the claim that twofoldness is essential to the experience of pictures – and the claim that looking at pictures requires the exercise of the special perceptual capacity that he terms seeing-in.[59] The most trenchant advocate of this position is Lopes,

who argues that 'Some pictures, *contra* Gombrich, are experienced simultaneously as designed surfaces and as of their subjects; other pictures, *contra* Wollheim, preclude twofoldness.'[60] In place of Wollheim's strong twofoldness, he advocates what he terms 'weak twofoldness': the claim that twofoldness is merely consistent with the experience of pictures. Since twofoldness is a property that is possessed by some pictures but not by others:

> Pictures might be thought of as arranged along a spectrum, at one end of which lie *trompe l'oeil* pictures . . . at some intermediate point lie pictures which afford one kind of experience or the other, but not simultaneously . . . At the other extreme lie pictures typical experiences of which are simultaneously experiences of their subjects and experiences of flat, pigmented surfaces . . . Experiences of these pictures may properly be described as twofold.[61]

Whereas Wollheim's account purportedly privileges 'art pictures' over demotic forms of representation, Lopes maintains that his spectrum view can accommodate the full range of pictures, from anatomy textbook illustrations to family snapshots: while aesthetic appreciation of 'painterly' works of art might require the experience of twofoldness, this is neither a necessary, nor a desirable, feature of other kinds of pictorial representation.

Should we accept this conclusion? Lopes's claim that it is possible to reconcile Wollheim's approach with the illusion theory of depiction is initially attractive, and the suggestion that twofoldness is restricted to artworks rather than illustrations does not appear too damaging given that Wollheim is explicitly concerned with painting as an art. I shall argue, however, that to sever the connection between representational seeing and the conditions for seeing a picture is to abandon Wollheim's project rather than to delimit its scope.[62] The spectrum theory of depiction, in which twofoldness is located at one pole and illusionism at the other, identifies twofoldness as a feature that inheres in, or is elicited by, certain types of pictures. Wollheim himself appears to endorse this view when he claims that *trompe l'oeil* paintings and some abstract paintings are not characterized by twofoldness and so are non-representational. I believe that this concession is mistaken and that a robust defence of strong twofoldness can be mounted only by showing that the thesis identifies a non-empirical condition on the possibility of seeing a picture *as* a picture. Unless the viewer exercises the special perceptual capacity

that Wollheim terms 'representational seeing', she will not see a picture as a picture, but only a pattern of marks on a surface or – in the case of a *trompe l'oeil* painting – an illusion of something that is not actually present to the senses. There are numerous empirical conditions that must also be satisfied, such as standing sufficiently close to the picture to be able to make out its content or the presence of a light source that is powerful enough to illuminate its surface. However, the experience of twofoldness possesses a different, presuppositional status insofar as it is a conceptually necessary condition of the possibility of experiencing a picture as a picture.

What I mean by this can best be explained by re-examining the two cases that – according to Wollheim – are not covered by the twofold thesis: *trompe l'oeil* paintings and abstract paintings that are experienced as surface designs. Citing Ruskin's observation that *trompe l'oeil* invariably 'has some means of proving at the same time that it is an illusion', John Hyman has persuasively argued that enjoyment of the skill and virtuosity of this genre of painting depends precisely on the viewer's recognition that she is looking at a depiction rather than, say, a set of shallow boxes containing stuffed birds.[63] The viewer who is genuinely taken in by the illusion does not see the painting as a painting: she is fooled into believing that she sees a real collection of ornithological specimens. Although the roles are reversed, the viewer who makes this mistake is no different to the birds who are supposed to have pecked at Zeuxis's painting believing that the grapes were real. To see the picture as a picture, she must not only recognize what is represented; she must also be aware that it is a representation – and this requires some awareness, however minimal, of its configurational features. This argument is not restricted to the genre of *trompe l'oeil* for, as Goodman has pointed out, under the right circumstances 'even the most unrealistic picture can deceive'.[64] Rather than serving as a limit case, marking the point at which twofoldness is no longer applicable, *trompe l'oeil* helps us to identify a specific kind of failure or breakdown of representational seeing that can, in principle, take place in relation to any picture whatsoever.

The opposite, but complementary failure to engage in representational seeing occurs when someone sees a painting as a marked surface without this eliciting any recognition of content, including pictorial depth. Here, too, Wollheim erroneously identifies this generic possibility with a specific *type* of painting, which he classifies as non-representational. If a single mark placed on a blank canvas allows for representational seeing, then *a fortiori*, an abstract painting that contains one or more

marks can be viewed as containing non-planar spatial relations. To see a picture as a picture – rather than as mere surface design or configurational pattern – the viewer must see something in the design, even if what she sees meets only the minimal requirement of pictorial depth. It is a mistake to conceive the configurational aspect of the experience of pictures exclusively in terms of the viewer's awareness of brushstrokes, or the facture of the marked surface, as Lopes suggests when he claims that Wollheim invalidly takes 'painterly' art pictures as paradigmatic. What Lopes terms 'pictorial design features' – including 'marks, directions, boundaries, contours, shapes, colours, hues' – are just as prevalent in 'demotic' pictures as art pictures.[65] It is true that when we look at works of art we tend to pay special attention to their design properties, rather than simply extracting whatever informational content they may contain, but nothing prevents us from focusing our attention on the design properties of demotic pictures – thereby submitting them to a specifically aesthetic mode of contemplation. In the case of abstract paintings that do not appear to contain any objective informational content, the complementary danger arises that they might be viewed merely as surface designs. When Kandinsky produced his first fully abstract paintings some time around 1911 he was worried that they might be seen as 'works having the appearance of geometrical ornament, which would – to put it crudely – be like a tie or a carpet'.[66]

The pioneers of abstract art, including Mondrian and Malevich as well as Kandinsky, were acutely aware that their claim to have produced work that could be experienced as significant depended upon maintaining continuity with the tradition of easel painting. If non-objective art was to hold the interest of the viewer and to satisfy the demand for new forms of complexity and simplification, it had to be viewed as a picture rather than as a pleasing decorative pattern. In the absence of recognizable imagery, the establishment of spatial depth provided a means of securing the status of abstract painting and of ensuring that the viewer sustain the appropriate expectations of meaning. What I have termed 'strong twofoldness' allows for the possibility that a fully abstract painting can meet these requirements, even if the risks of failure are higher.

CHAPTER 4

RESEMBLANCE AND DENOTATION

PICTORIAL SIGNS

In an interview published in 1961 Daniel-Henry Kahnweiler, the Parisian
art dealer who had represented Braque and Picasso in the pre-war years,
declared: 'absolutely fundamental . . . to the comprehension of Cubism
and of what, for me, is a truly modern art [is] the fact that painting is a
form of writing (*écriture*).' He then went on to explain in more detail
what this puzzling assertion might mean:

> A woman in a painting is not a woman; she is a group of signs that
> I read as 'woman'. When one writes on a sheet of paper 'f-e-m-m-e',
> someone who knows French and knows how to read will read not
> only the word '*femme*', but he will see, so to speak, a woman. The
> same is true of paintings; there is no difference. Fundamentally,
> painting has never been a mirror of the external world, nor has it
> ever been similar to photography, it has been a creation of signs,
> which were always read correctly by contemporaries, after a certain
> apprenticeship, of course. Well, the Cubists created signs that were
> unquestionably new, and this is what made it so difficult to read
> their paintings for such a long time.[1]

The claim that painting is a form of writing is exposed to an obvious
rejoinder: we must first learn the meaning of the word *femme* if we are to
grasp what it stands for or represents, but there does not seem to be any
comparable learning process required in order to see what is represented
in an unfamiliar picture. Whereas someone who does not know Dutch
and German would not be able to understand the original titles of
de Hooch's *De Appelen van een van de Vrouw Schil* (Plate 1) and
Menzel's *Dame mit Opernglas* (Plate 5), no such impediment stands in
the way of recognizing that both pictures represent a woman. We do not
have to read a picture: we simply look and see.

This objection is not as conclusive as it first appears. Kahnweiler acknowledges the ease with which viewers are able to interpret certain pictorial signs, but he suggests that this is a matter of enculturation. Once we have undergone the necessary 'apprenticeship', we have no difficulty understanding a painting produced in accordance with a specific system. Although nearly two hundred years separate Menzel's drawing from de Hooch's painting, both pictures employ the same basic techniques of pictorial representation. The development of Cubism, or so Kahnweiler and others have argued, represents a radical break with the conventions for depicting objects and non-planar spatial relations that were established during the Renaissance. Most viewers still experience considerable difficulty identifying the subject of Braque's painting of 1911–12, *The Portuguese* (Plate 8). Even amongst experts, there is disagreement as to what it represents. For a long time, the stencilled letters 'D BAL' at the top right hand corner were interpreted as a fragment of a poster advertising a dance hall ('[GRAN]D BAL'). However, the assumption that the setting of the painting is a café has been challenged by the discovery of a letter from Braque to Kahnweiler in which he describes a picture of 'an Italian emigrant standing on a bridge of a boat with the harbour in the background'.[2] The dense, overlapping planes and the partial or contradictory character of the visual clues make it difficult to assign determinate pictorial sense to the different parts of the painting. Does the figure hold a guitar diagonally from his body or is it horizontal as the angle of the strings suggests? Should the rope-like marks under the lettering be interpreted as a curtain tie, such as might be found in a café, or as a heavy ship's rope tied to a bollard? What representational function is fulfilled by the shoals of brushstrokes that float free of any confining shape or boundary? And how are we to interpret the letters and numbers that are stencilled onto the surface of the painting? Are they a device for drawing attention to the relation between the picture plane and the physical surface of the painting – thereby emphasizing the painting's two-dimensionality – or should they be read illusionistically as fragments of a poster affixed to a wall in the background?

Kahnweiler's observation that Braque and Picasso invented new pictorial signs provides one way of accounting for the difficulty of deciphering Cubist paintings – though more, of course, needs to be said about the nature of these signs and how Cubism differs from other forms of representation. I shall return to this issue at the end of this chapter when I consider the viability of recent semiotic – or sign-based – interpretations of Cubism. The bold suggestion that Braque and Picasso discovered the

'principle of semiological arbitrariness' and that they showed how this could be used to construct a non-mimetic system of pictorial representation deserves independent consideration.[3] First, however, I want to examine the more radical claim that *all* painting is a creation of signs. In the passage cited above, Kahnweiler argues that Cubism differs from earlier forms of art not in its deployment of signs but in the unfamiliarity of the signs it uses. According to this interpretation, the incorporation of features such as parallel lines for the strings of the guitar and fragments of the outline shape of the figure's arm and face provide a means of orientation for the viewer who is not yet conversant with Cubism. But these remnants of the Renaissance system of representation turn out to be just another set of signs that no more provide a mirror of reality than do the words and numbers that are written across the picture's surface. Just as the shallow, interlocking planes of Cubist pictorial space both suggest and contradict the illusion of spatial depth, so the use of a restricted vocabulary of rectilinear and curvilinear forms allows the same set of marks to be read in multiple ways. A circle can stand for both a glass and a bottle, while the arc that describes the figure's shoulder might also stand for the back of a chair or the hull of a ship. The insistent materiality of the painted surface, with its individuated brush strokes and grid-like structure, defeats any attempt to treat the picture as transparently opening on to the space it depicts. If Kahnweiler is right, then the complexity of Cubist painting, with its multiple terms of reference and its incorporation of letters and numbers alongside illusionistic details, helps us to recognize something that had been obscured by the quest for verisimilitude: we have to learn how to interpret a painting just as we learn how to understand a language. To identify painting as a form of writing, as Kahnweiler proposes, is to hold that pictorial signs, like words, are conventional and that their reference is established not through natural likeness or similarity but through human cultural practice.

The distinction between what belongs to nature (*physis*) and what is a matter of convention or agreement (*thesis*) can be traced back to Plato's dialogue *Cratylus* in which the participants discuss whether names are 'natural and not conventional', as Cratylus proposes, or whether, as Hermogenes contends, 'there is no name given to anything by nature; all is convention and the habit of the users'.[4] The clearest and best-known attempt to distinguish between 'natural' and 'conventional' signs is to be found in a treatise written in the fourth century AD by the theologian St Augustine of Hippo.[5] Augustine defines a sign as 'a thing which, over and above the impression it makes on the senses, causes something

else to come into the mind as a consequence of itself'.[6] He then proceeds to distinguish between two types of sign. A natural sign (*signa naturalia*) stands in a causal or intrinsic relation to what it signifies. Thus, for example, the track left by an animal is a sign that it has passed by. The sign is caused by the imprint that the weight of the animal's body leaves in soft ground and its shape or form is determined by the anatomy of the animal's foot. By contrast, a conventional sign (*signa data*), such as the word 'fox', does not possess any intrinsic connection to the animal it represents. Augustine concludes that in order to understand a conventional sign we need to know what it is intended to signify: conventional signs 'are those which living beings mutually exchange for the purpose of showing, as well as they can, the feelings of their minds, or their perceptions, or their thoughts'.[7] Unlike a natural sign, a conventional sign neither resembles nor possesses any direct casual connection to what it represents; its meaning depends on human custom and contrivance.

Closer scrutiny shows that Augustine conflates two different types of relation that a natural sign can have to its referent. Whereas some natural signs – such as the imprint of an animal's foot – look like or resemble what they represent, others stand in a causal connection without this resulting in any physical likeness. Smoke, for example, is a sign of fire although there is no visual correspondence between the smoke and the flames beneath it. Similarly, spots can be a sign of measles or a knock on the door a sign that someone is outside. In order to capture these differences, the American philosopher Charles Sanders Peirce proposed a tripartite division of signs into icons, indices and symbols.[8] The first two types of sign correspond to what Augustine terms a natural sign. An *Icon* represents in virtue of its 'similarity' to its referent: 'Anything whatever . . . is an Icon of anything, in so far as it is like that thing, and used as a sign of it.'[9] A picture, for example, is an icon according to Peirce since it resembles what it represents.[10] By contrast, an indexical sign and its object are linked by what Peirce terms a 'dynamical connection': 'An *Index* is a sign which refers to the Object that it denotes by virtue of being really affected by that Object.'[11] Thus, for example, a weathercock is an index of the direction of the wind because the wind causes it to point in a specific direction, and a low barometer is an index of rain because the height of the gauge is determined by the degree of moisture in the air. Peirce's third type of sign, which he terms a 'symbol', corresponds to Augustine's category of a conventional sign: 'A *Symbol* is a sign which refers to the Object that it denotes by virtue of a law, usually an association of general ideas, which operates to cause

the Symbol to be interpreted as referring to that Object.'[12] Peirce claims that 'All words, sentences, books, and other conventional signs are Symbols.'[13] Unlike icons and indices, a symbol is connected to its referent only through habit or agreement among those who use it. For this reason, it requires a 'law', or rule, by which it is to be interpreted.

Although Peirce presents the tripartite schema of icon, index and symbol as an analysis of different types of sign, it is best understood as describing different sign functions, for, as he acknowledges, the same sign can stand in more than one relation to its referent. If we return once again to the example of a track left by an animal, we can see that a footprint is both an index and an icon: the weight of the animal causes the mark, but the mark also resembles the shape of the animal's foot. Some conventional signs also have iconic or indexical constituents. The familiar Woolmark sign is a symbol, since we need to know the convention or rule that allows it stand as a guarantee of a garment's fibre content and quality, but it also functions iconically by representing the plaiting strands characteristic of wool fibres. Similarly, a painting or a drawing is also an index since the individual marks are caused by the movement of the artist's hand and thus function as a sign of the artist's activity.

The analysis of sign functions allows for the possibility that the referent of a sign can be established in more than one way, and that the same sign can have more than one referent. Thus, for example, the figure on the right hand side of Bellini's *San Zaccaria altarpiece* (Plate 4) is an iconic sign of a man reading a book; however, in accordance with the rules or conventions of Christian art, it is also a symbol of St Gerome, who translated the Bible into Latin. To interpret the sign as an iconic representation of a man reading a book, we need to be able to recognize its likeness or similarity to what it represents; but to interpret the sign as a symbolic representation of St Gerome we need to know the code established by the Christian church that allows saints to be identified through the possession of specific attributes, such as a book, a key, a transverse cross and so forth. Peirce does not investigate the question in any detail, but he appears to have upheld the traditional view that whereas words and other symbols are based on conventions, and thus require knowledge of the rule or law governing the relation between the sign and its referent, no prior knowledge is needed to interpret an iconic sign. Contrasting icons with indexes, he claims that 'The icon has no dynamical connection with the object it represents; it simply happens that its qualities resemble those of that object, and excite analogous sensations in the mind for which it is a likeness.'[14]

Peirce's analysis of different sign functions has been taken up by advocates of a semiotic, or sign-based, approach to the study of visual culture. However, some adherents of this approach have rejected what they see as the residual, perceptualist elements in Peirce's account and have sought to show that pictorial meaning, like language, is conventional through and through. Norman Bryson, for example, maintains that the ability to identify what is represented in a painting 'presupposes competence within social, that is socially constructed, codes of recognition'.[15] He rejects the idea that depiction can be explained in terms of the psychological and physiological responses of the individual viewer, arguing that 'the crucial difference between term "perception" and the term "recognition" is that the latter is *social*':

It takes one person to experience a sensation, it takes (at least) two to recognize a sign. And when people look at a representational painting and recognize what they see, their recognition does not unfold in the solitary recesses of the sensorium but through their activation of codes of recognition that are learnt by interaction with others, in the acquisition of human culture.[16]

The advantage of the semiotic approach – at least according to its proponents – is that it opens up to analysis the social and political dimension of painting that is excluded by perceptualism. As Rosalind Krauss, another exponent of the semiotic approach, has argued:

the impulse toward structural linguistics . . . is not the drive for a method for unpacking a style or a painting, for decoding it, so to speak, but is instead motivated by a wider consideration about the nature of representation. That wider consideration is one of total resistance to a realist or reflectionist view of art, namely, the idea that the painting or the text is a reflection of the reality around it, that reality enters the work of art with the directness of the image striking the mirror.[17]

Salutary as this goal might be, it is far from clear that semiotics offers the only alternative to a reflectionist view of art. As we saw in Chapter 2, even those philosophers who define painting in terms of 'mimesis' or imitation recognize that since a work of art is not a replica it must be understood in terms of its difference as well as its similarity to what it represents. Moreover, Gombrich, whose work Bryson identifies as 'the

climax of the "Perceptualist" tradition', explicitly rejects the idea that painting can be understood as a 'copy' of reality.[18] Here we need only bring to mind core features of his account such as the selectivity of vision, the limits of likeness imposed by the medium, the importance of the beholder's share and the interplay of schema and correction.

The real difference between perceptualism and semiotics lies in the role that is accorded to the conventional elements of pictorial representation. Defenders of the perceptualist approach such as Gombrich and Wollheim claim that pictorial recognition depends on perceptual mechanisms that are natural rather than social: pictures stimulate responses in the viewer that are at least partially conditioned by recognitional capacities that are also engaged in ordinary perception. By contrast, proponents of a full-blown conventionalist account of depiction deny that there are perceptual and psychological constraints on pictorial representation. Pictorial signs, like linguistic signs, are arbitrary and have no inherent connection to what they signify: pictures can be understood only through reference to the laws or rules through which signs are co-ordinated with their referents. Even where these rules have sedimented into habit or custom, the 'codes of recognition' that enable viewers to recognize what a picture represents are socially constructed rather than natural, and so have to be learned or acquired.

The analysis of an artwork as a system of signs holds out the prospect of a unified theory that can accommodate both pictorial and linguistic representation. However, in its more extreme, conventionalist form it threatens to erase the salient differences between language and painting. A more promising strategy is adopted by the philosopher Nelson Goodman in his book *Languages of Art*. While Goodman – in common with other symbol theorists – seeks to identify cognitively significant affinities between verbal and non-verbal symbols, he also shows how non-verbal symbol systems such as pictures, diagrams, maps and models, differ from verbal systems.[19] Whereas most advocates of the semiotic approach refer somewhat vaguely to a plurality of 'systems of representation', without elucidating the features that distinguish one system from another, Goodman identifies the individuating characteristics of each of the different systems he discusses. John Hyman is surely right to observe that 'Without this precision, conventionalism can provide historians and critics with a range of convenient and attractive metaphors, but it cannot amount to a testable theory of art.'[20] However, Hyman begs the question by assuming from the outset that Goodman's is a convention theory of art. Despite some of Goodman's more provocative remarks,

I shall argue that his detailed account of the specific syntactic and semantic properties of non-linguistic symbol systems effectively undermines the claim that a picture can be interpreted in accordance with a set of rules or conventions that correlate signs with referents. Far from reducing painting to writing, he shows why perceptual discrimination is central to looking at pictures but does not play the same role in other symbol systems.

A SYMBOL THEORY OF ART

In the Introduction to *Languages of Art* Goodman warns that 'the reader must be prepared to find his convictions and his common sense – that repository of ancient error – often outraged by what he finds here'.[21] Perhaps the most deeply held of these convictions is that we know what a picture represents because it resembles its subject. Consider, for example, Goya's portrait of the Duke of Wellington, which hangs in London's National Gallery (Plate 9). Surely it is the visual similarity between the picture and the Duke that makes it a picture of the Duke rather than, say, a picture of the Duchess or the Duke's London residence, Apsley House. The reader of these pages, who has already encountered a number of challenges to the copy theory of representation, is unlikely to be outraged by Goodman's observation that resemblance is not *sufficient* for depiction. Indeed, his arguments against what he terms the naïve view of representation have been widely accepted. What is at issue is whether these arguments suffice to support his claim that, once understood correctly, 'Resemblance disappears as a criterion of representation', that is, it is neither sufficient nor necessary.[22]

Goodman considers two different versions of the resemblance theory: (i) *A* represents *B* if and only if *A* appreciably resembles *B*, and (ii) *A* represents *B* to the extent that *A* resembles *B*. Neither formulation is able to withstand critical scrutiny. As Goodman points out, resemblance is reflexive and symmetric: if *A* resembles *B*, then *B* resembles *A*. But representation is clearly asymmetric: Goya's painting represents the Duke of Wellington, but the Duke does not represent the painting. Moreover, although nothing resembles the Duke so much as the Duke, the Duke does not represent himself. There are many things that resemble each other without one being a representation of the other. An identical twin resembles but does not represent his brother, and a car off an assembly line is not a picture of any of the rest.[23]

The resemblance theory of depiction is evidently inadequate as it stands: that A resembles B does not suffice to make A a representation of B. However, rather than investigating whether it is possible to retain the central intuition of the resemblance theory – perhaps by modifying the way in which the theory is formulated or by incorporating it within a more sophisticated account that provides an alternative means of accounting for the difference between resemblance and representation – Goodman summarily declares that resemblance plays no role in explaining depiction:

> The plain fact is that a picture, to represent an object, must be a symbol for it, stand for it, refer to it; and that no degree of resemblance is sufficient to establish the requisite relationship of reference. Nor is resemblance *necessary* for reference; almost anything may stand for almost anything else. A picture that represents – like a passage that describes – an object refers to, and more particularly, *denotes* it. Denotation is the core of representation and is independent of resemblance.[24]

It is this argument – rather than Goodman's criticisms of the naïve version of the resemblance theory – that has awakened the fiercest opposition. Lopes writes of Goodman's 'extraordinary insouciance' in moving from a rejection of the resemblance theory to the claim that 'what a picture symbolizes is a matter of what symbol system or language it belongs to, as if the resemblance theory of depiction were the only possible perceptual theory.'[25] And Budd has argued that although Goodman's argument is both valid and sound, 'it inflicts no harm on the idea that it is of the essence of a picture that it looks like what it depicts, since it only shows that *looking like* is not fully constitutive of *depiction*, not that it is not a necessary condition of it.'[26]

I shall return in the next section to the question whether Goodman's construal of depiction as a species of denotation entails the claim that pictorial reference is independent of resemblance or whether this stronger claim is an inessential addition to his theory – and hence can be excised without doing it damage. For the moment, I want to follow Goodman in assuming that we must first rid ourselves of the 'dogma' that depiction can be defined in term of resemblance before we can provide a more adequate characterization. This leaves open the possibility, tentatively explored by Goodman himself in later writings, that resemblance may yet have a role to play in a full account of pictorial representation.[27]

Denotation is just one of a variety of ways in which symbols can refer. Goodman also discusses other species of reference such as exemplification, expression, literal and metaphorical reference, and mediate reference through a chain of links that include both denotation and exemplification.[28] Here I shall focus exclusively on his account of denotation. Goodman borrows the term 'denotation' from the philosophy of language, where it is used to describe the relation that holds between a word, such as a name or a predicate, and the object or property that it stands for. The name 'Duke of Wellington' denotes the Duke of Wellington and the predicate 'decorated' denotes the receipt of military honours. To claim that denotation is the core of representation is thus to claim that pictures, like names and predicates, refer to or stand for what they represent.[29] Since Goodman denies that resemblance is sufficient to secure reference, he needs to provide an alternative means of explaining how pictures refer to their subjects. The first part of his answer is that denotation is possible only within a symbol system. Just as words and sentences possess meaning in virtue of the language, or linguistic system, to which they belong, so the meaning of a visual symbol is governed by the pictorial system to which it belongs. Denotation is system-relative: the same symbol or set of symbols can denote an object in a one system and a different object in another system. (We are familiar with this phenomenon in natural languages: the word 'Rock' denotes a skirt in German and a mass of stone in English.) Goodman's full answer to the problem of pictorial reference thus requires that he specify the principles that distinguish one symbol system from another. Although his account of these differences is couched in highly technical language – and thus is initially rather forbidding – the results are genuinely illuminating and help to reveal important characteristics of painting that are downplayed or overlooked by other approaches.

Goodman describes *Languages of Art* as 'an approach to a general theory of symbols', including maps, diagrams, models, sketches, sculptures and musical scores, as well as texts and pictures.[30] In a brief summary such as this it is not possible to do justice to the full range of topics that he addresses. My goal is to isolate one important strand that runs through the book, namely, how pictorial denotation is to be distinguished from verbal denotation. Nonetheless, in order to understand Goodman's solution to this problem, we need to broaden the frame of reference to include another type of symbol system, which he terms a 'notation'. A notation is, in respects yet to be defined, radically unlike a picture. Goodman's analysis of the properties that are required of a

notational system results in the identification of five mutually independent conditions that may or may not be satisfied by other systems.[31] These conditions are: unambiguity, syntactic disjointness, syntactic differentiation, semantic disjointness and semantic differentiation. As we shall, whereas a linguistic system, such as a natural language, satisfies some but not all of these conditions, a pictorial system, such as a painting, typically violates all five. By examining the properties of a notational system Goodman arrives at a new and highly original means of distinguishing different types of symbol system from one another.

Let us start by considering the distinction between syntactic and semantic conditions. Once again, Goodman has taken these terms from the philosophy of language, or, rather, linguistics, where 'syntax' is used to describe the ordering and combination of words in phrases and sentences and 'semantics' refers to aspects of meaning, whether at the level of individual words or complete sentences. What Goodman terms a symbol *scheme* is a purely syntactical ordering and combination of characters. A symbol scheme can be analysed without reference to what, if anything, the characters stand for or represent. A symbol *system*, on the other hand, requires the co-ordination of a scheme with a realm of compliants, that is to say, it consists of a symbol scheme correlated with a field of reference.[32] Syntactic conditions, then, pertain solely to the internal ordering or structure of a symbol scheme; semantic conditions pertain to the relation between the characters of a scheme and what, if anything, those characters denote. The significance of this distinction will become clear once we consider the specific conditions that characterize a notational system.

The first requirement of a notational system is that the characters that make up the symbol scheme must be *disjoint*: no mark may belong to more than one character. Thus, for example, in musical notation, the same mark cannot be both a crotchet and a quaver. Similarly, in a natural language that uses the Roman alphabet, the same mark cannot be both an 'a' and a 'd'. This is a syntactic condition on a symbol scheme: without it, the scheme could not function as it does. We must be able to assume that a mark in one scheme is either a crotchet or a quaver, and that a mark in another is either an 'a' or a 'd', otherwise midway through a piece of music or a text the same mark might form a different character, making it impossible to read on with any certainty. In practice, of course, especially in the case of manuscripts, but also when reading old type faces such as Gothic, it can be difficult to determine to which character a mark belongs. For this reason, the second requirement on a notational

system is that the characters of its scheme be *effectively differentiated*. Goodman acknowledges that this may sometimes involve considerations of context: in musical notation a mark can be identified as a quaver rather than a crotchet by working out that otherwise there would be too many beats to the bar, and in a written text a mark can be identified as an 'a' rather than a 'd' by taking into account the other letters of the word to which it belongs.[33]

Whereas a natural language has a notational scheme, and thus is able to satisfy the requirements of disjointness and effective differentiation, a picture violates these requirements and so is non-notational. A natural language such as English, which uses the Roman alphabet, is disjoint and differentiated: there is no character between 'c' and 'd', and it is always possible, in principle, to determine to which character a mark belongs. By contrast, a picture has what Goodman terms a *syntactically dense* scheme. This type of scheme allows for infinitely many characters such that between any two there can always be a third. In a picture a line can always be a bit longer or shorter and a colour can always be a bit lighter or darker. But why is this distinction important? The pay off comes when we recognize that since the characters in a pictorial scheme are not disjoint small differences in the inscription of the marks are syntactically significant. In a notational scheme, it only matters what character a mark belongs to – the significance of the mark is exhausted once we have determined whether it is an 'a' or a 'd'. Substituting one type face for another, or writing one letter larger or smaller than another, has no syntactic effect: the marks rock, ROCK and ROCK all inscribe the same characters. But in a pictorial scheme differences such as a heavier line, a more rounded shape, or a darker colour are syntactically relevant since they play a role in determining the character that has been inscribed.

The semantic conditions that must be fulfilled by a notational system closely parallel the syntactic conditions that must be fulfilled by a notational scheme. *Semantic disjointness* requires that no two characters have the same compliant in common. What this means can best be understood by considering a natural language such as English, which fails to meet this requirement. The terms 'doctor' and 'Englishman' semantically intersect since they can be used to denote one and the same individual.[34] Moreover, some words and phrases in English are ambiguous: for example, the word 'wood' denotes both a piece of a tree and a geographical area covered with many trees. For this reason,

English is not a notational system. To meet the requirement of *semantic differentiation* every character in the scheme must have a corresponding class of compliants. The denotation of pitch in a musical score is notational since both the characters and their compliants are finitely differentiated (middle C, C sharp, D and so forth) and there is a one-to-one correspondence between the notes marked on the staff and the pitches sounded by an instrument.[35] However, the verbal language for tempos (unlike metronome marks) is not notational: the marking *rallentando* (getting gradually slower) can be performed in a variety of different ways.[36] The system allows for an intermediate tempo between any two notated tempi.

Goodman terms a system that fails to meet the requirements of semantic disjointness and differentiation *semantically dense*. Pictures are semantically dense since for every two compliance classes the system provides for the possibility of a third. Just as there is an infinite number of characters that can be formed by minute differences in the inscription of the marks, such as the length of a line or the shade of a colour, so there is an infinite number of possible compliance classes to which these characters can be correlated. A slightly darker red pigment can denote a slightly darker red coat and a slightly shorter line can denote a slightly shorter ribbon. It is central to Goodman's theory that there need not be a one-to-one correlation between symbols and what they represent: 'Pictures may function as representations within systems very different from the one we happen to consider normal; colours may stand for their complementaries or for sizes, perspective may be reversed, or otherwise transformed, and so on.'[37] Consider, for example, how a red coat shows up green in the negative of a colour photograph. A pictorial system that provides for complementary colour relations would allow different shades of green to denote different shades of red. Goodman argues that, appropriately interpreted, a picture produced in accordance with this system would yield exactly the same information as picture painted in normal colour.[38]

The foregoing analysis of different types of symbol system appears to result in a wholly negative characterization of pictorial representation: whereas linguistic systems are able to meet the syntactic conditions, but not the remaining semantic conditions on a notational system, pictorial systems typically fail to satisfy any of the five requirements. However, if we return to the question of how pictures differ from descriptions, we can see that Goodman has, in fact, provided the required positive

characterization. Whereas linguistic systems are syntactically and semantically differentiated, pictorial systems are *dense throughout*:

> Nonlinguistic systems differ from languages, depiction from descrip-tion, the representational from the verbal, paintings from poems, primarily through lack of differentiation – indeed through density (and consequent total lack of articulation) – of the symbol system . . . A system is representational only insofar as it is dense; and a symbol is a representation only if it belongs to a system dense throughout or to a dense part of a partially dense system.[39]

Although syntactic and semantic density is sufficient to distinguish pic-torial representations from descriptions, further specification is needed if pictures are to be distinguished from other representational systems such as diagrams, maps and line-graphs. Even a simple symbol system such as an ungraduated thermometer meets the requirement of syntactic and semantic density: unless a thermometer is graded into discrete units, minute differences in the height of the mercury column denote minute differences in temperature.

How, then, is pictorial representation to be distinguished from other dense systems? Goodman's answer is that whereas diagrams and other non-pictorial systems are *attenuated*, pictorial systems are *relatively replete*. To take a reading from a thermometer we need only consider the height of the column; everything else, such as the colour of the mercury and the thickness of the column, is devoid of syntactic or semantic relevance. By contrast, every feature of a painting or a drawing is poten-tially meaningful. The difference between pictorial and diagrammatic systems lies in the number of features that can be ignored as contingent. Goodman brings this argument home by means of a thought experiment. Imagine that an electrocardiogram and a Hokusai drawing of Mount Fujiyama both have the same undulating black line against a white back-ground. In the diagram only one aspect of the line has meaning: the relative position of any point that it traverses. But in the drawing the weight of the line, its texture, its relation to other lines and shapes and its size relative to the picture as a whole are all potential bearers of meaning. Whereas, theoretically at least, there is a sharp distinction between dense and articulate, that is, disjoint and differentiated, schemes, repletion is a matter of degree since a greater or lesser number of features can be rel-evant in different symbol systems.[40] Compared to an electrocardiogram, a drawing is relatively replete, that is to say, a comparatively greater

number of features are relevant to the determination of meaning. Even the qualities of the paper on which it is drawn are potentially significant: nothing can be ruled out, nothing can be ignored.[41]

RULES AND CONVENTIONS

Despite his professed wariness of the terms 'convention' and 'conventional', which he describes as 'dangerously ambiguous', Goodman does not explicitly distinguish his position in *Languages of Art* from a conventionalist theory of depiction.[42] Indeed, a number of his more notorious statements actively invite this interpretation. The difficulties begin with his insistence that 'denotation is the core of representation'. Most readers have rightly taken his claim that denotation is 'free' to entail that there need be no intrinsic relation between a symbol and what that symbol stands for or represents.[43] What this means can be explained through an anecdote told by one of Kant's biographers. The story goes that Kant was discussing a military battle with some officers one evening when a young lieutenant accidentally knocked over a glass of wine. To save the young man's embarrassment, Kant is supposed to have used the spilled wine to represent the enemy troops and to have made further marks on the table to show how the battle unfolded.[44] It is possible, of course, that the wine just happened to form a shape that resembled a military battalion and that it was this that gave Kant his genial idea. But any such resemblance would have been purely contingent. In order for a spillage to denote enemy troops there does not need to be an intrinsic relation between the mark and what it is used to signify: Kant could have used the stain to represent his home town of Königsberg or the Duke of Wellington, just as he could have placed his hat on the table or used a button off his coat instead of the spilled wine.

If all that Goodman had to say about representation were contained in his claim that 'denotation is the core of representation', he would undoubtedly be committed to conventionalism. In the absence of any other connection between a sign and what it signifies, there must be what Peirce terms a 'rule that will determine its Interpretant'.[45] Otherwise, we have no way of knowing what the sign refers to or denotes. However, we need to distinguish between Goodman's formal reminder that, from a logical point of view, anything may stand for anything else, and the full account of pictorial representation that he gives in the rest of the book. The difference between the two can be explained by considering one of

Goodman's own examples, which ties in nicely with the anecdote about Kant. We are asked to imagine a situation in which troops have commandeered a museum and a briefing officer, for want of anything better, uses the pictures from the walls to represent enemy emplacements.[46] Just as with Kant's spilled wine, there need not be any visual resemblance between a picture and what it is used to denote: given the appropriate principles of co-ordination, Goya's *Duke of Wellington* could stand for Napoleon. Goodman is therefore right to argue that 'Almost any picture may represent almost anything; that is, given picture and object there is usually a system of representation, a plan of correlation, under which the picture represents the object.'[47] If someone designates that henceforth 'x' should be taken to represent 'y', then 'x' can be used to represent anything whatsoever. However, this argument is valid only if 'representation' is used in the restrictive sense of denotation. As Arthur Danto has pointed out, it is puzzling why Goodman adds the qualification 'almost', for surely there are no limits to denotational reference.[48]

The confusion arises from Goodman's failure clearly to distinguish between two different meanings of the term 'representation'. The example of the military briefing is intended to show that the use of a picture to denote something does not by itself constitute *pictorial representation*. It is this second sense of the term that is being used when Goodman claims that 'taken as mere markers in a tactical briefing or used as symbols in some other articulate scheme [pictures] do not function as representations'.[49] At the heart of Goodman's symbol theory of art is the claim that the relation between a symbol and what it denotes is determined by the symbol system to which it belongs: it is only within a specific symbol system that something is a symbol of a given kind. For a picture to function as a pictorial symbol it must belong to a system that is syntactically and semantically dense and relatively replete. The briefing officer who uses Goya's *Duke of Wellington* to denote Napoleon employs the picture within a system that is disjoint and differentiated: each picture on the wall is correlated with a determinate compliant. This clearly violates Goodman's specifications for a pictorial symbol system. He is therefore entitled to conclude that:

> denotation by a picture does not always constitute depiction . . .
> To represent, a picture must function as a pictorial symbol; that is,
> function in a system such that what is denoted depends solely on the
> pictorial properties of the symbol.[50]

I take this to be Goodman's considered view for it reveals how his detailed examination of the differences between a notation and other symbol systems can be connected to the rest of his theory. Pictures represent through denotation within a symbol system. But it is only when a picture is employed within a system that satisfies the requirements of density and repleteness that it can be characterized as a depiction. Anything can be used to represent anything else, given the appropriate 'plan of correlation', but not every representation qualifies as a pictorial representation.

The full consequences of this argument become apparent when we recall the specific requirements that a pictorial symbol system must satisfy. The standard way of accounting for the difference between pictures and descriptions is to observe that, unlike a verbal description, a picture resembles what it represents. Goodman's dissatisfaction with this account means that he has to provide an alternative means of distinguishing painting from writing. His strategy, as we have seen, is to identify symbol systems on the basis of their formal properties rather than the nature of the individual symbols they employ. Since nothing depends on the internal structure of the symbol, resemblance drops out of his account as a criterion for distinguishing pictures from descriptions: pictorial symbol systems differ from notational systems in virtue of being syntactically and semantically dense and they differ from other representational systems in virtue of being relatively replete. Goodman contends that all three identifying features of a pictorial symbol system 'call for maximum sensitivity of discrimination': syntactic and semantic density 'demand endless attention to determining character and referent', while density 'demands such attention along . . . more dimensions'.[51] Whereas reading a text requires that we sort the marks on the page into a determinate set of characters, to each of which there is a corresponding denotatum, looking at pictures for their informational content requires that we attend to subtle differences in the shape, colour and ordering of the marks since every difference potentially makes a difference in what is denoted. Goodman's theory of art explains why perceptual discrimination plays a role in understanding pictures that it does not play in other, articulate symbol systems. Unlike perceptualism, however, which takes the experience of the viewer as primary, his theory is grounded in an analysis of the structural features of different symbol systems rather than the study of psychological effects.

With these observations in place, we are now in a position to address the question left hanging at the start of the previous section: does

Goodman's symbol theory of art issue in a convention theory of depiction, as most commentators assume, or does it allow for the possibility that – suitably qualified and shorn of its definitional function – the concept of resemblance still has a role to play in explaining how pictures represent? Those such as Hyman who claim that Goodman is a thoroughgoing conventionalist, draw a hard and fast distinction between a naturalized account of depiction, which holds that 'a viewer's ability to perceive the content of a picture depends on her knowledge of the appearances of the objects it depicts,' and a conventionalist account, which holds that 'a picture, like a text or graph, is composed and interpreted in accordance with a set of rules or conventions that correlate symbols with denotata.'[52] Hyman then has easy play in showing that whereas, for example, there are iconographic conventions that fix the symbolic attributes of saints, there are no rules of this kind that govern ordinary pictorial reference. This objection misses its target, however, since Goodman explicitly rejects the view that Hyman attributes to him. Contrary to what many of his critics believe, Goodman states unequivocally that 'Understanding a picture . . . is not a matter of bringing to bear universal rules that determine the identification and manipulation of its component symbols.'[53] Once again, the key to his position is to be found in his analysis of the specific syntactic and semantic conditions that a pictorial symbol system must satisfy.

Rules or conventions are generalizations that require the identification – and re-identification – of basic elements whose behaviour can be regulated. Lexicons and grammars can be provided for a natural language because a linguistic system is made up of distinct units – letters, phonemes, words, phrases, sentences – that are determinate and discriminable. Unlike a natural language, or the notation of music in graphic symbols, a dense scheme does not have a disjoint and differentiated set of characters that are tokens of recognizable types. Instead, as we have seen, a pictorial scheme potentially has an infinite number of characters, since any small difference in the inscription of the marks will result in a different character. Recall once again Clark's attempt to 'stalk' Velázquez's *Las Meniñas* (Plate 6) and the way in which, as he got closer to the painting, the image broke up into 'a salad of beautiful brushstrokes'. There is no limit to the diversity of colours, shapes and patterns out of which a painting can be made; individual brushstrokes, just like chalk or pencil marks, can be placed on top of each other or blended together, and they can vary in weight, density and texture as well as in direction and rhythm. Even a mosaic, which is made up of individual

tesserae, does not have a disjoint set of characters, since no two tesserae are ever exactly the same and they can be put together in any combination. Clark's hope that he could uncover the process by which the artist had transformed 'appearances into paint' was defeated by the recognition that the marks that make up a hand, a ribbon, or a piece of velvet, do not match up on a one-to-one basis with constituent elements of the objects they represent. It is only in a semantically articulate system that individual characters can be directly correlated with discrete compliance classes: in a dense system 'concrete symbol-occurrences do not sort into discriminably different characters but merge into one other, and so also for what is denoted.'[54] The sensitivity of discrimination required to interpret character and referent, and the impossibility of telling whether any two symbols belong to the same type, renders the goal of providing determinate, satisfiable rules that correlate symbols with denotata unrealizable for pictorial representation.

It is clear, then, that Goodman's position differs in important respects from the conventionalism proposed by other advocates of the semiotic approach, such as Kahnweiler and Bryson, who claim that pictorial signs can be understood on the model of linguistic signs.[55] But we have yet to see how – or, indeed, whether – his theory can make good the evident shortcomings of this approach without becoming entrapped, once again, in the naïve account of resemblance that he rejects at the start of *Languages of Art*. There he restricts his account of resemblance to showing that it is neither necessary nor sufficient for depiction. As Lopes points out, 'Goodman is not interested in the *roots* of reference – how referential relations are established. His remarks about what determines what a picture represents are entirely negative.'[56] Goodman's characterization of depiction as a species of denotation is intended to serve as a corrective to the ingrained assumption that we know what a picture represents because it looks like its subject: only once representation is 'disengaged from perverted ideas of it as an idiosyncratic process like mirroring, and is recognised as a symbolic relation that is relative and variable' can a more satisfactory account be provided.[57] However, even if we accept Goodman's core insight that nothing is intrinsically a representation and that representation is always relative to a symbol system, we are still faced with the task of explaining how pictorial reference is secured. Lopes has argued that this omission in Goodman's theory is best filled by a hybrid account that combines the insights of the symbol theory of art with a naturalized account of depiction that draws on the psychology of perception.[58] The recognition that a picture must belong

to a symbol system that determines which features are salient or relevant suffices to undermine the naïve resemblance theory of representation. But the symbol theory of art does not exclude the possibility that perceptual mechanisms of recognition play a central role in understanding what a picture represents.

In publications written after the appearance of *Languages of Art* Goodman offers a number of concessions to his critics without abandoning his core claim that the 'apprehension [of resemblance] does not assure, nor its absence preclude, understanding what a picture represents.'[59] He willingly accepts that 'many pictures resemble their subjects', but he insists that this does not provide a secure basis for explaining depiction:

Resemblance may be as difficult a notion as meaning, but for a different reason. Whereas meanings are elusive, resemblances are ubiquitous. Any two objects resemble each other in some respect. The problem is to specify the sort of resemblance that is required for pictorial representation.[60]

Narrowing down the concept of resemblance to visual resemblance does not solve the problem since pictures can resemble their subjects in any number of ways. It is far from clear what role the identification of similarities plays in understanding pictures that represent fictional subjects such as unicorns or cases where we have no independent access to what is depicted. Most of us are willing to assume that Goya's *Duke of Wellington* resembles the Duke of Wellington without any knowledge of what the Duke of Wellington looks like. Goodman does not need to deny the existence of visual similarities between a picture and its subject to point out that the specification of which similarities are relevant is relative to a symbol system and thus context-dependent. Even in supposedly clear-cut cases we still have to determine what properties to look for. There are a wide range of variables at play both at the level of perception and at the level of depiction. Just as there is no single way that something looks, but rather many different ways of seeing, so there is no firm, invariant relation between a picture and what it depicts.

Much of Goodman's theory of art is counter-intuitive, but here he is on firm ground. To walk through a collection of paintings that spans different periods and cultures is to be made aware of the sheer diversity of pictorial styles and the seemingly infinite variety of means through which artists have depicted the same, limited repertoire of subjects. An Impressionist painting that captures subtle effects of light and

atmosphere has no less claim to objectivity than an architect's drawing or a meticulously observed Dutch still-life. The same arrangement of fruit and flowers or the same subject for a portrait will be painted in different ways by different artists. To Goodman's question, 'Which is the more faithful portrait of a man – the one by Holbein or the one by Manet or the one by Sharaku or the one by Dürer or the one by Cézanne or the one by Picasso?' there is clearly no right answer.[61] Every artist selects, orders and emphasizes different aspects of his subject in accordance with his own sense of what is significant or effective. This recognition opens the way for an account of pictorial diversity that not only accommodates the variety of ways in which pictures can represent their subjects but also acknowledges the disclosive potential of different modes of pictorial representation.

SEEING AND READING

In Chapter 1, I observed that both perceptualism and the symbol-based approach to art derive inspiration from Gombrich's ground-breaking book *Art and Illusion*. Although Goodman does not share Gombrich's interest in the psychology of pictorial representation, focusing, as we have seen, on the formal and structural properties of artworks as symbolic systems rather than on the production of effects in the mind of the viewer, he fully endorses Gombrich's claims concerning the selectivity of vision and the limits of likeness. In *Languages of Art* we find him claiming that 'The case for the relativity of vision and of representation has been so conclusively stated elsewhere that I am relieved of the need to argue it at any length here', with the specification that 'Gombrich, in particular, has amassed overwhelming evidence to show that the way we see and depict depends upon and varies with experience, practice, interests and attitudes.'[62] Recent advances in cognitive science have supported Gombrich's conclusions, and there is now a broad consensus that vision is an attention-directed system that selects and processes information from the visual field, filling-in gaps and integrating saccades – rapid eye movements that last between 20 and 200 microseconds – into short and long-term visual memories.[63] It follows that if what we see is dependent upon what we look for, that is to say, on which aspects of the visual field are identified as relevant or important, a picture must also be highly selective. As Gombrich observes, 'so complex is the information that reaches us from the visible world . . . no picture will ever embody it all.

That is not due to the subjectivity of vision but to its richness.'[64] Much of *Art and Illusion* is taken up with showing that the artist cannot simply copy what he sees, but must first employ a schema or design through which he can organize and give form to his experiences: once we acknowledge that representation is never duplication and that even the most realistic painting can only produce its effects through the resources of the medium, we are obliged to concede that there is a conceptual as well as a perceptual basis to pictorial representation.

It is unsurprising, then, that Gombrich has been interpreted, by some readers at least, as endorsing a convention theory of pictorial representation.[65] However, both in *Art and Illusion* and in his later writings, he trenchantly rejects the claim that learning to understand a picture requires mastery of an arbitrary code that links signs with their referents, insisting that recognition of the conventional elements of depiction need not issue in full-blown conventionalism.[66] I take Gombrich and Goodman to be in basic agreement on this issue despite their differing assessments of its consequences. What separates them is Gombrich's continued adherence to the idea that there is a 'standard of truth' by which different systems of representation can be measured. In particular, he has argued that the method of geometrical perspective described by Alberti in the fifteenth century, and developed and refined by subsequent generations of artists, is true to experience in way that is unmatched by other representational systems.[67] It is central to Gombrich's position that a flat, multi-coloured surface cannot duplicate the moving, three-dimensional world. His theory of depiction rests on the claim that through a process of trial and error artists have discovered how to provide visual cues that can trigger the same responses in the mind of the viewer: a landscape artist need not use green pigment to represent green grass as long as the disposition of the colours on the canvas succeeds in conveying the appearance of a sunlit lawn.[68] Gombrich's 'standard of truth' is therefore based not on a relation of correspondence or identity between the painting and its subject, that is to say, on a comparison of the motif with the image, but 'on the potential capacity of the image to evoke the motif'.[69]

Viewed under the appropriate conditions, it is undoubtedly the case that pictures produced in accordance with the laws of geometrical perspective are able to provide us with 'object-presenting experiences', even if this does not constitute a fully fledged illusion in the sense in which Gombrich uses this term.[70] When we look at Bellini's *San Zaccaria altarpiece* (Plate 4) or de Hooch's *Woman Peeling Apples* (Plate 1) we

have no difficulty seeing what is depicted. Moreover, there are also good grounds for believing, as Gombrich and others have argued, that this ability derives from the exercise of the same perceptual and cognitive capacities that enable us not only to discriminate objects in our environment but also to re-identify them under changed conditions of light, distance, viewing angle and so forth. It may well be that our brains have evolved to interpret visual cues with a rapidity and plasticity that artists can exploit for their own purposes. If this is right, then realism cannot simply be a matter of the viewer's familiarity with an entrenched system of representation as Goodman argues.[71] Whether or not a system is standard for a given culture is only one factor determining its effectiveness: there are also psychological and perceptual constraints on our ability to discern what a picture represents. No matter how familiar we might be with the works that Braque and Picasso produced during their Cubist period, a painting such as *The Portuguese* (Plate 8) does not allow the same 'instant and effortless recognition' that Gombrich esteems in Renaissance art. But nor, as we shall see, is it intended to.[72]

Goodman's claim in *Languages of Art* that 'vestiges' of the resemblance theory 'persist in most writings on representation' suggests that he wishes to extirpate it entirely.[73] As we have seen, however, he is more plausibly interpreted as challenging our naïve or pre-theoretical assumptions. His demonstration that resemblance is not sufficient for depiction and that understanding what a picture represents is always relative to the symbol system to which it belongs reveals the limits of a strictly naturalistic account of pictorial representation. The distinction between having to read a picture and simply seeing what it represents serves to remind us that a process of interpretation is involved even when it seems as if we merely register its content. Hyman is therefore wrong to claim that Goodman makes depiction fully dependent on conventions. Instead Goodman seeks to undermine the strict dichotomy between what is natural and what is conventional. If, as he claims, no firm line can be drawn between the two, we have good grounds for relinquishing the underlying dualism that opposes two different sources of knowledge, one grounded in the realm of nature and the other in the realm of human cultural practice. The system of geometrical perspective provides a highly effective means of pictorial representation, but since pictures are necessarily selective both about which properties they depict their subjects having and how these properties are represented it does not reveal the world 'as it is' independent of all interpretation. In place of Gombrich's claim that there is a single 'standard of truth', Goodman

reminds us that there are many, equally valid ways of seeing and representing the world.

Goodman's anti-realism is closely linked to his cognitivism. In his book *Ways of Worldmaking* he puts forward the thesis that 'the arts must be taken no less seriously than the sciences as modes of discovery, creation and enlargement of knowledge in the broad sense of advancement of understanding.'[74] He rejects what he terms 'the usual contrasting of the scientific-objective-cognitive with the artistic-subjective-emotive', arguing that 'art, like science, provides a grasp of new affinities and contrasts, cuts across worn categories to yield new organisations, new visions of the world we live in.'[75] If a work of art simply mirrored or reflected a pre-given reality, it could not advance our understanding in the way that Goodman suggests. Only once we give up the idea that there is a single, right way of depicting the world can we explain why art has genuine cognitive potential. A new style of painting, or a new system of representation, does not necessarily improve on or correct what went before except insofar as an established style or technique may have become formulaic or overly restrictive.[76] Moreover, it is clear that not all art aims at the production of an 'object-presenting experience'. This is as true of earlier periods in which the symbolic content or ritual function of art was given priority over mimetic accuracy as it is of the avant-garde movements of the twentieth century, whose rejection of the very goal of fidelity to nature was based on a profound distrust of pictorial immediacy and a demand for greater critical self-awareness about the means and methods of representation.

I want to conclude this chapter by examining these issues in relation to the semiotic interpretation of Cubism with which I began. As early as 1912, the poet and critic Apollinaire declared that 'Cubism, differs from the old schools of painting in that it is not an art of imitation, but an art of conception which tends towards creation.'[77] That same year, Jacques Rivière observed that 'The true purpose of painting is to represent objects as they really are; that is to say, differently from the way we see them.'[78] The apparent shift from an art of perception to an art of conception was interpreted in a variety of different ways, ranging from the claim that the Cubists depicted the same object from a plurality of viewpoints, thereby capturing the durational quality of experience, through to more speculative claims concerning the 'higher truth' that is known through the mind rather than the senses.[79] The origins of the semiotic interpretation of Cubism can be traced back to these ideas, but it also has its roots in the work of the linguist Ferdinand de Saussure, whose theory of the arbitrary

character of the linguistic sign was presented in a series of lectures given in Switzerland between 1907 and 1911, that is to say, at roughly the same time as the development of Cubism. In the absence of any evidence showing that Braque and Picasso were aware of Saussure's ideas, advocates of the semiotic approach have argued that there was simultaneous breakthrough in the fields of art and language. The first person to describe Cubism in semiotic terms seems to have been Kahnweiler, who argued in 1949 that:

> These painters turned away from imitation because they had discovered that the true character of painting and sculpture is that of a *script*. The products of these arts are signs, emblems, for the external world, not mirrors reflecting the external world in a more or less distorting manner. Once this was recognised, the plastic arts were freed from the slavery inherent in illusionistic styles.[80]

Kahnweiler was also the first to propose that Picasso's discovery of the mutability of the pictorial sign was prompted by his acquisition in 1912 of a Grebo mask in which the eyes are represented by projecting cylinders and the mouth by two parallel bars. Although Picasso had been collecting African and Iberian artefacts since 1908, Kahnweiler suggests that this encounter with a work of non-Western art enabled him to recognize that the 'human face "seen" or rather "read", does not coincide at all with the details of the sign, which . . . would have no significance if isolated.'[81] The same shape can be used to represent an eye, a mouth, the neck or any other part of human anatomy as long as it is placed within a context that fixes its meaning. In the case of a mask, the meaning of the sign is dependent upon our knowledge of the shape of the human face and the characteristic disposition of its elements. It is only because a face is something with which we are so familiar that we are able to read the cylinder as an eye; seen in isolation it no more represents an eye or a mouth than it does anything else.

Kahnweiler's ideas have been developed by a number of art historians, including Yves-Alain Bois and Rosalind Krauss, both of whom have argued that there are close analogies between the insights of structural linguistics and the second, 'synthetic' period of Cubism when Braque and Picasso began to explore the possibilities of collage. This new technique, sometimes termed *papiers collés*, involved pasting pieces of newspaper, printed oilcloth, wallpaper and other commercially manufactured products directly onto the surface of the canvas. With great economy

of means, Braque and Picasso assembled their pictures out of discrete elements that are allowed both to retain their independence and to enter into new relations. The visual simplicity of the collages, which are often made up of just a few marks and pieces of paper, belies a sophisticated investigation into the nature of pictorial signs. By recombining found materials, such as fragments of written text, sheet music, bottle labels and even slips of *faux bois* paper, the two artists juxtaposed multiple systems of reference that the viewer must piece together or 'synthesise'. The letters 'j-o-u' cut from a newspaper might be read as the first part of the word *journal* or as a shortened form of the word *jouer* (to play). But the piece of paper with its printed text could also be given a separate, pictorial function as part of a still-life where it might serve as a representation of a table top or some other familiar object.[82] Picasso and Braque showed with seemingly endless inventiveness that the same shape or mark could be made to carry different meanings depending on its relation to other elements in the picture. However, the claim that the Cubists discovered 'the principle of semiological arbitrariness and, in consequence, the nonsubstantial character of the sign' can easily lead to misunderstanding if it is not qualified, as Bois reminds us, by the recognition that a sign can only function 'within a system that regulates its use'.[83]

In a justly celebrated analysis of Picasso's *Violin* of autumn 1912 (Plate 10), Krauss places great emphasis on the fact that the two pieces of newsprint that are pasted on to the support have been cut from the same sheet of paper: both match along one edge, but one has been turned over to reveal its reverse side. The lower piece is integrated into a schematic charcoal drawing of a violin so that its shape assumes the profile of part of the violin's body and the lines of print are allowed to stand for the grain of the wood. Unmistakeably pasted onto the surface, the newsprint sits flat on top of the support, 'resolutely frontal, facing the viewer'.[84] But the addition of two differently sized sound holes encourages us to read the violin as placed at an angle, with the smaller f hole indicating perspective diminution. The second piece of newsprint is placed higher up, its left edge cupping the pegs and scroll of the instrument. Here the piece of newspaper serves as a background so that 'the lines of type now assume the look of stippled flecks of graphite, the painter's visual shorthand for atmospheric surround'.[85] If Krauss's reading is correct, then Picasso has used one and the same sheet of paper to represent both opacity and depth, figure and ground. Whereas the different sizes of the f holes obey, however minimally, the traditional method of representing foreshortening, the two pieces of newsprint acquire their meaning

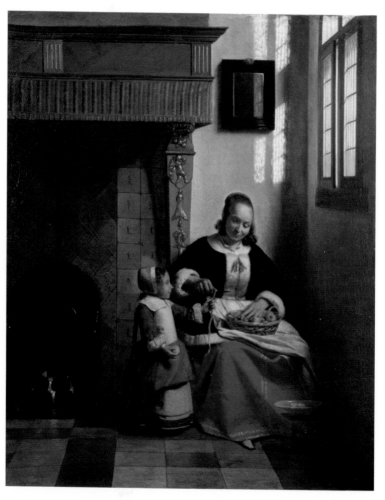

Plate 1 Pieter de Hooch, *A Woman Peeling Apples*, c. 1663, oil on canvas, 71 × 54 cm. (Wallace Collection, London/The Bridgeman Art Library.)

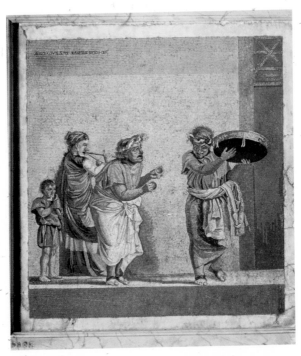

Plate 2 Dioskourides of Samos, *Strolling Masked Musicians*, 2nd century BC, limestone and marble tesserae, 41.5 × 43.5 cm. Found in Villa of Cicero, Pompeii. (Museo Archeologico Nazionale, Naples/The Bridgeman Art Library.)

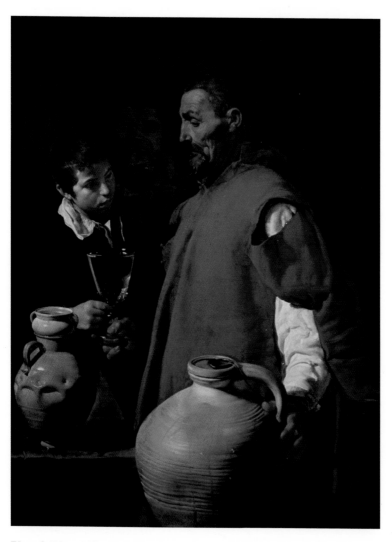

Plate 3 Diego Vélazquez, *The Waterseller of Seville*, c.1618–22, oil on canvas, 106.7 x 81 cm. (Apsley House, The Wellington Museum, London/ Giraudon/ The Bridgeman Art Library.)

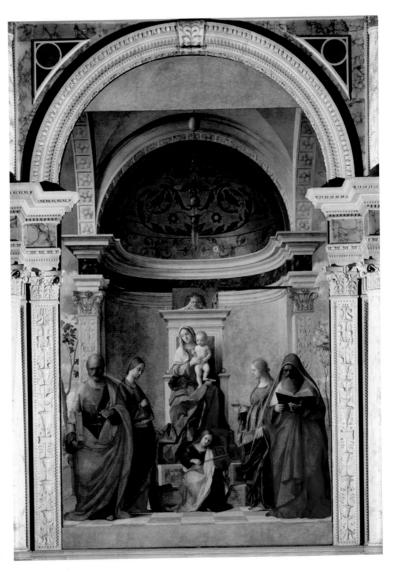

Plate 4 Giovanni Bellini, *Virgin and Child Enthroned with Saints* (*S. Zaccaria altarpiece*), 1505, oil on canvas, transferred from wood, 402 × 273 cm. (Church of San Zaccaria, Venice/Cameraphoto Arte Venezia/ The Bridgeman Art Library.)

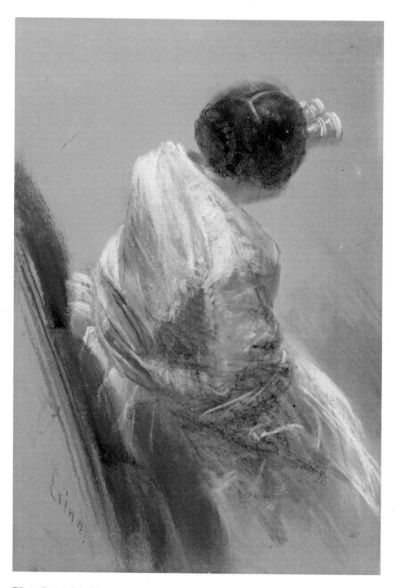

Plate 5 Adolph Menzel, *Lady with Opera Glasses*, c. 1850, coloured chalks on paper, 28.2 × 19.4 cm. (Bpk/ Kupferstichkabinett, Staatliche Museen zu Berlin. Photo: Jörg P. Anders.)

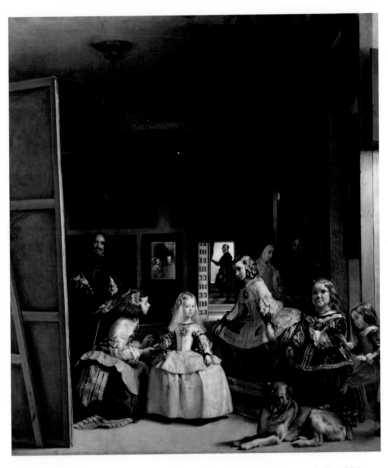

Plate 6 Diego Vélazquez, *Las Meniñas*, c. 1656, oil on canvas, 318 x 276 cm. (Museo del Prado, Madrid/ Giraudon/ The Bridgeman Art Library.)

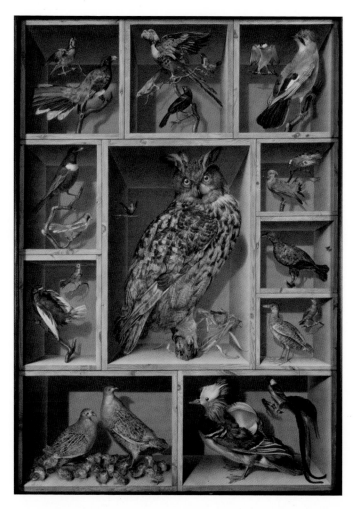

Plate 7 Alexandre-Isidore Leroy de Barde, *Still-Life with Exotic Birds*, c. 1810, watercolour on paper, 124.6 × 88.5 cm. (Musée du Louvre, Paris, D.A.G. Photo RMN/Gérard Blot.)

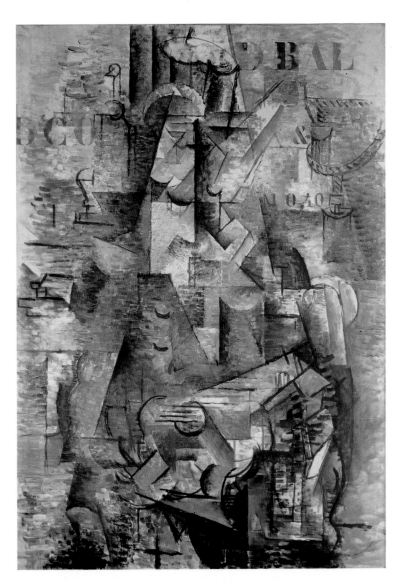

Plate 8 Georges Braque, *The Portuguese (The Emigrant)*, 1911–12, oil on canvas, 117 × 81.5 cm. (Kustmuseum Basel, Gift Raoul La Roche 1952. Photo: Kunstmuseum Basel, Martin Bühler. © ADAGP, Paris and DACS, London 2007.)

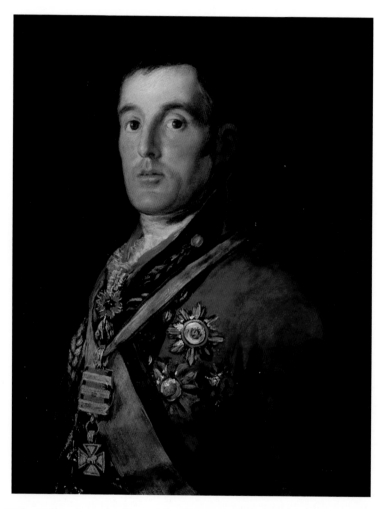

Plate 9 Francisco de Goya, *The Duke of Wellington*, 1812–14, oil on mahogany, 64.3 × 52.4 cm. (National Gallery, London/The Bridgeman Art Library.)

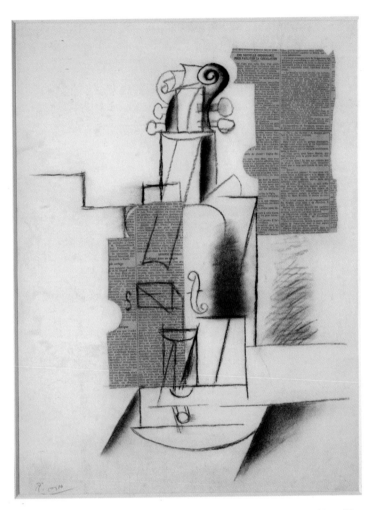

Plate 10 Pablo Picasso, *Violin*, 1912, pasted paper and charcoal, 62 × 47 cm. (Musée National d'Art Moderne – Centre Georges Pompidou, Paris. Photo CNAC/MNAM Dist. RMN. © Succession Picasso/ DACS, London 2007.)

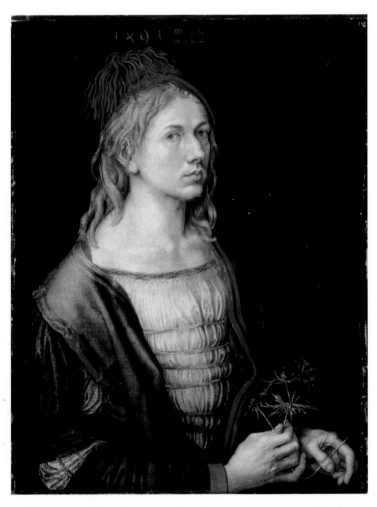

Plate 11 Albrecht Dürer, *Self-Portrait with a Thistle*, 1493, oil on velum, 56.5 x 44.5 cm. (Musée du Louvre, Paris. Photo RMN/Jean-Gilles Berizzi.)

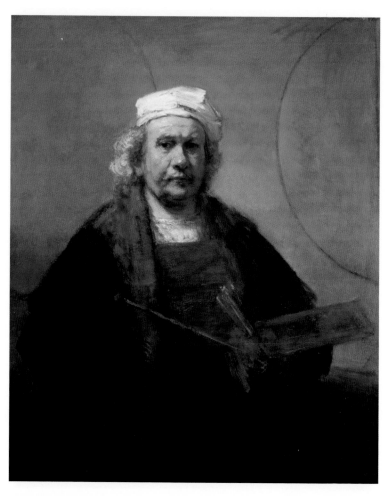

Plate 12 Rembrandt van Rijn, *Self-Portrait with Two Circles*, 1661–62, oil on canvas, 114.3 × 94 cm. (The Iveagh Bequest, Kenwood House, London/ The Bridgeman Art Library.)

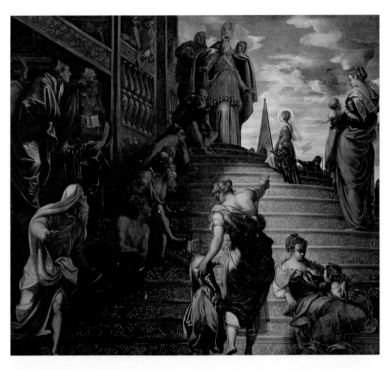

Plate 13 Jacopo Tintoretto, *The Presentation of the Virgin*, 1552, oil on canvas, 400 × 480 cm. (Madonna dell'Orto, Venice/Cameraphoto Arte Venezia/The Bridgeman Art Library.)

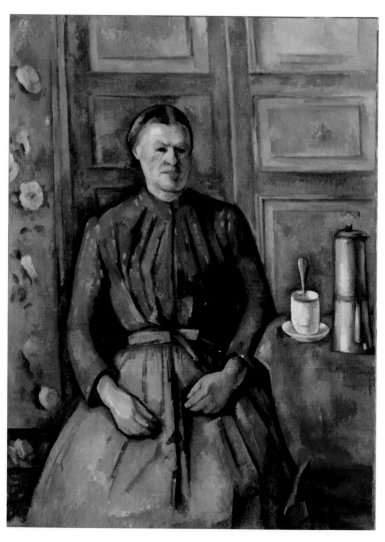

Plate 14 Paul Cézanne, *Woman with a Coffee Pot*, c. 1890–95, oil on canvas, 130.5 × 96.5 cm. (Musée d'Orsay, Paris. Photo RMN/Hervé Lewandowski.)

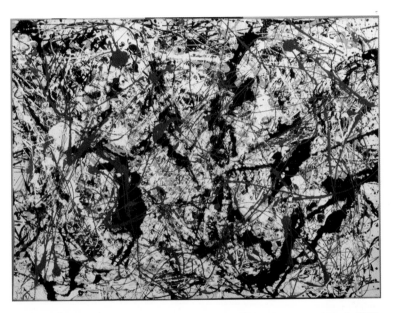

Plate 15 Jackson Pollock, *Silver over Black, White, Yellow and Red*, 1948, oil and enamel on paper laid over canvas, 61 × 80 cm. (Musée National d'Art Moderne – Centre Georges Pompidou, Paris. Photo CNAC/MNAM Dist. RMN/ Philippe Migeat. © ARS, NY and DACS, London 2007.)

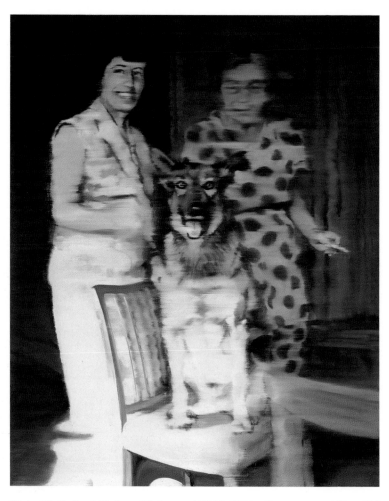

Plate 16 Gerhard Richter, *Christa and Wolfi*, 1964, oil on canvas, 150 × 130 cm. (Joseph Winterbotham Collection, 1987.276, The Art Institute of Chicago. Photography © The Art Institute of Chicago.)

through the binary opposition between 'front and back' and 'light and shade'.

Deploying Peirce's categorization of different types of sign, Krauss uses her interpretation of *Violin* to argue that 'with the new medium of collage, [Picasso] entered a space in which the sign has slipped away from the fixity of what the semiologist would call an iconic condition – that of resemblance – to assume the ceaseless play of meaning open to the symbol, which is to say, language's unmotivated, conventional sign.'[86] By 'unmotivated' she means that a sign has no demonstrable relation to its referent, whether causally (an index) or through resemblance (an icon). In short, an unmotivated sign is equivalent to what Peirce terms a symbol. The invention of collage thus marks a 'momentous' change – 'a change not within the system of illusion from one type to another, but a conversion from one whole representational system, roughly called iconic, to another, roughly called symbolic.'[87] Notwithstanding the brilliance of Krauss's analysis, I believe that we should reject this conclusion. Just as a cylinder can only be interpreted as an eye or a mouth within the 'system of values' established by the anatomy of the human face, so the different meanings accorded to the pieces of newsprint depend upon their relation to the iconographic representation of the violin, which exploits our awareness of the look of a familiar object. Krauss's proposal that the medium of collage allows Picasso to demonstrate the arbitrary character of the pictorial sign fails to acknowledge the extent to which even a work as compressed and elusive as this remains firmly anchored in perceptual experience.

Rather than marking a transition from one system of signs to another, as Krauss contends, the invention of collage is best seen as a deepening and further extension of the ongoing investigation into the structures and processes of depiction that had characterized Cubism from the outset. During the first, 'analytic' period of Cubism, Braque and Picasso explored the minimum requirements for recognition, sometimes representing an object through a single attribute, such as an *f* hole for a violin or an ellipse for the top of a glass. The limits of the Renaissance system of representation are made clear by the mocking addition in one of Braque's paintings of a 'realistic' depiction of nail, which casts an illusionistic shadow on the painting's surface.[88] In the words of the critic Clement Greenberg, by the end of 1911 both artists 'had pretty well turned traditional illusionist paintings inside out'.[89] In the final, so-called 'hermetic' phase of analytic Cubism the breakdown of coherent pictorial space and the dissolution of the integrity of form approaches the brink

of full abstraction. However, both artists seem to have realized that the removal of identifiable subject matter would have broken the complex interplay between the depiction of recognizable objects and the independent reality of the marks on the surface of the painting.

The technique of collage provided a means of overcoming this impasse by securing, once again, determinate reference to the external world. Illusionistic effects, achieved through drawing directly onto canvas or by pasting in pictures, *faux bois* and other *trompe l'oeil* devices, could be isolated so that they no longer deceived the eye. However, the experimental, improvisatory nature of Cubism militates against the idea that Braque and Picasso sought to impose an alternative system based on the arbitrary character of the sign. Without the expectations generated by the context of use, the meaning of a sign remains indeterminate. This is as true of a pencil mark or a brush stroke as of one of Picasso's pieces of newsprint. A curved line can represent the profile of someone's nose or the prow of a ship: everything depends on its relation to other signs. What Bois terms the 'relative motivation' of the sign requires that any mark or unit, whether it belongs to a dense system such as painting or an attenuated system such as a text or a musical notation, be given a positive value.[90] In the case of pictorial art, this is determined not only by our familiarity with the symbol system to which it belongs but also by our knowledge of how things look.

CHAPTER 5

PICTORIAL STYLE

In Chapter 2 I drew a distinction between two different conceptions of painting, both of which can be found in Alberti's treatise *On Painting*. The first conception, which is rooted in classical theories of *mimesis*, holds that the artist should strive to represent as accurately as possible the way in which objects reveal themselves to sight. For Alberti, this is to be achieved by obeying the laws of mathematical perspective, which permit the artist to represent on a flat surface a cross section through the visual pyramid formed by the rays of light that travel from the surfaces of objects to the eye. A painting should be like a 'window onto the world', opening transparently onto the scene it represents. By contrast, the second conception identifies a painting as a composition, that is to say, a purposively structured unity that possesses its own rules and principles. If the artist is to hold the attention of the viewer and to present his *historia* in an effective way, he needs to select and order its constituent elements. These two conceptions, which remain in constant tension throughout Alberti's treatise, are brought together, somewhat disarmingly, in the final pedagogical section, when he reminds the prospective artist that he 'should be attentive not only to the likeness [*similitudinem*] of things but also and especially to beauty [*pulchritudinem*], for in painting beauty is as pleasing as it is necessary'.[1] Whereas the demand for 'likeness' requires that the painter adhere as closely as possible to the way in which objects present themselves to normal vision, the demand for 'beauty' requires that he consider the symmetry, proportion, cohesion and lucidity with which the various parts of the painting are combined into an effective and pleasing whole. If one axis connects the painting to the world, a second equally important axis connects the different parts of the painting to each other.

Up to this point I have primarily been concerned with how pictures represent, that is to say, with providing an account of the complex relation between the marks out of which a picture is made and recognition of its subject matter or content. However, it is clear that our interest in painting is directed not only at *what* is represented but also at the particular

way in which the subject has been depicted by the artist. I now want to turn to the broad set of issues that are traditionally grouped under the heading of composition, but which extend to include a wide range of other features, including facture or the handling of the medium, the relative intensity and saturation of colour, the contrast between gradations of light and dark, and the organization of the contents of the painting in relation to the twin boundaries of the framing edge and the picture plane. It is important to recognize that these 'design features' are properties of the painting rather than what it represents.[2] It is Bellini's *San Zaccaria Altarpiece* (Plate 4) that has a smooth surface in which the brushstrokes are blended into each other, not the scene depicted. Less obviously, the location of the two nearest figures just behind the picture plane and the low angle of vision that ensures that we gaze upwards at the Virgin and child are aspects of the way in which the picturing has been done rather than the scene itself. The orientation of the figures, the disposition of light and shade within the rectangle of the canvas, and even the texture of the marked surface, enter into and inform our recognition of the painting's content. But to see the picture as a picture rather than as a 'window onto the world' is to acknowledge that these features are the result of choices made by the artist and that they can vary independently of what is shown.

I have described two different axes or lines of enquiry, one of which runs between the painting and its model in nature and the other of which remains internal to the painting itself. It is a weakness of Alberti's theory of depiction – and, indeed, of any theory that assumes that painting is a direct representation of the world as it reveals itself to sight – that it is unable to show how these two axes intersect. A similar problem confronts Gombrich's illusion theory of depiction insofar as he detaches the viewer's awareness of the marked surface of a painting from his awareness of what that surface represents: although we can alternate between attending to the marks on the surface and entering into the illusion that they sustain, the two experiences are mutually effacing. One of the advantages of Wollheim's theory of 'seeing-in' is that it shows why this account is wrong. The distinctive phenomenology of representational seeing permits simultaneous attention to both surface and subject: attention to a painting's design features – its configurational aspect – and attention to its subject matter or content – its recognitional aspect – stand in a relation of reciprocity or mutual enhancement.[3] In the experience of looking at a painting it is not always clear whether we are responding to the way in which the artist has presented his subject or to features of the

scene depicted; the two interact with one another, mutually enriching and complicating our awareness of the materiality of the surface and what that surface represents.[4]

This argument is extended rather than contradicted by Goodman's account of the density and relative repleteness of pictorial symbol systems: looking at a painting requires 'maximum sensitivity of discrimination' since every difference in the structure, order, texture, brightness, colour and disposition of the marks on the surface of the canvas is potentially significant.[5] In their sophisticated versions, both perceptualism and the symbol-based approach to art give equal weight to a picture's design features and thus provide for an integrative theory of depiction. But we have yet to investigate whether it is possible to provide a 'general theory' of these features that possesses the same degree of rigour that Goodman brings to the analysis of verbal and non-verbal symbol systems. *Languages of Art* is tightly focused on the problem of reference, that is to say, with describing the syntactic and semantic structures through which different types of symbol are given meaning. Goodman argues that understanding what a picture refers to is always relative to the symbol system to which it belongs; not only are the ways of seeing and picturing 'many and various', but none can lay claim to be 'the way of seeing or picturing the world as it is'.[6] This raises the question – unanswered in *Languages of Art* – whether it is possible to provide a systematic analysis of the relational differences that distinguish one pictorial representation from another.[7] If no two artists ever depict the same motif in exactly the same way, how are these differences to be characterized? Are we confronted with an irreducible plurality of ways of seeing and picturing, as Goodman suggests, or is it possible to identify a set of underlying structural principles that would allow us to make meaningful comparisons between the design features of different paintings even when – as is most often the case – they have a different content or subject matter?

THE PROBLEM OF STYLE

The term that is standardly used to describe differences in the form or manner of representation is 'style'. Etymologically, it derives from the Latin word for a pointed instrument for writing on wax tablets – *stilus*; by extension, the term came to be employed figuratively to characterize an author's own way of formulating and presenting his ideas.[8] Recognition that a painter, like a writer, has his own style, and that this can be

used to distinguish the work of one artist from another, is already to be found in Quintilian. This usage continued throughout the Renaissance, where the term was virtually interchangeable with the Italian *maniera*, the expression of an artist's personality through his individual manner of painting.[9] When Gombrich addresses the 'riddle of style' at the start of *Art and Illusion* he takes this to mean 'Why is it that different ages and different nations have represented the visible world in such different ways?'[10] However, it was not until the eighteenth century that the concept of style began to acquire its historical bias. The fusion of the ancient rhetorical understanding of style with the modern idea of historicism – the belief that works of art can only be understood in relation to the practices, institutions and ideals of the culture in which they were produced – is generally accredited to the German art historian Johann Joachim Winckelmann, whose *History of the Art of Antiquity* was published in1764.[11] Winckelmann was the first to employ stylistic analysis as a means of reconstructing the evolution of art through various phases, each of which is characterized by a distinctive set of traits or features. He also sought to link changes in artistic style to specific cultural and political developments, arguing, for instance, that there is a connection between the democratic freedoms instantiated in the Athenian city state and the aesthetic freedoms that characterize the 'high' period of Greek art.

The claim that works of art are an expression of the collective spirit of a nation or an age is most fully articulated in Hegel's *Lectures on Aesthetics*, delivered between 1818 and 1831. Hegel's conviction that 'every work of art belongs to its own time, its own people, its own environment' and that 'scholarship in the field of art demands a vast wealth of historical, and indeed very detailed facts' was enormously influential in shaping the fledgling discipline of art history.[12] Even those who rejected other elements of Hegel's philosophy accepted that the task of the art historian was not merely to situate artworks in their appropriate context, but to organize the history of art into a unified narrative. If every work of art is the product of an historically specific constellation of interests and values, then historical knowledge is essential to understanding the art of the past. The assumption that artworks produced under the same social and cultural conditions are likely to share certain features in common also allowed art historians to proceed in the other direction: stylistic analysis could be used as a means of dating and classifying an artwork for which there was a lack of evidence linking it to a particular artist or school. The concept of style thus provided both a structure

for the history of art – a means of organizing the diversity of artworks into broader categories and sequences of development – and a set of procedures for identifying when, where and sometimes by whom, an artwork was made.

When, in 1967, Gombrich went 'in search of cultural history', he was forced to concede that '*Kulturgeschichte* has been built, knowingly and unknowingly, on Hegelian foundations that have crumbled'.[13] He argued that the great project of categorizing artworks into stylistic categories that express the 'spirit of the age' – Classical, Romanesque, Gothic, Renaissance, Baroque, Rococo, Neo-Classical, Romantic – arose from a collectivist and deterministic conception of history that had long since ceased to be viable and that even the supposedly neutral and descriptive use of style labels as a tool for the attribution and dating of artworks should be challenged on the grounds that 'description can never be completely divorced from criticism'.[14] In the course of the late nineteenth and early twentieth century the march of styles was consumed in a blaze of 'isms', each of which took the place of its predecessor with ever greater rapidity. The sheer profusion of media and practices that characterized so-called 'advanced art' threatened to render the term redundant. Already at the close of the nineteenth century, the art historian Heinrich Wölfflin spoke of the 'uprooting' of style, observing that in his own time 'styles change like fancy dresses being tried on for a masquerade'.[15] His search for a 'more weighty' conception of style led him to focus on the art of the High Renaissance and the Baroque, two periods in which stylistic differences were strongly marked. Few critics today would seek to distinguish a contemporary artist's work on stylistic grounds. However, even when employed in relation to the art of the past, the concept of style remains difficult to define with any precision.

The problem arises, at least in part, from the sheer multiplicity of style terms. An artist is said to have his or her own individual style, which, in turn, can be subdivided into early, middle and late style. Style labels are also used to identify recurrent features or constancies that link the work of different artists. Thus, for example, a period label such as Gothic is used to identify characteristic attributes of medieval art from the mid-twelfth century onwards, while a school style – such as the school of Giotto or the school of David – is based on the identification of features that are common to the work of artists who studied under or were strongly influenced by the same master. Other collective labels include regional styles that group together artists from the same geographical area – such as the school of Leiden or the Swabian school – and the names of artistic

movements such as Impressionism and Futurism, where membership is held to involve sharing the same goals and techniques. This suprapersonal conception of style is sometimes extended to include 'universal' styles such as classicism or naturalism that are not restricted to the work of a particular artist, period or school, but reappear in varying forms at different times and places.

It does not take much probing to see that many of these categories are little more than convenient place holders. Not only are the borders between historical periods subject to constant revision, but the classification of individual, regional and period styles frequently results in overlapping and contradictory designations.[16] The imposition of unity that lies behind the identification of a collective or group style can also cover over or marginalize important differences: although Gérard, Girodet, Gros and Ingres all studied under David, they developed their own individual interests and techniques. Even artists who belong to the same movement, such as Impressionism, need not paint in the same style. Degas is categorized as an Impressionist on the basis of his participation in the group's exhibitions and his interest in the representation of modern life rather than a commitment to *plein-air* painting and the use of small touches of pure colour. Most problematic of all are universal style terms such as naturalism: the employment of single label to characterize tendencies that are supposedly found in the art of ancient Greece, the Renaissance and nineteenth-century France invites considerable misunderstanding, not least because it suggests that there is a common project underlying markedly disparate practices.

It is unsurprising, then, that there has been extensive debate not only about how style terms are to be understood, but whether the concept of style can be freed from its historicist underpinnings. Some art historians, such as Svetlana Alpers, have sought to avoid using the concept of style altogether, arguing that it is wrong to assume that 'a frankly external system of style classification' can tell us something about the character of individual works.[17] A less radical solution has been proposed by James S. Ackermann, who contends that stylistic change can be characterized without recourse to a deterministic model of historical development. Once we acknowledge that the history of art is motivated by 'a constant incidence of probings into the unknown, not a sequence of steps towards the perfect solution', it is possible to develop a more nuanced, context-sensitive approach that avoids the pitfalls of historical collectivism and aesthetic transcendentalism.[18] Ackermann argues that the concept of style remains an 'indispensable historical tool' since

'by defining *relationships* it makes various kinds of order out of what otherwise would be a vast continuum of self-sufficient products.'[19] The alternative would be an atomistic conception of art, in which individual artworks are treated as discrete entities that can be studied only in isolation. Even art historians such as Alpers who remain wary of the concept of style acknowledge that 'the historical nature of the stylistic problematic . . . has been the basis for the most serious thinking about style and art.'[20] The relation between the concept of style and larger processes of historical change remains central to art-historical enquiry. Yet it is far from clear how these two dimensions are to be brought together in the study of individual artworks.

INDIVIDUAL AND GENERAL STYLE

It is in the context of these debates that I now want to examine Wollheim's revisionist theory of pictorial style.[21] As we shall see, his position is grounded in a deep-rooted scepticism about the historical explanation of works of art. In particular, he rejects the claim that there is a 'special feature of the visual arts . . . which has, allegedly, the consequence that if we are to understand painting, sculpture or graphic art, we must reach an historical understanding of them'.[22] In a series of lectures and articles, and in his book *Painting as an Art*, he draws a set of distinctions that are intended to dispel confusion and to re-order the way that style concepts are employed.[23] Criticizing what he describes as 'the extreme theoretical poverty of the existing discussion', he argues that these distinctions should provide the basis for future empirical work on the subject.[24] His paper, 'Pictorial style: two views', first published in 1979, concludes with a list of maxims designed to guide a research project of the appropriate kind.[25] In his final article on the topic, published in 1995, he expressed his disappointment that this project had yet to be carried out, but he reiterated his belief in the '*a priori* or intuitive appeal' of his position, claiming that it 'furnishes the most natural way of ordering the material of style'.[26] His proposals are thus intended to be of practical as well as theoretical significance; if accepted, they should transform the way in which both critics and art historians analyse the stylistic properties of works of visual art.

Wollheim's first, ground-clearing move is to distinguish between, on the one hand, individual style, that is to say, the style of a particular artist, and, on the other, all the various other style labels, including period style,

school style and universal style, which he brings under the category of general style. The key to his position lies in the claim that only individual style has psychological reality: it forms part of the artist's 'mental store', and it directly influences his practice of painting.[27] The concept of individual style is *generative*: it explains how an artist comes to paint in a certain way by characterizing the actual processes and decisions that guide that artist's work. By contrast, general style terms are merely *taxonomic*: they are developed by critics and art historians as a means of organizing the diversity of works and approaches with which they are confronted when they turn to the art of the past. General style terms provide a way of grouping different sets of characteristics for our convenience. They offer a shorthand for identifying what is considered particularly interesting, significant or distinctive from a particular standpoint at a particular moment in time. They are thus relative to a certain point of view and can and do vary with changes in the discipline of art history.

As we might expect, the positive, or constructive, part of Wollheim's theory resides in his account of the psychological reality of individual style. He has devoted considerable attention to explaining how an artist's conscious thoughts and beliefs – as well as other desires, attitudes and emotions of which he may be unaware – shape his activity as a painter. One of his most suggestive lines of enquiry concerns the way in which an artist's style is formed not only by his ideas about painting but also by characteristic modifications of his bodily movements: an artist's disposition to paint in a certain way reaches deep into the limbs and muscles, and is thus more properly characterized as possessing 'psycho-motor reality'.[28] By contrast, Wollheim's account of general style is largely negative or destructive: he argues that insofar as art historians fail to identify a 'productive system' that can account for a period, school or universal style, such designations serve merely to cluster or colligate certain features together.[29] Since it is hard to see what could qualify as a productive system other than the psychological and physiological traits of an individual artist, the productivity requirement effectively rules out the possibility of providing a non-intentionalist explanation of pictorial meaning. Wollheim concedes that the view of pictorial style that he advocates:

> cannot be expected to find favour, or even to possess intelligibility, outside a broader framework within which the art of painting may be set. This framework . . . presupposes that, in trying to understand

a painting, in trying to grasp its meaning, we should always see it as (what after all it is) the product of a human mind: the mind of its painter.[30]

The question at issue is whether this framework suffices to provide a full understanding of the concept of style. I shall argue that it does not and that Wollheim's proposals serve to exorcize rather than to explain what Alpers terms the 'historical basis of the stylistic problematic'. The revisionist thrust of Wollheim's theory derives not from the distinction between individual style and general style, which accords with our common sense understanding of the subject, but from two further theses that he builds on to this distinction. These are, first, the *description thesis*: the claim that general style terms are merely taxonomic; and second, the *relativization thesis*: the claim that general style terms are relative to the changing point of view of those who seek to understand the art of the past. Let us consider each of these theses in turn, starting with the relativization thesis.

It is a consequence of the relativization thesis that 'style-descriptions can be written and rewritten unconstrained by anything except prevailing art-historical interests'.[31] Unlike individual style, which is '*in* the artist who has it', both psychologically and physically, general style 'lacks reality': not only may art historians define general styles in any way that seems useful, there is no 'fact of the matter' for them to get right or wrong.[32] The relativization thesis issues in a radically constructivist account of art-historical enquiry that is at odds with current practice. The identification of shared stylistic features continues to play an important role in the dating and attribution of paintings, supplemented in many cases by archival research and the evidence provided by X-ray photography and chemical analysis. While classification on stylistic grounds alone must always remain uncertain, the provision of independently verifiable evidence through modern conservation techniques allows for an on-going process of correction and corroboration, which in turn provides an appropriate measure of objectivity. Wollheim's theory fails to accommodate the possibility of a hermeneutically sensitive search for an increasingly correct employment of general style terms for which any proposed revision in the scope or reference of a term must respond to and demonstrably improve on previous categorizations while itself remaining open to revision in the light of new arguments and interpretations.[33]

All of this would count for nothing, however, if the first of Wollheim's theses were correct. The description thesis holds that general style terms

are merely tools of classification and that 'the attribution of a style to a painter [has] no explanatory force in respect of his work'.[34] Wollheim's claim that only an account of the actual processes through which an artist comes to produce a work of art in a certain style has explanatory value is simply another way of stating his view that in order to understand a work of art we need to consider the activity from which it issues. There is a risk of circularity here insofar as the description thesis depends on the restriction of explanatory force to psychological accounts of pictorial meaning. I have already expressed reservations concerning Wollheim's attempt to impose on seeing-in a standard of correctness based on the fulfilled intentions of the artist.[35] In Chapter 3, I argued that awareness of the artist's intentions – however broadly construed – is only one component in understanding the meaning of a painting. If this is correct, then other factors can also play a role, including knowledge of a work's place in the history of art, that is to say, its classification according to period, school and region. The distinction between a generative conception of style and a merely taxonomic conception is invidious because it fails to acknowledge that locating an artwork in the appropriate stylistic category can change the way in which it is understood and interpreted. In Goodman's typically succinct formulation, the assumption that concepts of style are merely 'curatorial devices for sorting works according to origin' is misleading since it assumes that 'attribution is alien to aesthetics'.[36]

The dating of a painting and the establishment of a meaningful context for comparison not only directs our attention to salient properties of the work, it also helps us to identify its distinguishing features. To recognize Leonardo's painting of thirteen figures seated at a dinner table as a representation of the Last Supper requires familiarity with a specific pictorial tradition; moreover, appreciation of the distinctive way in which Leonardo has arranged the figures – who are all arrayed along one side of the table – requires understanding how this differs from, say, Giotto's treatment of the same subject in the Scrovegni Chapel in Padua.[37] Erwin Panofsky has argued that we cannot even identify the 'primary' or literal subject matter of a painting unless we know what style it is in. In his now classic essay, 'Iconography and iconology', he discusses the right hand panel of Roger van der Weyden's *Middelburger Altarpiece* [c. 1445, Gemäldegalerie, Berlin], which depicts the apparition of the infant Christ before the kneeling figures of the three Magi.[38] The ability to identify the child as Christ and the three figures as the Magi depends, of course, on familiarity with the relevant iconographic conventions. But Panofsky

goes on to argue that the pre-iconographical interpretation of the painting as depicting an apparition of a child – irrespective of who the child is taken to be – depends on knowing that it is in the style of Renaissance naturalism. We deduce that the child hovers in mid-air from the fact he is 'depicted in space with no visible means of support'. Yet there are many pictures in which objects 'seem to hang loose in space in violation of the law of gravity, without thereby pretending to be apparitions'.[39] It is only because we identify the painting as being in one style rather than another that we are able to discount the possibility that the artist has simply placed the child against an abstract ground for decorative or dramatic effect.

The limits of Wollheim's approach should now be clear. If knowledge about shared stylistic features plays an indispensable role in arriving at a correct interpretation of the meaning of an artwork, then the adoption of an explanatory framework that is exclusively focused on the intentions of the artist proves to be too narrow. Stylistic analysis is essentially comparative, identifying similarities and drawing distinctions between artworks within a dynamic structure that undergoes continual change and transformation. Rather than isolating the concept of style from wider questions of historical development, we need to find an effective and non-prejudicial way of bringing the two together. I now want to examine whether it is possible to establish a basis for the comparative analysis of works of visual art that can meet the twin requirements of objectivity and explanatory value. This should enable us to characterize differences in the formal organization of artworks irrespective of their subject matter and without direct reference to the intentions of the artist.

I have already observed that neither perceptual nor symbol-based theories of pictorial representation provide an adequate set of resources for carrying out this project. For this reason I want to examine the work of the early 'critical historians' of art, focusing in particular on the proposals put forward by Wölfflin in his book *Principles of Art History*, which was first published in 1915. This remains the most ambitious attempt to draw up a set of 'criteria' (*Maßstäbe*) through which the 'historical transformations' of style can be defined.[40] As in his earlier writings, Wölfflin centres his discussion on the High Renaissance and the Baroque. However, as the original German title – *Kunstgeschichtliche Grundbegriffe* – clearly signals, his goal is not simply to describe historical developments specific to the sixteenth and seventeenth centuries, but to identify the most basic or 'fundamental concepts' of art-historical analysis. I begin with a brief discussion of Wölfflin's own views as these

are articulated in *Principles of Art History*, before going on to consider more recent attempts to provide a 'critical reconstruction' of his position. I show that if Wölfflin's theory of style is to form the basis for a philosophically defensible account of the 'logic of depiction', it needs to be extricated from the cyclical conception of history within it was originally articulated. Nonetheless, reconstruction of the fundamental concepts as purely formal or relational categories runs the risk of severing stylistic analysis from the explanation of historical change. I therefore conclude by returning to Wölfflin's account of the 'transformations' of style, showing that his explanation of the 'decorative' significance of the fundamental concepts provides an important corrective to the claim that progress in art can be understood in terms of increasing perfection in the imitation of nature.

THE SPECIFICALLY VISUAL

In order to grasp the distinctive character of Wölfflin's project it is helpful to compare his approach with that of the Swiss historian Jacob Burckhardt, under whom he studied at the University of Basel.[41] Although Burckhardt was sceptical of Hegel's systematic ambitions, insisting that his own work was guided by detailed historical knowledge rather than philosophical principles, he too sought to explain the development of art as part of a larger process of cultural history. His best-known book, *The Civilization of the Renaissance in Italy* (1860), is as much concerned with the legal, political and financial structures of the Italian city-states as it is with art and literature.[42] Wölfflin accepts Burckhardt's claim that since artworks are shaped not only by the ideas of the artist, but also by the social and intellectual environment in which they are produced, the history of art cannot be reduced to the study of individual artists, no matter how significant their contribution might be. However, he points out that the analysis of cultural phenomena as reflections or manifestations of the 'world-outlook' of different historical periods runs the risk of losing what is specific to the visual arts. Art needs to be studied not only in relation to external social factors, but also in relation to internal patterns of influence. It is not enough to place artworks in their original social and historical context; we must also seek to uncover the 'inner development' of art as this changes over time.[43]

Wölfflin begins *Principles of Art History* by identifying two different 'roots' of style. The first, social or cultural root, branches into the

familiar categories of individual style, national style and period style. The study of each of these offers 'grateful tasks' to the descriptive art historian. What links them together is the assumption that art can be analysed in terms of expression, whether this be the expression of the temperament of the individual artist or of the spirit of a nation or an age. Wölfflin recognizes that this is a legitimate and valuable enquiry, as is the analysis of art in terms of its quality. However, he insists that these two possibilities do not exhaust the field. Alongside the social or cultural root of style, there is also a specifically 'visual root' that can be studied independently of other factors:

> This book is occupied with the most universal forms of representation. It does not analyse the beauty of Leonardo or Dürer but the element in which that beauty became manifest. It does not analyse the representation of nature according to its imitative content . . . but the mode of apprehension (*Auffassung*) which lies at the root of the representative arts in the various centuries.[44]

Wölfflin maintains that 'there can be discovered in the history of style a substratum of concepts referring to representation as such'.[45] These should be seen as *prior* to expression since they do not impose constraints on the expressive possibilities available to the artist. Rather, they provide the medium through which different expressive contents are first realized. The important point for us to note here is that Wölfflin's analysis of the fundamental concepts of art history is intended to take place at a level that *subtends* the distinction between individual and general style. He envisages 'a history of the development of occidental seeing, for which the variations in individual and national characteristics would cease to have any importance'.[46] Indeed, in the original foreword to the *Principles of Art History*, he entertained the possibility of an 'art history without names', which was to be exclusively concerned with transformations in the mode of representation without reference to individual artists or to the wider social context in which art was produced.[47]

Wölfflin's claim that 'vision has its own history' can be interpreted in both a strong and a weak sense.[48] Taken in its strong sense, Wölfflin is committed to the belief that human beings see the world in different ways and that it is possible to discern historical patterns of change or development in the 'forms' in which nature is seen. He even speaks of a 'development of the eye', referring not to physiological changes in the human body but to transformations in the way in which visual

phenomena are apprehended.[49] In its weaker sense, the claim is simply that different historical periods have produced different forms of representation. The former is a claim about human beings and their perception of the world; the latter is a claim about the configurational and relational properties of artworks. Wölfflin does not keep these two claims distinct, and it is frequently unclear whether he is describing forms of beholding or forms of depiction. Throughout the text, he moves interchangeably between 'forms of seeing' (*Sehformen*), 'forms of apprehension' (*Vorstellungsformen*) and 'forms of representation' (*Darstellungsformen*) without ever fully clarifying the relation between them.[50] Here I shall restrict my discussion to the weaker of the two claims, for this bears directly on our enquiry into the design properties of painting. However, it should be borne in mind that for Wölfflin – as for Goodman – there is a close connection between the diversity of 'ways of seeing' and the diversity of 'ways of picturing'. Both emphasize the degree of ordering and selectivity that is involved even in so-called ordinary perception; and both hold that there is no single 'standard of correctness' against which depiction can be measured since pictures can emphasize or disclose different aspects of visual experience.

As I have already indicated, Wölfflin presents his account of the fundamental concepts of art history through a close analysis of Western art of the sixteenth and seventeenth centuries, including not only painting, but also sculpture and architecture.[51] They consist of five pairs of contrasting concepts: linear and painterly, planimetric and recessional, closed form and open form, composite unity and fused unity, and absolute clarity and relative clarity. In each case, the first member of the pair is derived from a characteristic feature of the classic art of the High Renaissance, while the second derives from the freer art of the Baroque. Wölfflin concedes that from a strictly philosophical perspective this derivation must look merely 'adventitious'.[52] Not only is there no unifying principle that links the five pairs of concepts together, but he cannot be certain that there are not yet more concepts that await discovery. Nonetheless, he believes that by focusing on the underlying visual schemata rather than the expressive content of the art of his chosen period he has succeeded in identifying a set of formal possibilities that – with appropriate modification and extension – can also be used to characterize the art of other times and places. Wölfflin's claim for the universal relevance of his theory is based on a periodic model of historical change in which the same basic process repeats itself in ever-varying forms throughout the course of history. He maintains that the transition from

the first to the second member of each pair of concepts 'follows a natural logic, and cannot be reversed', likening the process to a stone rolling down a hillside that may vary its course but not its direction.[53] Once the movement from one set of properties to the other has worked itself out, a new cycle begins that obeys the same 'internal necessity'. An equally sweeping conception of history is to be found in the work of Wölfflin's contemporary, Alois Riegl, who describes the history of art as a single overarching movement from a 'haptic' or tactile to an increasingly 'optic' or subjective mode of vision.[54]

If Wölfflin's fundamental concepts are to be deployed outside of this deterministic model of history, we need to find an alternative means of establishing their validity. This requires that we reject not only his cyclical conception of historical change, but also his claim that there is a necessary pattern of development governing the transition from one form of representation to another. The most promising solution is to recast the concepts as relational categories that can appear in any order or configuration, without geographical or temporal restriction on their scope of application. On this view, it is only once the fundamental concepts are freed of all historical content that they can serve as tools for the analysis of pictorial style. This approach has been adopted by Andreas Eckl and Lambert Wiesing, both of whom offer a 'formal-logical' reconstruction of the five pairs of concepts.[55] Eckl takes his starting point from Wölfflin's observation that the fundamental concepts can be termed 'categories of intuition' (*Kategorien der Anschauung*) without risk of being confused with the categories that Kant had identified in his *Critique of Pure Reason*.[56] The comparison lies ready at hand, for Kant had argued that we do not simply receive data from the outside world, which we then combine through a variety of associative mechanisms, habits and conditioned responses. Rather, the mind makes an active contribution to objective knowledge by supplying the basic forms and categories through which experience is ordered. Eckl acknowledges that Wölfflin's five pairs of concepts are abstracted directly from experience, and thus cannot stand comparison with Kant's 'deduction' of the categories of the understanding. But, contrary to Wölfflin's own views, he contends that it is possible to provide a 'transcendental-philosophical grounding' of the fundamental concepts by demonstrating that they identify necessary conditions of the possibility of pictorial representation.[57]

Wiesing also argues that Wölfflin's five pairs of concepts can be reconstructed as transcendental rather than empirical conditions that any pictorial representation whatsoever must satisfy. However, he suggests

that the appropriate context for understanding Wölfflin's ideas is to be found in the post-Kantian tradition of formalist aesthetics. The key insight of this tradition is that 'the relation between forms is what is decisive about forms'.[58] By analysing a picture as a complex of relations its adherent seek to identify properties that belong to the picture rather than to what it represents. As Wiesing observes, formalist aesthetics 'is concerned with the question: what are the structural features of a representation that make the representation possible but do not themselves represent anything?'[59] Insofar as art historians such as Riegl and Wölfflin succeed in elucidating the 'logical' rather than the 'factual' conditions of visual representation, they can be said to have contributed to a '*transcendental* theory of the possibilities of making visible'.[60] Wiesing shows that the analysis of immanent pictorial relations – or what he terms the 'logic of depiction' – differs in important respects from the standard theory of logical relations that was worked out by Peirce and others in the nineteenth century. The categories of relational logic – transitivity, symmetry and reflexivity – provide a means of characterizing the *extension* of concepts, that is to say, the relations between the objects to which concepts refer, rather than *intensional* differences in the way in which objects are represented. Since pictorial representation allows the same objects to be depicted in a potentially infinite variety of ways, a further set of categories is needed to characterize the intensional properties that distinguish one representation from another. The formal logic of relations 'bypasses what is specifically aesthetic'.[61] Wölfflin's fundamental concepts of art history can be used to make good this deficit once it is recognized that they describe the formal possibilities that stand at the artist's disposal.

A LOGIC OF DEPICTION

With these considerations in mind, I now want to look closely at each of Wölfflin's five pairs of concepts, starting with linear and painterly. The basic distinction is between a clear presentation of forms through the use of line and the merging of forms into each other and into their environment through use of broader marks and patches. This is how Wölfflin describes the difference between the two styles:

> Linear style is the style of distinctness, plastically felt. The evenly firm and clear boundaries of solid objects gives the spectator a

feeling of security, as if he could move along them with his fingers . . . The painterly style, on the other hand, has more or less emancipated itself from things as they are. For it, there is no longer a continuous outline and the plastic surfaces are dissolved. Drawing and modelling no longer coincide with the underlying plastic form, but only give the visual semblance of the thing.[62]

In the first case, objects are presented as discrete and isolatable from one another, with their boundaries sharply defined; in the second, they are fused together so that it is no longer certain where one thing stops and something else begins. The characterization of the linear style as 'tactile' and the painterly style as 'visual' is clearly metaphorical, since both are modes of visual representation. Similarly, Wölfflin's identification of the painterly style as an art of 'semblance' and the linear style as a representation of things 'as they are' can only be understood in an extended sense. Nonetheless, the aptness of these descriptions quickly becomes apparent when we relate them to specific examples. Whereas Wölfflin has a large number of illustrations at his disposal, we shall have to restrict ourselves to just two. As a representative of the linear style I have chosen Dürer's *Self-Portrait with a Thistle*, 1493 (Plate 11), and as a representative of the painterly style Rembrandt's *Self-Portrait with Two Circles*, of 1661–62 (Plate 12).

Dürer's painting shows that the use of line to define forms is not restricted to the outline of objects but also provides a means of modelling the folds of cloth and the features of the face. We can see at once why Wölfflin likens the linear style to the movement of the hand as it feels along the body, for both give a sure sense of solidity and physical presence. The clarity of presentation allows everything to apprehended without difficulty. The spiky, angular leaves of the thistle – variously interpreted as a pledge of fidelity to the artist's fiancé and as an allusion to Christ's crown of thorns – accentuate the fineness of detail and draw attention downwards to the interlocking motif of the artist's hands in which each finger is separately articulated. The emphasis on what is solid and tangible is sustained through a strong, rhythmic line that both connects and distinguishes individual forms. If we turn from Dürer's self-portrait, painted at the age of 22, to Rembrandt's *Self-Portrait with Two Circles*, painted in the final years of his life, we can see that line no longer plays a central role and that even the contours of objects are left broken and indeterminate. The dominant ordering device is the deployment of light and shade or what Wölfflin terms a grouping into 'patches'

(*Fleckenerscheinungen*).[63] It is not merely that Rembrandt's handling of paint is broader and more vigorous, with a pronounced facture that allows the brushstrokes to remain visible even at a distance. Rather, the delineation of individual objects is subordinated to the realization of an overall visual impression in which forms are allowed to fuse and merge into one another. Whereas the linear style 'sharply distinguishes form from form . . . the painterly eye aims at that movement which passes over the sum of things'.[64] What matters is less the definition of the individual elements – whose precise shape remains elusive – than the totality of their relations. Rembrandt does not depict every detail of brocade or the exact pattern of the decorative embroidery but the appearance of the whole as it is revealed by the play of light, which both illuminates and obscures. Instead of the permanent and enduring, we are offered the transitory and indeterminate – a 'semblance' that is disclosed to subjective vision for a passing moment.

The second pair of concepts, planimetric and recessional, characterizes differences in the way in which the contents of a painting are ordered in relation to the picture plane. All painting involves recession, of course, but as the term suggests, a strictly planimetric composition is organized in strata that line up parallel to the surface of the picture, while a strongly recessional composition depreciates the plane, emphasizing the relation between the foreground and the background. We can make this distinction clear by comparing Bellini's *San Zaccaria Altarpiece* (Plate 4) with Tintoretto's *The Presentation of the Virgin* (Plate 13). Although Bellini opens up a fictive space behind the architectural frame that is sufficiently deep to hold the image of the enthroned Virgin and saints, he arranges the figures in three separate bands or strata. By aligning the contents of the painting with the picture plane, he creates a sense of order and repose: it is as if we were gazing into a world more regular and harmonious than our own that is nonetheless arranged for our contemplation. Tintoretto decisively rejects this mode of organization in his *Presentation of the Virgin* in favour of a dramatically recessional composition. We follow the pointing arm of the massive foreground figure up a precipitously diminishing staircase to the figure of the Virgin, who is dwarfed by her surroundings. The resulting juxtapositions of scale create a powerful sense of energy and movement. The near-station point of the viewer, the exaggerated foreground and the use of violent foreshortening all contribute to the vertiginous recession into depth.

Wölfflin observes that all successful art displays necessity, the sense that nothing can be changed without loss, but is at is must be.[65]

The purpose of his third pair of concepts, closed form and open form, is to show that this can be achieved in different ways. Closed form is characterized by a stable equilibrium between the parts, realized through a pronounced use of verticals and horizontals, and a balance around the middle axis. Once again, Bellini's *San Zaccaria Altarpiece* provides us with a good example. The emphatically symmetrical composition, with the Virgin and child at the centre, is supported by an underlying geometry that establishes exact relations between each of the figures and the surrounding architectural structure. Open form, by contrast, avoids the sense of regularity and order that is produced by such visible 'scaffolding' in favour of a more dynamic and seemingly adventitious mode of presentation. Whereas closed form 'makes of the picture a self-contained entity, pointing everywhere back to itself', open form 'everywhere points beyond itself and purposely looks limitless, although, of course, secret limits continue to exist.'[66] Wölfflin borrows from mechanics the idea of oscillating or labile balance to describe the achievement of a freer sense of order. The *Presentation of the Virgin* is no less structured than Bellini's altarpiece, but rather than placing the figures in a clear relation to the edge of the picture, Tintoretto allows it to cut through the motif as if we were looking at 'a piece cut haphazard out of the visible world'.[67]

The final two pairs of concepts are more resistant to summary, at least in part because they elaborate on, and further extend, the distinctions we have already discussed. Wölfflin uses the term 'composite unity' to describe an articulated compositional structure in which each element retains its independent function while also remaining a necessary part of the whole. It is as if the parts could be isolated from one another and still continue to be recognizable. With the transition to 'fused unity' this independence is abandoned in favour of the dominating total motif. A painting in a strongly linear style such as Dürer's *Self-Portrait with a Thistle* allows us to identify individual objects and parts of objects with great clarity. But if we try to focus on the objects depicted in Rembrandt's *Self-Portrait with Two Circles*, such as the painter's hat or his palette and brushes, they seem to recede from our grasp, rapidly dissolving into streaks and marks. The same is true of the painter's features; we can no longer trace the structure of the jaw or the angle of the nose as we can with Dürer, though there is no loss of vividness or power of expression. Whereas the classic style aims at 'an exhaustive revelation of form', the Baroque style, wherever possible, will leave something to be guessed at, emphasizing the indeterminate and changing character of appearances.[68] The parallelism of the table and the picture plane in Leonardo's *Last*

Supper obeys the requirements of a planimetric composition; but the seating of the figures along just one side is also a pictorial device that allows the spectator to take in the relations between the different groups without them blocking one another from view. Everything is displayed with maximum clarity, including all twenty-six hands, not one of which is allowed to drop below the level of the table.[69] Tintoretto, in contrast, deliberately obscures the faces of some of his protagonists, delighting in the use of strong light and shadow. The 'relative clarity' of the Baroque must still be comprehensible, but the ordering of the scene should appear an 'accidental by-product' rather than something that has been purposefully arranged in the interests of the viewer.[70]

If Wölfflin's claim to have identified the 'most general forms of representation' is to be justified without recourse to his periodic account of history, we need to show that he has succeeded in elucidating properties that characterize pictorial representation as such rather than specific features of the art of the High Renaissance and the Baroque. Here I shall focus on Wiesing's interpretation, which recommends itself on the grounds of elegance and simplicity. However, I shall follow Eckl in reducing Wölfflin's five pairs of concepts to three; since the last two pairs do not represent independent structural principles they fall to Ockham's razor.[71] The key to Wiesing's reconstruction of the fundamental concepts as a formal 'logic of depiction' is the recognition that each of the pairs demarcates a basic polarity within which any picture whatsoever can be located. On this interpretation, the fundamental concepts are 'limit values' (*Grenzwerte*): they identify notional final points on a scale of possibilities. Reduced to its essentials, the distinction between painterly and linear modes of representation is a distinction between different types of transition from one mark to another on the picture surface. Whereas painterly transitions are merging and fluid, linear transitions are differentiated and distinct. Since all pictorial representation is created by means of marks of some kind, the relation between the marks must be locatable somewhere on a scale between the pole of the purely linear and the pole of the purely painterly. These are notional or ideal types, for a purely linear picture would be devoid of any continuity between individual marks and a purely painterly picture would be fully amorphous.[72] However, there are innumerable intermediate possibilities: every picture achieves its own, individual 'balance' (*Ausgleich*) between these two extremes.[73]

The second pair of concepts, planimetric and recessional, provides a means of characterizing two different ways in which the contents of a

painting can be ordered in relation to the picture plane. On Wiesing's reconstruction, the opposition planimetric-recessional demarcates a further relational property of pictures: the relation between surface and depth. Once again two extremes are possible: depicted objects can be placed alongside one another so that they are arrayed across the picture plane or they can be placed behind one another so that they recede into depth. All pictorial representation must take up a position somewhere between these two poles. Wiesing notes that in this respect images differ fundamentally from language: unlike linguistic description, visual representation is necessarily spatial. We can say 'Stan and Ollie are standing there' without specifying the spatial relationship of Stan to Ollie. But it is not possible to depict two figures without situating them somewhere on the spectrum of pure alongside one another (plane) and pure behind one another (depth).[74] The third pair of concepts, closed form and open form, describes the relation between the contents of a picture and its physical boundary or frame. A fully closed ordering would issue in a symmetrical and strictly regular arrangement, while a fully open ordering would be accidental or arbitrary, without any acknowledgement of the shape of the support or the need to establish pictorial unity. All visual representation must be locatable somewhere on the scale between a maximally ordered and a maximally free relation between the parts. Taken together, the three pairs of concepts identify 'transcendental limits' or what Wiesing terms the '*a priori* formal properties of a representation'.[75] It is possible that further pairs of concepts can be discovered: the claim is not that these three pairs of concepts are exhaustive, but that the logic of depiction involves *at least* the configurational features that they describe. They provide the minimum constituents of a formal logic of depiction.

WÖLFFLIN'S HISTORY OF VISION

The reconstruction of the fundamental concepts of art history as relational categories frees them of any residual dependency on a cyclical theory of history. In principle, they can be employed in any order whatsoever without prior constraints as to which of each pair should take precedence over the other. Moreover, although they provide a set of tools for the analysis of pictorial style they are distinct from other general style terms in that they do not identify a particular school, region or period – and thus are without restriction in time or place. The question I now want to consider is whether stylistic analysis carried out on the basis of these

concepts can avoid the relativism and descriptivism that Wollheim believes to be an inevitable consequence of any theory that that seeks to characterize the specifically visual properties of artworks rather than the underlying psychological and physical processes through which an artist comes to paint as he does. The distinction between a generative and a taxonomic conception of style rests on the claim that there is an 'ineliminable gap' between the two: whereas a 'style description' reconstructs something that is real and causally effective, the provision of a 'stylistic description' is an empty project of classification, subject to the changing interests of each new generation of critics and art historians.[76]

According to the relativization thesis, stylistic descriptions can be rewritten at will: 'at different moments, there will be different historical interests, different contemporary concerns, that will make different characteristics, though still a mixed lot, seem distinctive of a particular stretch of art and, as this happens, the characteristics associated with a given general style will alter.'[77] The foregoing reconstruction has shown, however, that it is possible to identify necessary structural features that any pictorial representation must possess. Elucidation of these features provides an objective basis for the stylistic analysis of works of visual art that is independent of transient interests and concerns. Rather than sorting artworks into a set of categories – labelled linear, painterly, planimetric and so forth – the fundamental concepts of art history demarcate a scale of possibilities that allow the configurational properties of artworks to be analysed in relation to one other. The characterization of an artwork as more or less linear, or more or less painterly, depends on the term of comparison. As Wölfflin points out, 'It is throughout a question of relative judgement. Compared with one style, the next can be called painterly.'[78] But such judgments are relative to the artworks that have been selected, not to the subjective standpoint of the viewer. The fundamental concepts of art history provide a means of analysing properties that are *intrinsic* to works of visual art. Wollheim's restriction of explanatory force to an intentionalist account of pictorial meaning is more difficult to counter, since much depends on how on what is allowed to count as an explanation. However, it is clear that the comparative analysis of artworks is not reductively 'taxonomic' in the sense in which he uses this term. Insofar as the fundamental concepts of art history enable us to understand the structure of an artwork as the result of a choice between a range of alternatives they also fulfil an explanatory function: they disclose the abstract or formal possibilities that the medium of visual representation makes available to the artist.

In practice, of course, an abstract or formal possibility is not yet a concrete possibility. It would be anachronistic to suggest that an artist working in the fifteenth century could have employed compositional structures that were first developed in the sixteenth century. Wölfflin repeatedly stresses that the linear style was an historical achievement and that the 'solution' to the problem of pictorial order that characterizes classic art – the identification of plastic limits through a firm and even line, the consistent acknowledgement of the plane, a balanced mode of distribution, the construction of the picture as a self-contained entity, and the clear and harmonious arrangement of the parts in relation to the central axis and the framing edge – was only arrived at through a lengthy process of discovery and experimentation. Similarly, Wölfflin argues that it was only after the consolidation of the classic style that artists could seek to find a way to overcome its restrictions. Many of the innovative features of Baroque art – the use of a dynamic recessional composition, the release of spatial energy through foreshortening and unusual vantage points, the integration of the parts into a single, dominating motif, and the emphasis on the momentary rather than the static and enduring – arose from the conscious rejection of a mode of pictorial organization that had come to be seen as too strongly willed, and hence as artificial and lacking in vitality.

Wiesing's 'transcendental' reconstruction of the fundamental concepts is potentially misleading, since it fails to acknowledge that there are historical constraints on the range of possibilities that are available to artists in different times and places. It is clear that artists cannot learn from or reject modes of pictorial composition they have never encountered.[79] Just as Leonardo could respond to Giotto's fresco of the Last Supper when painting his own version of the subject, but not the other way round, so the process of assimilation and rejection that characterizes the relation between the High Renaissance and the Baroque can only be traced in a single direction. We are now in a position to understand why Wölfflin speaks of a 'history of vision', even if the internal history of art cannot be isolated from broader cultural and social changes in the way in which he sometimes suggests. His much-quoted claim that 'Not everything is possible at all times' serves to identify the limits of a strictly formal-logical approach.[80] Although the fundamental concepts allow us to analyse the configurational properties of artworks – and hence open up to investigation the constituent features of visual as opposed to verbal forms of representation – their explanatory potential can be realized only when they are employed in the appropriate historical context.

A defence of Wölfflin's position cannot be complete without considering Gombrich's criticism that the five pairs of fundamental concepts do not provide a neutral descriptive framework for analysing structural differences between artworks because they contain a hidden norm. Gombrich challenges the idea that art historians can proceed in a manner akin to that of botanists or entomologists. He points out that unlike the categories used by natural scientists most stylistic labels were coined as terms of criticism or opprobrium. If we forget the origin of these terms, and succumb to the illusion that they identify 'natural classes', we run the risk of ignoring their evaluative character. Gombrich claims that the morphological approach to art history culminates in Wölfflin's *Principles of Art History*, which purports to equip the reader with a purely descriptive set of categories but is guided all along by a 'normative idea'. This idea, which Gombrich identifies with 'Vasari's idea of perfection', is already familiar to us from our discussion of *Art and Illusion* in chapter 3: it 'rest on a firm conviction about the purpose of art and the means of achieving this end. The purpose . . . is the plausible evocation of a sacred or at least significant story in all its naturalistic and psychological detail, the means the mastery of representation'.[81] Gombrich endorses Vasari's claim that the classic style of the High Renaissance represents an 'optimum solution beyond which one cannot go with impunity'. Whether covertly – as in the case of Wölfflin – or explicitly, all other styles are measured against this ideal: the various different style labels are 'only a series of masks for two categories, the classical and the non-classical'.[82] What this shows, according to Gombrich, is that:

> there are limits to historical relativism. Such a morphology of styles as we have we owe to the stability and identifiablility of a classical solution. There is something like an 'essence' of the classic that permits us to plot other works of art at a variable distance from this central point.[83]

Wölfflin explicitly rejects this view. It is not a 'magic trick' or a careless omission that leads him to give equal weight to the two poles of his schema. Rather than giving priority to either the Classical or the Baroque, he claims that there is no overarching normative standard against which they can be measured: they are 'two conceptions of the world, differently orientated in taste and in their interest in the world, and yet each capable of giving a perfect picture of visible things'.[84] Although the painterly style is the later of the two, 'it is not a higher stage in the solution of one

problem of the imitation of nature, but a totally different solution'.[85] Contrary to the tradition of thought that extends from Vasari to Gombrich, he contends that the historical 'transformations' of art cannot be understood primarily in terms of progress in the imitation of nature. The differences between Dürer and Rembrandt, or between Bellini and Tintoretto, do not derive from a greater technical facility in the 'mastery of representation', but from changes in the way in which nature is seen and described. He employs the term 'decorative' to describe non-mimetic features of art that can vary independently of what is depicted. Each of his five pairs of concepts have both an imitative and a decorative dimension: they not only allow the artist to represent different aspects of the visual world, they also provide a means of ordering the picture in response to a 'new feeling for beauty'. Wölfflin's central insight is that differences in the design features of works of art cannot be captured in terms of greater or lesser mimetic accuracy since 'even the most perfect imitation of natural appearances is still infinitely different from reality'.[86] A genuinely pluralistic account of art must be able to accommodate differences in both the 'what' and the 'how' of representation. Although the ways of seeing and picturing are 'many and various', the fundamental concepts of art history provide at least a minimal objective basis for the comparative analysis of the non-representational features of artworks.

CHAPTER 6

MODERNISM AND THE AVANT-GARDE

THE LIMITS OF FORMALISM

We should remember that a picture – before being a war horse, a nude woman, or telling some other story – is essentially a flat surface covered with colours arranged in a particular pattern.

Maurice Denis, 1890

Composition is the art of arranging in a decorative manner the diverse elements at the painter's command to express his feelings. In a picture every part will be visible and will play its appointed role, whether it be principal or secondary. Everything that is not useful in a picture is, it follows, harmful. A work of art must be harmonious in its entirety . . .

Henri Matisse, 1908

The representative element in a work of art may or may not be harmful; always it is irrelevant. For to appreciate a work of art we need bring with us nothing from life, no knowledge of its ideas and affairs, no familiarity with its emotions. Art transports us from a world of man's activity to a world of aesthetic exaltation.

Clive Bell, 1914.[1]

The philosophy of art normally takes place at a safe distance from the artistic fray, occupying an elevated standpoint from which it can oversee rival positions without risk of being drawn into the conflict. As these three quotations make clear, however, the emergence of a full-blown formalist theory of painting is closely tied to developments in avant-garde art practice in the late nineteenth and early twentieth centuries.[2] The articulation of formalism as a theoretical doctrine by Clive Bell and Roger Fry was part of a campaign to persuade an insular and sceptical British public of the significance of recent French art, spearheaded by the organization of two large-scale exhibitions of modernist painting and

sculpture at the Grafton Galleries in London in November 1910 and December 1912. The first exhibition, entitled 'Manet and the Post-Impressionists', featured the work of Cézanne, Van Gogh and Gauguin. The author of the catalogue introduction claimed that these artists had rejected the residual naturalism that characterized Impressionism in favour of a new emphasis on pictorial structure and design; rather than adopting a 'passive attitude towards the appearance of things', the Post-Impressionists were 'exploring and expressing the emotional significance which lies in things'.[3] In the catalogue to the second exhibition, which gave greater prominence to the work of Matisse and Picasso, Fry explained that the modern movement 'implied a reconsideration of the very purpose and aim as well as the methods of pictorial and plastic art . . . these artists do not seek to give what can, after all, be but a pale reflex of actual appearance, but to arouse the conviction of a new and definite reality.'[4] Through their defence of formalism, Fry and Bell sought not merely to legitimize the critical priorities of the artists whose work they admired, but also to provide a universally relevant theory of art. Both Fry's theoretical essays and Bell's book *Art*, published in 1914, are thus at once polemical interventions in defence of modernist art and a contribution to aesthetics.

The second Post-Impressionist exhibition was better received than the first, and although Fry and Bell did not win full acceptance for the art they promoted they did succeed in generating extensive debate about the ideas on which it was based.[5] Bell, in particular, possessed a gift for ringing and pugnacious formulations, whose effectiveness as propaganda was often bought at the expense of distortion or over-simplification. Views that had been expressed in a more tentative and exploratory form by artists and critics on the Continent were hardened into a doctrine that could easily be grasped. Bell begins *Art* by declaring that the central task of aesthetics is to identify the 'essential' feature that distinguishes art-works from other objects and artefacts, for 'either all works of visual art have some common quality, or when we speak of "works of art" we gibber.'[6] He then goes on to formulate his 'aesthetic hypothesis':

What quality is common to Sta. Sophia and the windows at Chartres, Mexican sculpture, a Persian bowl, Chinese carpets, Giotto's frescos at Padua, and the masterpieces of Poussin, Piero della Francesca, and Cézanne? Only one answer seems possible – significant form. In each, lines and colours combined in a particular way, certain forms and relations of forms, stir our aesthetic emotions. There relations

and combinations of lines and colours, these aesthetically moving forms, I call 'Significant Form'; and 'Significant Form' is the one quality common to all works of visual art.[7]

The principal constituents of Bell's theory of art are all to be found in this short passage. The identifying feature of works of visual art is their capacity to arouse in the viewer a unique type of response, which he terms 'aesthetic emotion'. Aesthetic emotions are distinct both from the emotions we feel in our everyday lives and from any feelings that might be awakened by an artwork's depicted content or subject matter; they are prompted exclusively by its formal properties, that is to say, by those non-representational relations of line, shape and colour that he designates as 'significant form'. Bell's argument is notoriously circular: he characterizes art in terms of its power to awaken aesthetic emotion, aesthetic emotion as a response to significant form, and significant form as the property of art that arouses aesthetic emotion. Having thus closed the circuit, he rules out of consideration the 'representative element', which he dismisses as, at best, irrelevant to genuine aesthetic appreciation. To use line and colour 'to recount anecdotes, suggest ideas, and indicate the customs and manners of an age' is to meet a demand for illustration that has been rendered otiose by the 'perfection of photographic processes and of the cinematograph'.[8] A painting may be admired for the information it conveys, its psychological associations, or its skilful technique, but this is not to value it as art. Aesthetic emotion allows the viewer to enter 'a world with an intense and peculiar significance of its own . . . unrelated to the significance of life'.[9]

Fry's position is more equivocal; in particular, he seems to have been unwilling to accept Bell's claim that representational content is entirely irrelevant to the value we place on art.[10] In the 'Retrospect' added to his first collection of essays, *Vision and Design*, he envisages a spectator who, when looking at Raphael's *Transfiguration* (1516–20, Pinacoteca Vaticana, Vatican City), is 'so absorbed in purely formal relations as to be indifferent even to [the] aspect of the design as representation'.[11] Fry concedes that the ability to concentrate exclusively on the formal meaning of a work of art is not only 'extremely rare' but also unduly restrictive insofar as it renders the viewer 'entirely blind to all the overtones and associations of a picture like the *Transfiguration*'.[12] Most viewers – including Fry himself, as he admits – respond not only to the 'formal design' of an artwork but also to its 'dramatic idea'. Nonetheless, he maintains that the fusion of these two 'sets of emotion', whereby each

reinforces and heightens the other, is merely apparent. Closer analysis of the viewer's mental state reveals that it is possible 'to isolate the elusive element of the pure aesthetic reaction from the compounds in which it occurs'. Once we recognize that it is possible 'to be moved by the pure contemplation of the spatial relations of plastic volumes', we can distinguish between the various ancillary emotions that are aroused by the work's subject matter and a properly aesthetic reaction to its formal properties.[13]

In January and February 1910, the same year as the first Post-Impressionist Exhibition, Fry translated an article on Cézanne by the French painter and theorist Maurice Denis for publication in the *Burlington Magazine*.[14] In his 'Introductory note', he described the 'new conception of art' as one in which 'the decorative elements preponderate at the expense of the representative', observing that the 'great and original genius . . . who really started this movement, the most fruitful and promising of modern times, was Cézanne'.[15] This assessment was echoed by Bell, who bluntly declared that 'Cézanne is the full-stop between Impressionism and the contemporary movement.'[16] Although in some measure based on a misunderstanding of Cézanne's ideas about art and his working practice – which remained indebted to the Impressionist project of registering the artist's sensations before nature through the application of individual touches of colour – Fry came to believe that his paintings were held together by 'a kind of abstract system of plastic rhythms'.[17] Taken out of context, Cézanne's advice to the painter Émile Bernard to 'treat nature by means of the cylinder, the sphere, the cone', appeared to support a formalist reading of works such as *Woman with a Coffee Pot* (Plate 14), with its simplified and strongly volumetric forms set against a shallow, patterned ground.[18] The privileged position accorded to Cézanne in the evolution of modernism was based on the claim that he had established the priority of the 'plastic' and 'decorative' dimension of art over the need for mimetic accuracy. The apparent distortions and simplifications, and the unfinished or sketch-like quality of some of his work, could be interpreted as sacrifices made in pursuit of greater pictorial unity and expressive power.

Writing in 1917, Fry summarized the 'revolution' that Cézanne had inaugurated as 'the re-establishment of purely aesthetic criteria in place of conformity to appearance – the rediscovery of the principles of structural design and harmony'.[19] Without going so far as Bell, who describes the period from Giotto to Leonardo as 'a long, and, at times, almost imperceptible fall', Fry contends that the pursuit of verisimilitude and

technical virtuosity for its own sake, which had reached its apogee in the Renaissance, had led to a neglect of the 'ideas of formal design . . . in the fervid pursuit of naturalistic representation'.[20] For both thinkers, rejection of the Vasarian narrative of the progressive 'conquest of appearances' permitted a re-evaluation not only of pre-Renaissance Italian art, including the work of so-called 'primitives' such as Cimabue and Duccio, but also the art of Byzantium and other, non-Western cultures. Post-Impressionism could thus be understood as a return to purely pictorial values that had been neglected or occluded by the drive towards naturalism. In Bell's memorable phrase, the Post-Impressionists 'shake hands across the ages . . . with every vital movement that has struggled into existence since the arts began'.[21] For all its apparent radicalism, Post-Impressionism maintains continuity with the great art of the past, whose 'essential quality' remains constant, irrespective of its time and place of origin; a painting by Cézanne moves us in the same way as a Persian bowl or a Chinese carpet since it is 'significant form' rather than depicted content that is the source of our properly aesthetic responses.

There are a number of features in common between the position defended by Fry and Bell and the views of Heinrich Wölfflin, discussed in the previous chapter.[22] Wölfflin can also be characterized as a formalist insofar as his account of the 'inner history of art' rests on a close analysis of differences in the internal structure and ordering of artworks, rather than, say, the study of workshop practices and the development of new techniques and materials, or an investigation into the wider social, economic and political contexts in which art is made and appreciated. Moreover, the emphasis that he places on the 'decorative' dimension of the visual arts might be thought to parallel the formalist claim that line, shape and colour are to be valued as independent pictorial elements. As we have seen, however, Wölfflin is primarily concerned with form as a means of articulating content: stylistic analysis allows us to discover how artists have utilized the resources as their disposal to give unity and coherence to their subject, whether this be a complex narrative or an isolated motif. Puttfarken rightly observes that in his descriptions of individual paintings Wölfflin 'fully acknowledged the interaction of formal arrangement and narrative meaning'.[23]

Rather than isolating form from content, Wölfflin seeks to show that the specifically visual meaning of a work of art depends on the relation between its representational and configurational features.[24] He contends that there are general principles governing the formal organization of artworks that can be analysed independently of what is

represented, not that form has independent value. Equally important, although he rejects the presuppositions behind Vasari's account of artistic progress – on the grounds that the development of art cannot be understood along the single axis of the imitation of nature – he does not seek to assert the priority of the 'decorative' over the 'imitative'. Wölfflin's theory of art is both pluralistic and value-neutral, accommodating a genuine diversity of solutions that satisfy different goals and interests. By contrast, Fry and Bell defend a strongly normative theory: not only are artworks to be valued primarily for their formal properties, but greater value is to be placed on those artworks that prioritize form over content.[25]

The formalist thesis that the artistic value of a representational painting derives exclusively from the internal relation between its formal elements and that what is depicted therefore has little or no role to play in aesthetic appreciation is exposed to a number of powerful counter-arguments. First, as Fry recognizes, in practice it is extremely difficult to abstract from the various ideas and associations that are prompted by a painting's subject matter; it is impossible to be certain in any particular instance whether and to what extent we are responding to an artwork's 'significant form'. Second, the thesis is at odds with what we know about the history of art, making it hard to understand why artists and patrons have devoted so much time and attention to the meaning of what is depicted rather than focusing exclusively on abstract spatial and coloured relations.[26] Finally, and most tellingly, the thesis fails to acknowledge that in the vast majority of cases appreciation of the formal properties of an artwork is inseparable from recognition of its representational content. Consider, for example, Tintoretto's *Presentation of the Virgin* (Plate 13). When looking at the large female figure in the foreground, we do not see an abstract form and a woman with an extended arm, as if these were two discrete entities; the visual excitement of the painting, which Wölfflin describes as 'bursting with spatial energy', depends on the direction of her gesture, with its dramatic movement into depth.[27] A more difficult case is presented by Cézanne's *Woman with a Coffee Pot*, whose resolutely planimetric composition seems designed to accentuate the correspondence between the upright cylindrical shapes of the percolator and the cup and the simplified form of the human figure. Nonetheless, to view the painting as a study in 'significant form' is to overlook its effectiveness as a portrait and thus to lose sight of Cézanne's sustaining interest in the contrast between the physical presence of the sitter and the inanimate objects that surround her. Appreciation of a painting's formal or plastic qualities and recognition of its

representational content are not independent activities that can be isolated and combined at will, for the pleasure of looking at a painting derives at least in part from the interplay of its representational and configurational aspects.

Given the force of these of objections, most philosophers agree that formalism fails as a theory of art. Budd states the consensus view when he observes that this 'counter-intuitive' doctrine 'not only lacks any plausible supporting arguments . . . it is flawed both internally and externally.'[28] One last ditch strategy, pursued by Nick Zangwill, has been to undertake a 'tactical retreat' in order to 'find and secure the truth in formalism'.[29] Zangwill's moderate formalist holds that 'while *some* aesthetic properties of works of art are formal, others are not' and that although most works of art have non-formal aesthetic properties 'there are *some* works of art that *only* have formal properties', such as instrumental music, and, in the field of visual art, fully abstract painting and sculpture.[30] Zangwill's approach is neatly captured in his reworking of Bell's declaration that 'To appreciate a work of art we need bring with us nothing but a sense of form and colour and a knowledge of three-dimensional space.'[31] He maintains that all we need to do is delete the 'nothing but' to produce a claim that is 'almost always true'.[32] Although unimpeachable, this emendation drains formalism of its philosophical interest for it reduces to the platitude that we appreciate art for its formal properties as well as for its content or subject matter. In the absence of any account of the *relation* between these two elements – such as Wollheim, Wölfflin and others have sought to provide – the theory is wholly uninformative. Zangwill's suggestion that an exception needs to be made for the specific case of abstract art is more persuasive, but, once again, without an account of the reasons behind the emergence of non-objective painting, or of why it should be accorded special value, the theory tells us nothing more than that abstract art pleases, if it does, through its formal properties alone.

Formalism stands or falls as a theory that encompasses both representational and abstract works of art, for its claim on our attention rests on the assertion that art's value as illustration and its value as plastic design are in conflict. What I shall term 'strong formalism' not only introduces an unwarranted bifurcation of pictorial value into illustration and plastic design, it holds that these two values are antithetical: whereas the first belongs to the domain of everyday needs and experiences, the second lifts us into a higher, imaginative realm that is detached from 'actual life and its practical utilities'.[33] Bell expresses this idea *in nuce* when he

claims that: 'Every sacrifice made to representation is something stolen from art.'[34] Fry entertained the possibility that, taken to its logical extreme, the 'method' that he discerned in the work of the Post-Impressionists would result in 'the attempt to give up all resemblance to natural form, and to create a purely abstract language of form – a visual music', but he insisted that the success of this project could be decided only on the basis of experience.[35] Like Bell, he intended his ideas to encompass a wide range of objects and artefacts, from the 'art of the bushmen' and 'ancient American art' through to the most recent experiments by contemporary artists.[36] Further to the criticism of Zangwill, above, the restriction of formalism to abstract art does more than limit its reach: it also deprives it of its rationale.

Bell later came to believe that although *Art* had been useful in overcoming the misconceptions and prejudices surrounding the work of Cézanne and other Post-Impressionist artists, its central arguments were deeply flawed. In the preface to the 1949 edition he describes it as little more than a historical document, claiming that if it 'has any value for future generations it will be as a record of what people like myself were thinking in the years before the first War'.[37] It is tempting to concur with this conclusion and to dismiss formalism as an historical phenomenon of limited relevance to philosophy. I would like to suggest, however, that the main problem with the theory of art put forward by Fry and Bell is that it is *insufficiently* historical. In their desire to establish the continuity of Post-Impressionism with the art of other times and places they overlook the fact that it possesses certain distinctive characteristics that make it unlike earlier forms of art practice. In particular, they fail to acknowledge that a commitment to at least some of the tenets of formalism played an important role in the self-understanding of the artists whose work they promoted. Both thinkers characterize significant form as a permanent and timeless quality that is as central to the art of Byzantium and the Italian 'primitives' as it is to the work of Cézanne and Picasso. They thereby downplay the oppositional character of the avant-garde in favour of an appeal to 'universal' values. The identification of an irresolvable conflict between the formal or decorative unity of a work of art and the requirements of verisimilitude is unpersuasive as a global thesis. However, once correctly interpreted as a historically specific response to the pressures under which artists found themselves working in the late nineteenth and early twentieth centuries – including the pervasiveness of photography and the perceived exhaustion of academic painting – it acquires considerable explanatory potential.

For this reason, I now want to examine the more sophisticated version of formalism put forward by the American art critic and theorist Clement Greenberg. I aim to show that Greenberg's theory of modernism as a self-critical process makes good the historical deficit that vitiates the formalism of Fry and Bell and that his writings offer an alternative framework for understanding the significance of non-objective or fully abstract art. Greenberg's ideas are rarely discussed by philosophers, who either neglect his work entirely or present a simplified and distorted summary of his views.[38] This problem is compounded by a tendency to focus exclusively on 'Modernist Painting', which remains the most widely read and anthologized of his writings. By the time he wrote this essay, which was originally given as a radio broadcast in 1960, his identification of a retrospective 'logic of development' had become increasingly doctrinaire and inflexible, serving as means of criticizing or excluding tendencies that did not fit with his account. The so-called 'crisis of modernism' in the 1960s, and the accompanying reaction against the dominance of Greenberg's views, have tended to obscure the originality of his early writings. I therefore begin by discussing what I see as the strengths of his position, drawing on his essays from the late 1930s onwards as a means of recovering the key insights behind 'Modernist Painting'. I shall argue that Greenberg's historicized variant of formalism makes two important advances over the 'strong formalism' defended by Fry and Bell and that it therefore deserves independent consideration despite the well-founded objections to which it is expose.

GREENBERG'S THEORY OF MODERNISM

In his first major essay, 'Avant-garde and kitsch', published in 1939, Greenberg set himself the task of explaining how it is that 'a part of Western bourgeois culture has produced something unheard of heretofore: – avant-garde culture'.[39] The concept of an artistic avant-garde, which attempts 'to wrest tradition away from a conformism that is about to overpower it', can be traced back to the early nineteenth century. The term was coined in the 1820s by the French socialist Saint-Simon, who used it to characterize art's place in the vanguard of social change.[40] The identification of advanced art practice with opposition to mainstream culture was consolidated in the mid-nineteenth century by Realist artists such as Gustave Courbet, who combined technical radicalism with explicit social critique. Even when artists turned away from the task of

directly picturing the conditions of modern social existence – such as for example in the Symbolist movement that flourished in *fin-de-siècle* Europe – formal experimentation continued to retain its transgressive and subversive connotations. Despite the absence of socially significant subject matter, Cubism, Expressionism and, of course Abstraction, were all seen as 'radical' movements that challenged the prevailing orthodoxy by asserting the independence of art from external constraints. Claims for the autonomy of art sat uneasily with claims for its efficacy as an agent of social change, however, resulting in periodic attempts to restore the connection between art and life, either through a return to more overt forms of picturing or by exploring alternative modes of engagement, such as those pioneered by Dada and Constructivism.

Greenberg's innovative response to this problem was to argue that the advent of the avant-garde was made possible by a 'superior consciousness of history – more precisely, the appearance of a new kind of criticism of society, an historical criticism'.[41] 'Avant-garde and kitsch' is ostensibly concerned with the distinction between high and low culture, but the essay's explanatory power derives from a second, more far-reaching distinction between the dynamism of the avant-garde and the decline of Renaissance naturalism in the late eighteenth and nineteenth centuries into 'a motionless Alexandrianism' in which 'the really important issues are left untouched because they involve controversy . . . all larger questions being decided by the precedent of the old masters'.[42] The result is academicism: the same themes are 'mechanically varied in a hundred different works, and yet nothing new is produced'. With this diagnosis in place, Greenberg is able to advance his claim that 'the true and most important function of the avant-garde was not to "experiment" but to find a path along which it would be possible to keep culture *moving*.'[43] Since this could not be achieved through the traditional methods of picturing, avant-garde artists turned their attention away from 'the subject matter of common experience' towards the 'disciplines and processes' of art itself. In a much cited passage, Greenberg observes that:

Picasso, Braque, Mondrian, Miró, Kandinsky, Brancusi, even Klee, Matisse and Cézanne derive their chief inspiration from the medium they work in. The excitement of their art seems to lie most of all in its pure preoccupation with the invention and arrangement of spaces, surfaces, shapes, colours, etc., to the exclusion of whatever is not necessarily implicated in these factors.[44]

Apart from its restriction of to a select group of artists, this variant of formalism is remarkably similar to that defended by Fry and Bell. The key difference lies in Greenberg's attempt to provide a historical justification for the phenomenon he describes.

The ideas that Greenberg had sketched out in 'Avant-garde and kitsch' were developed in greater detail the following year in an essay entitled 'Towards a newer Laocoon'. Here, for the first time, he explicitly seeks to explain the 'present supremacy' of abstract art. This qualification is important, for he insists that 'there is nothing in the nature of abstract art which compels it to be so': if at the time of writing it is abstract rather than figurative art that meets the most advanced standards of taste, this is a result of its position in a particular tradition of art.[45] The title of the essay refers to a book by the eighteenth-century German philosopher, Gotthold Lessing, entitled *Laocoon: An Essay on the Limits of Poetry and Painting*.[46] Drawing on Lessing's analysis of the problems that arise when one art form takes on the characteristic effects that are proper to another, Greenberg claims that the rise of literature to the status of a dominant art in the post-Renaissance period had resulted in a progressive 'confusion of the arts'. In seeking to imitate the narrative and anecdotal functions of literature, emphasis came to be placed on subject matter at the expense of the medium, which was treated as 'a regrettable if necessary physical obstacle between the artist and his audience'.[47] Without hesitating to identify the artists he has in mind – Vernet, Gérome, Leighton, Watts, Moreau, Böcklin, the Pre-Raphaelites – Greenberg observes that 'it was not realistic imitation in itself that did the damage so much as realistic illusion in the service of sentimental and declamatory literature':

> Everything depends on the anecdote or message. The painted picture occurs in blank, indeterminate space; it just happens to be on a square of canvas and inside a frame. It might just as well have been breathed on air or formed out of plasma . . . Everything contributes to the denial of the medium, as if the artist were ashamed to admit that he had actually painted his picture instead of dreaming it forth.[48]

We are now in a position to draw together the main strands of Greenberg's argument. The avant-garde's preoccupation with formal problems is not a matter of art-for-art's sake – an apolitical withdrawal into aestheticism – but a 'salutary reaction' against the confusion of the arts,

and thus an attempt to preserve painting by delimiting its field of activity. Similar developments are also to be found in the other arts, but the consequences for painting, according to Greenberg, have been particularly complex and rewarding. Each art is engaged in a struggle to establish its 'unique and proper area of competence', a struggle that takes place almost entirely through the progressive clarification of the resources and restrictions inherent in the medium. This process involves, first, the identification and exhibition of the 'indispensable properties' and 'limits' of the medium and, second, the expulsion of all effects borrowed from other art forms. In the case of painting, these limitations include the physical qualities of the pigment, the shape of the support and the 'ineluctable' flatness of the surface. Whereas the old masters had treated these limitations as 'negative factors that could be acknowledged only implicitly or negatively', under modernism they 'came to be regarded as positive factors, and were acknowledged openly'.[49]

It is not possible here to discuss the full ramifications of Greenberg's account, which is likely to persuade, if at all, only at an appropriate level of detail. Instead, I want to focus on two examples discussed earlier: the painting of Cézanne and the Cubism of Braque and Picasso. Unlike Fry and Bell, Greenberg gives due weight to Cézanne's debt to Impressionism. However, he claims that the unintended result of Cézanne's attempt to record his 'sensations' with individual dabs of colour was to draw attention to the picture plane as an independent factor. His willingness to 'adjust the representation in depth to the two dimensional surface pattern', while at the same time seeking to indicate solidity and three-dimensional space through parallel and roughly rectangular brush strokes, created 'a new and powerful kind of pictorial tension' characterized by a 'never ending vibration from front to back and back to front'.[50] Greenberg does not deny that Renaissance artists also paid careful attention to the picture surface, including properties of facture, handling and design, but he claims that they sought to avoid the sort of push and pull effects that result from Cézanne's emphasis on the surface of the painting as a physical entity with its own 'equally valid aesthetic rights'. In seeking to convey the potential richness and complexity of these effects, Greenberg offers a virtuoso description of Cézanne's mature technique:

> As [he] digs deeper behind his shapes with ultramarine . . . he makes them oscillate, and the back and forward movement within the picture spreads and at the same time becomes more majestic in its

rhythm because more unified and all-enveloping . . . The image exists in an atmosphere made intenser because more pictorial, the result of a heightened tension between the illusion and the independent abstractness of the formal facts.[51]

Both the strengths and the weaknesses of Greenberg's position become clearer when we turn to his interpretation of Cubism. In accordance with his claim in 'Towards a newer Laocoon' that the 'history of avant-garde painting is that of a progressive surrender to the resistance of the medium' and that this 'consists chiefly in the flat picture's denial of efforts to "hole through" it for realistic pictorial space', he characterizes Cubism as a continuation of the tendency that he had identified at work in the art of Cézanne.[52] During the first, analytic period of Cubism – to which works such as Braque's *The Portuguese* (Plate 8) belong – the 'fictive depths of the painting were drained, and its action was brought forward and identified with the immediate, physical surface of the canvas'.[53] The invention of collage in the second, synthetic period provided a yet more radical means of focusing attention on the material surface of the picture; the resolutely frontal layering of flat pieces of paper onto card or board – as in Picasso's *Violin* of 1912 (Plate 10) – makes itself felt as a 'flat and more or less abstract pattern rather than as a representation'.[54] Greenberg argues that the breakthrough of the collage technique lies not in the emphasis on surface pattern for its own sake – something that would be indistinguishable from a merely decorative design – but in the dynamic tension that is set up between the picture surface and the representation of depth. The resulting instability allows the various components of the picture both to recede and to come forward:

The strips, the lettering, the charcoaled lines and the white paper begin to change places in depth with one another, and a process is set up in which every part of the picture takes its turn at occupying every plane, whether real or imagined, in it . . .The flatness of the surface permeates the illusion, and the illusion re-asserts itself in the flatness. The effect is to fuse the illusion with the picture plane without derogation of either – in principle.[55]

This new and powerful 'fusion' of the literal, physical surface of the picture with the depicted content simultaneously mobilizes and undermines what for Greenberg remains the one indispensable condition of pictorial representation – the establishment of a figure-ground relationship.

The principal objection to Greenberg's interpretation is that however successful his analysis of Cubism might be in its own terms, it is too narrowly conceived to do justice to the full range and complexity of the exploration of pictorial meaning undertaken by Braque and Picasso. In reducing Cubism to a set of formal concerns that devolve exclusively on the relation between the picture surface and the representation of depth, Greenberg overlooks the problem of pictorial reference. His approach can thus be contrasted with the various semiotic interpretations, discussed in Chapter 4, which identify Cubism with the invention of new 'pictorial signs', as well as with more traditional social-historical accounts that emphasize the Cubists' fascination with popular and commercial culture. As we shall see, Greenberg's theory of modernism is exposed to the charge of reductivism on more than one front, for it also depends on an exclusionary and highly selective focus on certain artists and movements rather than others. Before discussing this issue – and the related problem of Greenberg's identification of an internal 'logic of development' that leads 'inexorably' from the advent of the avant-garde through to fully abstract art – I want to point up a second important difference between his views and the position defended by Fry and Bell. Whereas Fry and Bell leave the notion of 'significant form' undefined, tending to construe formalism privatively in terms of the need to abstract from a painting's representational content, Greenberg succeeds in presenting a *positive* characterization of the specific visual interest that is provided by the non-referential or strictly formal elements of pictorial art.

The difference between the two positions can best be explained by drawing on an argument put forward by Budd in his *Values of Art*. Budd claims that it is necessary to 'disambiguate' the idea of representational content as this figures in the core formalist thesis that a picture's representational content is irrelevant to artistic value. He points out that it would be 'absurd' to understand this thesis as implying that the value of a picture is determined by the two-dimensional design of the picture surface, considered independently of whatever it represents, for this would be tantamount to the demand that 'pictures should be seen as if they were not pictures, as if they were non-representational structures.'[56] The concept of significant form should therefore be understood as referring not to the two-dimensional surface of the picture but to what he terms its 'analogue content'. Irrespective of whether a painting depicts a woman with a coffee jug, a landscape or any other recognizable scene or objects, it can also be viewed as a representation of abstract volumes that are spatially related to one another. To attend to a painting's significant form

SIGNIF FORM

ECA

is thus to disregard, as far as possible, its subject matter and to consider it 'only from the point of view of its "analogue content", that is to say, its being a spatial composition of the elements of colour (hue, brightness, saturation), shape, size and depth'.[57] The idea of analogue content thus provides a means of understanding how, on the formalist view, a picture's aesthetic value derives neither from the two-dimensional array of coloured marks upon its surface nor from its illustrative content or subject matter but from the 'plastic construction' of coloured masses in space.

Although Budd's reconstruction allows strong formalism to be presented as a positive rather than a merely negative thesis, it also brings out its major weakness. Budd rightly observes that the formalist bifurcation of pictorial value into illustration and plastic construction is fatally flawed since it fails to acknowledge the phenomenon of twofoldness. As we saw in Chapter 3, the appreciation of a picture as a picture involves a dual awareness of the materiality of the surface and the depicted content: these two forms of awareness do not merely co-exist, but interpenetrate and reciprocally transform each other in the viewer's experience. Budd is therefore on secure ground when he claims that:

ECA

> it is mistaken to think of the artistic function of the picture surface . . .
> as either decorative or representational (plastic expression or suc-
> cessful illustration); for this neglects the crucial characteristic of
> pictorial art, namely the *interrelationship* between the marks on the
> surface and what is depicted in them.[58]

It is clear, however, that this charge cannot be levelled against Greenberg's version of formalism, which makes the working out of the relationship between the materiality of the picture surface and the representation of depth central to the development of modernist painting. Greenberg is, of course, largely indifferent to the subject matter of the works he describes, focusing instead on their internal, formal relations. But whereas strong formalism rests on the implausible – and ultimately incoherent – claim that the viewer must abstract from a painting's representational content in order to attend to its plastic form, Greenberg seeks to disclose an alternative source of pictorial value. Far from contradicting Wollheim's insight into the distinctive phenomenology of 'representational seeing', according to which the viewer is simultaneously aware both of the marked surface and of what that surface represents, Greenberg argues that the tension between these two dimensions is the source

of painting's most powerful and distinctive pictorial effects. In contrast to Fry and Bell, whose strong formalism rests on the denial that the formal and the figurative interpenetrate in the experience of looking a picture, Greenberg makes the dual awareness of surface and subject into the fulcrum of his account. Indeed, his claim that the representation of pictorial depth is conditional for painting as an art anticipates ideas that Wollheim was not to develop until several decades later. Like Wollheim, he distinguishes representation from figuration, arguing that 'the first mark made on a canvas destroys its literal and utter flatness'.[59] The orientation towards flatness characteristic of modernist painting is thus to be construed not as a negation of painting but as an attempt to make its limiting conditions both more explicit and more expressive.

ABSTRACTION AND THE EASEL PICTURE

Greenberg's account of an 'historically self-conscious' avant-garde, which seeks to restore the identity of painting by emphasizing the opacity of the medium, allows him to make a powerful case for the aesthetic validity of fully abstract art. In his essay 'Modernist painting' he claims that the essence of modernism lies 'in the use of the characteristic methods of a discipline to criticize the discipline itself, not in order to subvert it but to entrench it more firmly in its area of competence'.[60] The guarantee of art's 'standards of quality as well as of its independence' is to be found in the process of self-criticism through which each art determines the type of experience that it alone is able to afford. To achieve autonomy painting has had to divest itself of any effect that 'might conceivably be borrowed from or by the medium of any other art', including both sculpture and literature. Greenberg acknowledges that abstract art entails a loss of many of the satisfactions that painting has traditionally provided, but he contends that this is a 'necessary impoverishment'.[61] For what has been abandoned in modernist painting is not so much the representation of recognizable objects as the 'representation of the kind of space that recognizable objects can inhabit'.[62] The real achievement of the avant-garde lies not in the 'deliverance of painting from representation' but in its 'recapture of the literal realization of the physical limitations and conditions of the medium and the positive advantages to be gained from the exploitation of those limitations'.[63]

There are a number of places in which Greenberg argues that painting is no longer an appropriate medium for depicting the lived reality of

modern social existence and that those artists who continue to paint landscapes, still-lives and figure studies in the academic tradition are condemned to produce work that is derivative or second-rate. Thus, for example, in an essay published in 1944 he claims that 'the techniques of art founded on conventions of representation have exhausted their capacity to reveal fresh aspects of exterior reality' and that 'instead of being aroused, the modern imagination is numbed by visual representation.'[64] However, his defence of abstract art is founded, for the most part, in an account of the rewards to be gained from a concentration on purely pictorial factors. Nothing determines in advance that abstract painting will be superior to figurative painting, and it may well be that the ratio of good to bad painting is higher where there is recognizable subject matter, but, when measured against the best art of the past, experience reveals that 'the most ambitious and effective pictorial art of these times is abstract or goes in that direction.' The absence of figurative content is compensated by the 'necessity that painting become more sensitive, subtle and various, and at the same time more disciplined and objectivized by its physical medium'.[65]

Nowhere is Greenberg's receptivity to the subtlety and variety of abstract painting more vividly revealed than in his analysis of the work that Jackson Pollock showed in a series of exhibitions in New York, beginning with his first one-man show in 1943 (see Plate 15, *Silver over Black, White, Yellow and Red*, 1948). Greenberg initially found Pollock's style 'Gothic' and 'morbid', worrying that it was marred by 'inconsistencies, ugliness, blind spots and monotonous passages', but he also claimed that he was 'the most powerful painter in contemporary America', a judgement for which he was ridiculed at the time.[66] As we might expect, Greenberg contends that 'Pollock's strength lies in the emphatic surfaces of his pictures, which it is his concern to maintain and intensify.'[67] However, the key to his interpretation lies in the claim that Pollock succeeded in imposing a formal order and discipline that derived from Cubism onto paintings that were much larger in scale and ambition. Rather than compressing and tightening the space of the picture, Pollock allowed it to expand so that there were multiple centres of interest and intensity. He was thereby able to 'create a genuinely violent and extravagant art without losing stylistic control'.[68] Greenberg's insistence on the conscious and deliberate character of Pollock's method of painting serves to distinguish his interpretation from other, rival accounts that emphasize the freedom and spontaneity of the artist's celebrated drip technique. These include not only 'expressivist' interpretations that latch onto

Pollock's unguarded claim in 1947 that 'the source of my painting is the unconscious', but also the position defended by the critic Harold Rosenberg, who maintained that the significance of abstract expressionism lies in the existential 'drama' of the creative process rather than formal properties of the finished painting, which for the artist was nothing more than an 'arena in which to act'.[69]

Central to Greenberg's 'historical justification' of abstract painting is his claim that it stands in a relation of continuity with the past. Rather than initiating a radical break with tradition, as both advocates and detractors of abstraction maintained, the work of Pollock and other 'advanced' artists should be seen as a further stage in the self-clarification of painting that had begun in the nineteenth century. In the mid-1950s, Greenberg confidently asserted that 'the avant-garde survives in painting because painting has not yet reached the point of modernization where its discarding of inherited conventions must stop less it cease to be viable as art.'[70] However, there are features of his analysis of abstract expressionism that cast doubt on this assumption. As early as 1941, when reviewing an exhibition by Kandinsky, he had noted 'how easy it is for the abstract painter to degenerate into a decorator', describing this as the 'besetting danger of abstract art'.[71] Once artists such as Newman, Rothko and Pollock started to paint on a large scale, producing paintings that filled the viewer's visual field, they risked undermining what, for Greenberg, remained the last, indispensable convention of pictorial art. The 'crucial issue' raised by the work of these painters is therefore 'where the pictorial stops and decoration begins'.[72]

Greenberg contends that no matter how much a picture is flattened, as long as there is an indication of spatial depth, so that the 'forms are sufficiently differentiated and kept in dramatic imbalance', it will remain a picture.[73] But in Pollock's large-scale canvases from 1946 onwards he began to observe the appearance of a new 'all-over quality' in which there is no highlighting or grouping, and thus no obvious centre of dramatic interest, but rather an evenly distributed network of motifs that looks as if it extends beyond the boundaries of the frame. Although this tendency brought with it 'a greater concentration on surface texture and tactile qualities', Greenberg recognized that Pollock's 'decentralised', 'polyphonic' or 'all-over' style of painting threatened to undermine the distinction between easel painting and decorative design. Not only did the framing edge cease to determine the painting's internal structure or order, but there was also a risk that the painting would be seen as a 'single, indivisible piece of texture' rather than as 'the *scene* of forms'.[74]

The adoption of all-over painting by other artists led Greenberg to speculate that this 'dissolution of the picture into sheer texture, sheer sensation' might answer to something 'deep-seated in contemporary sensibility': the 'feeling that all hierarchical distinctions have been exhausted, that no area or order of experience is intrinsically or relatively superior to any other.' But in order to remain consistent with the premises of his own account, he had to accept that it had consequences for the future of painting, 'for in using the easel picture as they do – and cannot help doing – these artists are destroying it'.[75]

Despite Greenberg's acknowledgement of the 'crisis of the easel picture', the most effective challenge to his theory of modernism came not from advanced painting, as he understood this term, but from the avant-garde's abandonment of painting in favour of other, non-medium specific practices. The gradual narrowing of Greenberg's position must be seen, at least in part, as a response to the challenge posed by the various neo-avant-garde movements of the 1950s, which rejected the idea of aesthetic autonomy in favour of a more direct engagement with the experience of modern life. The 'assemblages', 'environments' and 'happenings' of Fluxus could no more be assimilated into Greenberg's account than the mixed-media work of artists such as Claes Oldenburg and Robert Rauschenberg, whose 'combine paintings' seemed designed to flout the very idea of purity and an orientation to flatness.[76] By 1960, when Greenberg wrote 'Modernist painting', with its declaration that the arts could save themselves from 'levelling down' only by 'demonstrating that the experience they provided was valuable in its own right and not to be provided by any other kind of activity', he was already fighting a rearguard action.[77] The identification of ambitious painting with the progressive isolation and testing of the cardinal norms and conventions of the easel picture bore little relation to what was happening in the galleries and studios and on the streets of cities such as New York, Paris and London. In the context of the civil rights and women's liberation movements and the growing opposition to the war in Vietnam, Greenberg's insistence on 'purity' began to look like a denial of art's responsibility to anything but itself. This situation was compounded by his dismissal of alternative forms of art practice as mere stunts that proceeded from the artist's intention to shock or scandalize rather than genuine aesthetic conviction.[78]

The second major problem with Greenberg's theory of modernism derives not from its narrowing down of painting to a self-critical tradition of abstract art – with all the attendant exclusions that brings in its train – but from the very idea of an internal 'logic of development'. Greenberg

first used this term in 'Avant-garde and kitsch' as a means of acknowledging that the developments he describes were not the result of a conscious programme.[79] He deploys the same argument in 'Modernist painting' when he insists that modernist self-criticism 'has been altogether a question of practice, immanent to practice, and never a topic of theory' and that 'no artist was, or yet is, aware of it, nor could any artist ever work freely in awareness of it.'[80] It is not hard to see that such statements are ultimately self-defeating and that by articulating the 'logic of modernism' Greenberg was contributing to its dissolution. He fiercely resisted the claim that the aesthetic quality of a painting could be determined by its contribution to the self-definition of art, insisting that aesthetic judgement is spontaneous and involuntary.[81] However, many artists and critics, including his influential follower, Michael Fried, came to believe that if art was to 'compel conviction' it had to reveal an awareness of both past and present developments. Fried sought to distinguish his position from Greenberg's 'essentialism' by claiming that modernism is a 'cognitive enterprise' in which the artist seeks to discover 'not the irreducible essence of *all* painting' but rather 'that which, at the present moment in painting's history, is capable of convincing him that it can stand comparison with the painting of both the modernist and the premodernist past whose quality seems to him beyond question.'[82] However, far from salvaging the critical potential of Greenberg's theory, Fried's revisions served only to make its strong historicist presuppositions more explicit.

As we saw in Chapter 5, historicism is the view that cultural artefacts, including works of art, can be fully understood only by taking into account the specific historical circumstances under which they were produced. This 'weak' contextualist commitment is relatively unproblematic and is adopted by most forms of historical enquiry, including art history. By contrast, 'strong' historicism holds that there are fundamental 'laws of development' that progressively unfold through history. Unlike Wölfflin, who believed that the cyclical development of art had irretrievably broken down by the start of the twentieth century, both Greenberg and Fried sought to link past, present and future in a continuous, linear narrative. The articulation of this narrative in the writings of modernist critics such as Greenberg and Fried as well as in the exhibition policies of major museums such as the Museum of Modern Art in New York allowed the work of the artists it enfranchised to gain considerable prestige and attention. As others were quick to point out, however, the apparent cohesion of modernism was achieved at the cost of exclud-

ing those movements and practices, such as Dada, Constructivism and Surrealism, that did not share the same critical priorities.

Two further, unintended consequences, served to undermine the theory of modernism at the very moment that it achieved institutional dominance. First, the idea that painting develops through a sequence of stages – together with the corollary that to be 'advanced' in relation to the art of the recent past was an indicator of aesthetic quality and ambition – inevitably led artists and critics to seek to identify, and in some cases to realize, the next stage in the process. As Ekaterina Morozova has shown, the problem of historical self-consciousness was at the forefront of disputes about art in the 1960s.[83] Despite Greenberg's protestations that the logic of modernism was only discernable in retrospect, he was criticized for attempting to *produce* history by determining the subsequent direction that painters should take if they were to occupy a place in the historical continuum. In an essay published in the same year as 'Modernist painting' he claimed that the trajectory of modernism had not, after all, come to an end with Pollock's 'all-over painting' but was being carried forward by a new generation of artists, including Morris Louis and Kenneth Noland, whose work he vigorously promoted.[84] Although the technique of staining paint into unprimed canvas could conceivably be interpreted as a further 'suppression of the difference between painted and unpainted surfaces', the putative advance of 'post-painterly-abstraction' was too dependent on Greenberg's prior construction of modernism to gain widespread support. Harold Rosenberg coined the term 'recipe painters' to describe artists who produced work to order or who were more concerned with their prospective place in history than with the genuine expression of feeling.[85]

The second unintended consequence of Greenberg's historicism is closely related to the first since the identification of an immanent logic of development inevitably points towards its own conclusion or termination. His claim that painting had been reduced to just two 'constitutive norms or conventions: flatness and the delimitation of flatness' left nowhere else for painting to go.[86] The problems inherent in Greenberg's account were brought to the fore by the series of Aluminium Paintings that Frank Stella exhibited in New York in 1960. By employing unusually thick stretchers, into which he cut notches both at the edges and at the centre, Stella allowed his paintings to stand out from the wall as three-dimensional objects. These works, which were deliberately ambiguous between the conventional easel picture, with its pictorial representation of spatial depth, and the literal depth of a material object, were interpreted both as

a further investigation of the cardinal norms of painting and as a break-through that paved the way for Minimalism and other forms of art that emphasized the physical properties of 'specific objects' in relation to the space of the viewer rather than relations that are internal to the work itself.[87]

To the informed art-world insider, the meaning of the Aluminium Paintings was, to a large extent, dependent upon their relation to Green-berg's theory of modernism. By producing work that was situated at the limit at which 'a picture stops being a picture and turns into an arbitrary object', Stella called into question the doctrine of medium-specificity and the idea that painting could continue to advance through a process of progressive self-delimitation.[88] It soon became clear that what Krauss termed the 'expanded field of art', encompassing such divergent prac-tices as land art, performance, installation and assemblage, could not be accommodated within the developmental narrative of modernism, whose exhaustion was closely identified with the exhaustion of painting as an ambitious art form. However, the breakdown of modernism was also brought about through internal pressures, including a second-order awareness – and rejection – of Greenberg's account of historical progress. In Greenberg's own terms, we might say that once the project of historical self-criticism was extended to include its own historicist presuppositions it could no longer fulfil a legitimating function.

CONTEMPORARY CHALLENGES

There have been periodic claims for the obsolescence of painting ever since the artist Paul Delaroche responded to the invention of pho-tography with the declaration 'From today, painting is dead!'[89] In the early years of the twentieth century Duchamp announced that he was 'abandoning painting' in order to pursue alternative forms of art practice, including his notorious readymades. He later insisted that 'for a period like ours . . . one cannot continue to do oil painting, which, after four or five hundred years of existence, has no reason to go on eternally'.[90] With an equal sense of theatre, the Russian artist Aleksandr Rodchenko stated that in 1921 he had 'reduced painting to its logical conclusion' by exhibiting three monochromatic canvases in the primary colours of red, blue and yellow, and that 'there will be no more representation'.[91] Whereas Rodchenko's position remained ambiguous between the end of representational painting and a new beginning through fully abstract

art, Asger Jorn's observation in 1959, 'Painting is over. You might as well finish it off. Detourn. Long live Painting,' is characterized by a weary finality.[92] These words were written to accompany an exhibition of his 'detourned paintings', the result of a deliberate end game in which he took representational pictures by amateur artists that he had found in flea markets and then over-painted them with abstract gestural marks reminiscent of Pollock.

What are we to make of such pronouncements and how much credence should we give to the claim that painting has been rendered obsolete? From the standpoint of the twenty-first century, should we look back on painting as an outmoded form of art, of no more relevance to contemporary life than stained-glass windows and alabaster carvings? Or does painting continue to offer resources that cannot be found in other media, resources that allow it to remain a source of aesthetic value and substantive critical interest? I want to conclude this chapter by offering a tentative answer to these questions that both draws on and suggests the limits of the analysis of painting carried out in this book.

At the risk of simplification, it is possible to identify two principal challenges to painting that have, if anything, become more pressing in the present day. The first, expressed with disarming candour in the quotation from Delaroche, derives from the invention of photography and other technologies of visual imaging. Photography, particularly in its modern, digital incarnation, is not only cheaper and faster than painting, which is a time-consuming, craft-like process dependent on brushes, oils, primers and stretchers, it is also more adaptable, ranging from microphotography at a scale that is inaccessible to unaided vision through to satellite cameras that take us above the surface of the earth. The sheer ubiquity of photographic and digital imagery, be it through news photographs, advertisements, or on our computer screens, also makes it seem more appropriate as a medium for capturing the look of things. We are familiar with photography in a way that painting cannot hope to match: it is both an integral part of the world we inhabit and the dominant mode of recording and transmitting visual information. The second major challenge to painting derives, as we have already seen, from the breakdown of modernism as a sustaining paradigm for the making and appreciation of art. For much of the modern period, so-called 'advanced' painting was closely associated with the pursuit of aesthetic autonomy, but by the mid-1960s neither formalism nor Greenberg's historicist account of modernist painting commanded widespread assent. If the idea of non-objective painting had run its course, or, at least, no longer seemed

relevant to contemporary concerns, how could artists find a way back to figuration without adopting the outmoded techniques of academic painting? After the demise of modernism, what possibilities remained open to painters who wished to make representational images, and how were they to compete with the success of photography?

That these two challenges are closely interrelated becomes clear when we reflect on the fact that the emergence of the avant-garde in the early to mid-nineteenth century was contemporaneous with the invention and dissemination of photography. It seems plausible to suggest that the ceding of the routine requirements of picturing to photography acted as a catalyst for a more explicit concern with non-mimetic factors and that the gradual withdrawal into abstraction provided a means of diffusing the tension between photography and painting.[93] However, it would be wrong to assume either that prior to photography painting had been exclusively concerned with imitation or that painters did not also learn new techniques of representation from photography. From the outset, there was a productive exchange between the two media, evinced, for example, in Degas's adoption of the photographic effect of 'cropping' – the partial occlusion of figures and objects by the frame – to present a more 'natural' and less obviously composed view of his subject.

The engagement with mass-media images that characterizes the work of Pop artists such as Andy Warhol and Roy Lichtenstein provides further evidence for the breakdown of the modernist project of aesthetic autonomy. However, it is significant that the return to figuration among avant-garde artists frequently took place through a re-working of images that were taken over from popular culture. The simple expedient of painting from photographs not only offered a way of re-introducing figurative content, it also enabled artists to address some of the complex issues surrounding pictorial representation. The recognition that photography offered a way out of the apparent impasse of painting is eloquently expressed by the German artist Gerhard Richter, who had begun painting from photographs in 1963:

I was surprised by photography, which we all use so massively every day. Suddenly, I saw it in a new way, as a picture that offered me a new view, free of all the conventional criteria I had always associated with art. It had no style, no composition, no judgement. It freed me from personal experience. That's why I wanted to have it, to show it – not to use it as a means to painting but to use painting as a means to photography.[94]

The paradoxical notion of using painting as a means to photography can be understood in a number of different ways. Initially, at least, Richter saw photopainting as a technique that enabled him to depict a wide range of subject matter without having to concern himself with the traditional requirements of invention, design, composition and pictorial unity. In his early writings and interviews, he repeatedly contrasts the artificiality of painting with the simplicity, directness and credibility of photography. He is, of course, fully aware that photographs can be subjected to manipulation, but he claims that unlike 'art' photography, which is fashioned in accordance with a prior idea of beauty, amateur snapshots, even when they are technically faulty or out of focus, are viewed as truthful in way that painting is not.[95] By taking up images from newspapers, advertisements and amateur photographs, including his own, and re-presenting them in the medium of paint, he sought to give painting something of the neutrality and objectivity of photography: painting, like photography, would be a source of information, a documentary record of the mediatized world, rather than a vehicle for the expression of the artist's feelings and ideas. It quickly became clear, however, that the re-presentation of an image in the medium of paint involves complex problems of translation and that the provision of a new context changes the way in which an image is seen and interpreted.

Consider, for example, Richter's painting *Christa and Wolfi* of 1964 (Plate 16), which is based on one of his wife's family photographs. It shows an everyday domestic scene in which two women look out at the camera, together with a dog sitting on a chair. One of the first things Richter realized was that by allowing the photographic source to determine the picture's composition, he was free to concentrate on such purely 'painterly' concerns as the texture and handling of the paint and the balance of tonal values. Although he describes his use of photography as a 'crutch' that helped him to get to reality, it also enabled him to sustain the modernist concern with the specific technical and physical resources of painting without abandoning recognizable subject matter.[96] As Ralph Rugoff has observed, one of the consequences of painting from photographs is that the artist has to pay equal attention to every part of the image, resulting in a unified consistency of detail and a levelling of hierarchical differences that echoes the 'all-over quality' that Greenberg had identified in Pollock's abstract paintings.[97] The orientation towards flatness characteristic of modernist painting, together with the absence of any determinate centre of interest, is brought into disorientating conjunction with the salience and spatial depth of the photographic original.

This sophisticated variation on the vaunted 'push and pull' effect is further emphasized by the depiction of the white border around the photograph at the top and two side edges, though this is difficult to make out in a reproduction.

Richter's photopaintings are no more accessible through photographs than the large scale abstracts of Jackson Pollock or any of the other artworks discussed in this volume. What we see in Plate 16 is a photographic reproduction of a painting of a photograph; as such, it loses the very 'painterly' qualities that distinguish *Christa and Wolfi* from its source. However, even in a reproduction it is possible to see that Richter has emphasized the photographic effect of imprecision or 'blurring' (the result of camera shake or insufficient depth of field) by dragging the paint across the surface of the canvas. This curious conflation of the hand-made and the mechanical renders the image unstable, making it difficult for the viewer to bring its subject into focus. Richter's painterly interventions cause the image to recede or withdraw at the same time as they it rescue from obscurity. Interpreted in the context of his other paintings from this period, which depict everything from chandeliers and folding clothes dryers through to administrative buildings and figures from newspapers, *Christa and Wolfi* appears to be yet another example of the banal and overlooked, temporarily lifted from the flood of photographic imagery by its re-working in the medium of paint. At the time he made these works, Richter insisted that his choice of subject matter was arbitrary: 'As a record of reality, the thing I have to represent is unimportant and devoid of meaning . . . All that interests me is the grey areas, the passages and tonal sequences, the pictorial spaces, overlaps and interlockings.'[98] However, he later conceded that the content of the photographs did play an important role in his selection of images.[99] *Christa and Wolfi* is one of several paintings from this period, including a picture of his Uncle Rudi in Nazi uniform, first shown at an exhibition in commemoration of the victims of Lidice, that make more or less explicit reference to recent German history.[100] As a number of critics have observed, Richter's strategy of both revealing and obscuring the photographic original evokes the processes of remembrance and forgetting that characterize our ambivalent relation to the past.[101]

How, then, are we to characterize the differences between photopainting and photography? On the one hand, it seems clear that far from simply doubling the photographic original, painting a photograph changes the way in which the source image is viewed. Insofar as we register the difference between the smooth surface of a photograph

and the worked-up surface of a painting, which is made up of innumerable touches of paint, our attention is drawn to its hand-crafted quality. Rugoff has argued that painting instils 'a crucial delay' in our response to photographic imagery: it is not only that it takes time to make a painting, as opposed to the instantaneity of the photograph, painting also takes longer for the viewer to process. The 'more nuanced and variegated surface' of a painting allows for a complex layering of information that 'invites the eye to linger, to scrutinize the hundreds of contacts between brush and canvas'.[102] On the other hand, photopainting works to undermine the opposition between the unique, hand-crafted art object and the infinitely reproducible photographic image. Even the most humble snapshot acquires a different status once it is transposed into the medium of paint and presented in a gallery context. It is accorded a singularity that such images are normally denied, creating a space for critical examination and reflection that is often truncated or compressed by the sheer quantity of visual information that surrounds us.

Richter's photopaintings constitute just one facet of the enormously diverse body of work that he has produced over the last four decades, including abstract paintings, monochromes, colour charts and three-dimensional objects.[103] Moreover, he is just one of a number of painters who have drawn on photography as a means of engaging with the forms and structures of the modern, highly mediatized world. Nonetheless, Richter's search for a way forward in face of the supposed superiority of the photographic image allows us to appreciate the remarkable resilience of painting. Although it has lost its privileged position in the contemporary art world, and is now treated as just one form of art among others, painting continues to re-invent itself. The core themes that we have addressed in this book – the difference between a copy and a representation, the relation of surface and subject, the problem of reference and denotation, the analysis of pictorial style and the role of historical self-consciousness – reveal the richness and complexity of painting as an art, a complexity that, so far at least, has enabled it sustain its relevance under ever-changing historical circumstances. However, the purported uniqueness of painting is becoming ever more difficult to sustain. As the emergence of photopainting indicates, the distinction between the hand-crafted and the mechanical has started to break down. Not only have technological advances allowed photography to achieve the scale, brilliance of colour and compositional complexity of oil painting – amply demonstrated by the work of photographers such as Jeff Wall and Andreas Gursky – but the transition from photochemical to electronic

and digital formats permits a degree of intervention and manipulation that stretches the notion of the photographic towards the painterly.[104] As the two practices become entwined, the idea of medium-specificity and of the artist's indebtedness to a particular tradition recedes in significance, allowing for a more open-ended range of possibilities in which painting and photography come together on a common ground.

NOTES

I PAINTING AND PHILOSOPHY

1 This idea can be traced back to Plato's *Thaetetus* (155d), where Socrates observes that a 'sense of wonder is the mark of the philosopher. Philosophy indeed has no other origin . . .'. Translated by F.M. Cornford in Plato (1989), p. 860.

2 Gombrich (1977). This book is based on Gombrich's A.W. Mellon Lectures in the Fine Arts, which he gave in 1956.

3 See Goodman (1960b) and Goodman (1976), esp. p. 7 and p. 10.

4 Gombrich (1977), p. 7.

5 Lopes (1996), p. 7. Cf. Lopes's observation that 'In my view, a theory of depiction should take demotic pictures as fundamental, while also providing the basis for an explanation of how pictures can transcend the commonplace and enter the realm of the aesthetic' (Lopes (1996), p. 7). He takes up the question of the aesthetic value of pictures in Lopes (2005). The extension of the field of study to include posters, advertising, cartoons, optical illusions and other images from popular culture was pioneered by Gombrich (1977).

6 Lopes, (1996), p. 7.

7 Newman (1990), p. 247. In an interview with Emile de Antonio given in 1970, Newman observed: 'even if you can build an aesthetic analysis or an aesthetic system that will explain art or painting or whatever it is, it's of no value really, because aesthetics is for me like ornithology must be for the birds' (Newman (1990), p. 304).

8 Newman's two most important essays are 'The first man was an artist' (1947) and 'The sublime is now' (1948). Both were published in *The Tiger's Eye*, a periodical for which Newman was an associate editor. They are reprinted in Harrison and Wood (2003), pp. 575–7 and pp. 580–2.

9 Newman is now ranked alongside Jackson Pollock and Mark Rothko as a leading figure of abstract expressionism, but his work originally met with incomprehension and bafflement, including the charge that it was nothing more than a calculated attempt to shock. For Newman's uncertainty about the meaning of *Onement I*, see Harrison (2003).

10 Lewis (1982) [first published in 1937], p. 100; Kahnweiler (1971), p. 43.

11 Adorno's *Aesthetic Theory* was left unfinished at the time of his death in 1969 and was published by his executors in 1970. His most concise

statement on this topic is to be found, paradoxically, in the section on natural beauty where he discusses the 'aporia of aesthetics as a whole': 'Its object is determined negatively, as indeterminable. It is for this reason that art requires philosophy, which interprets it in order to say what it is unable to say, whereas art is only able to say it by not saying it' (Adorno (1997), p. 72).

12 In an interview published in 1946 under the title 'The great trouble with art in this century', Duchamp declared: 'this is the direction art should turn: to an intellectual expression, rather than to an animal expression. I am sick of the expression "bête comme un peintre" – stupid as a painter'. Reprinted in Duchamp (1989), p. 126. For a discussion of Duchamp's criticisms of merely 'retinal painting' see my 'Interpreting the readymade: Marcel Duchamp's *Bottlerack*' in Gaiger (2003), pp. 57–103.

13 The first position is defended by Munro (1967) and the second by Weitz (1956).

14 The story is to found in Pliny (1857), Vol. 6, p. 151 (Book XXXV).

15 Podro (1987), p. 4.

2 A WINDOW ONTO THE WORLD

1 Piles (1993), pp. 14–15. In the original French, Piles' definition is 'un Art, qui par le moyen du dessein & de la couleur, imite sur une superficie plate tous les objets visibles'. This essay was originally published as part of a larger work entitled *Abregé de la vie des peintres*, Paris, 1699, revised edition 1715.

2 Dickie (1992), p. 109.

3 Dickie, (1992), p. 109.

4 Pliny, *Natural History*, Book XXXV, chap. 36, trans. in Pliny (1857), Vol. 6, p. 251.

5 Xenephon, *Memorabilia*, III. 10.6., trans. in Sörbom (1966), p. 85.

6 The *Greek Anthology* (*Anthologia Graeca*) was compiled by Meleager of Gadara in the first century BC, and was subsequently added to by other scholars. For a selection translated into English, see Jay (1981). The most comprehensive collection of primary sources on ancient Greek art is Pollitt (1990). See, too, Pollitt (1974).

7 Alberti (1972), p. 61.

8 Vasari (1987), Vol. 1, pp. 124–5 and p. 266.

9 Vasari, (1987), Vol. 1, p. 58 and p. 90.

10 Vasari, (1987), Vol. 1, p. 85 and pp. 124–5.

11 Braque, 'Thoughts on painting' (1917), translated in Harrison and Wood (2003), p. 214.

12 Plato, *Cratylus*, 432b–d, trans. B. Jowett in Plato (1989), p. 466. For a detailed discussion of Plato's theory of art, see Janaway (1995).

13 Alberti, (1972), p. 33.

14 Alberti, (1972), p. 55. Cf., too, Alberti's comparison of a painting with the reflective surface of water: 'What is painting but the art of embracing by means of art the surface of the pool?' (Alberti (1972), p. 63).

15 Alberti, (1972), p. 71.

16 See Puttfarken (2000). Puttfarken claims that 'From the beginning, Alberti's notion of a composition is neither derived from, nor is it concerned with, the picture as an entity, as a structured whole. It is derived from the observation of a single, individual object in nature and the way in which this object is visually made up of its surfaces' (Puttfarken (2000), p. 54). The opposing view is defended by Michael Baxandall, who claims that 'Composition, in the sense of a systematic harmonization of every element in a picture towards one total desired effect, was invented by Alberti in 1435' (Baxandall (1988), p. 135).

17 Alberti, (1972), p. 71.

18 Alberti, (1972), p. 79.

19 Alberti, (1972), p. 79.

20 Plato, *Cratylus*, 432b–d, in Plato (1989), p. 466.

21 See, Sörbom (1966). For a comprehensive discussion of the concept of *mimēsis*, see Halliwell (2002).

22 The classic discussion of the difference between the modern concept of art and the concepts employed in earlier periods is Kristeller (1951) and (1952). For more recent work on the topic, see Mortensen (1997) and Shiner (2001).

23 Plato, *Republic*, 595b, trans. P. Shorey in Plato (1989), p. 820.

24 Plato, *Republic*, 597b, in Plato (1989), p. 821.

25 Plato, *Republic*, 597e, in Plato (1989), p. 822.

26 Plato, *Republic*, 598b, in Plato (1989), p. 823.

27 Plato, *Republic*, 602b, in Plato (1989), p. 827.

28 Plato, *Republic*, 602c–d, in Plato (1989), p. 827.

29 Plato, *Republic*, 606b, in Plato (1989), p. 831.

30 Plato, *Republic*, 605a–b in Plato (1989), p. 830.

31 Plato, *Republic*, 603b, in Plato (1989), p. 828.

32 Plato, *Sophist*, 268d, trans. F.M. Cornford in Plato (1989), p. 1017.

33 Plato, *Sophist*, 240a–b, in Plato (1989), p. 983.

34 Plato, *Sophist*, 235d–236e, in Plato (1989), p. 978.

35 Plato, *Sophist*, 266c, in Plato (1989), p. 1014.

36 See Ijseeling (1997), pp. 16–21.

37 See, Plato, *Statesman*, 288c. trans. J.B. Skemp in Plato (1989), pp. 1056–7.

38 Plato, *Ion*, 534b, trans. L. Cooper in Plato (1989), p. 220. Cf. too, Plato's observation in *Socrates' Defence (Apology)*, 22c, that 'it was not wisdom that enabled [poets] to write poetry, but a kind of instinct or inspiration, such

as you find in seers and prophets, who deliver all their sublime messages without knowing in the least what they mean' (trans. H. Tredennick in Plato (1989), p. 8).

39 Plato, *Symposium*, 210–211, trans. M. Joyce in Plato (1989), pp. 561–3. Diotima's words are recounted by Socrates.

40 See, Plato, *Republic*, 598b, in Plato (1989), p. 823.

41 Winckelmann, for example, in his *Reflections on the Imitation of Greek Works in Painting and Sculpture* (1755) claims that 'In the masterpieces of Greek art, connoisseurs and imitators find not only nature at its most beautiful but also something beyond nature, namely certain ideal forms of its beauty, which, as an ancient interpreter of Plato tells us, come from images created by the mind alone' (translated in Harrison et al. (2000), p. 451). The 'ancient interpreter' to which Winckelmann refers is most likely Plotinus.

42 Reynolds (1997), pp. 44–5. This quotation is taken from the 3rd Discourse, which Reynolds delivered in 1770.

43 Alberti, (1972), p. 99.

44 Alberti, (1972), p. 99.

45 Alberti, (1972), p. 37.

46 Alberti, (1972), p. 37.

47 Alberti, (1972), p. 39.

3 SURFACE AND SUBJECT

1 This point is made by Budd (1992), p. 257.

2 Gombrich (1977), p. x.

3 Gombrich (1977), p. 108.

4 Gombrich (1977), p. 7.

5 Gombrich (1977), p. 30 and p. 99.

6 Plato, *Cratylus*, 432b–d, in Plato (1989), p. 466.

7 Gombrich (1973), p. 240.

8 Gombrich (1977), p. 304. See, too, Gombrich (1973), p. 200, where he quotes this passage and emphasizes its importance for understanding his claim that 'stimulation can, but need not, rely on the imitation of the trigger'.

9 Gombrich cites as an example the research of Aby Warburg, who succeeded in showing that Italian Renaissance artists who 'had previously been regarded as the champions of pure observation . . . frequently took recourse to a borrowed formula' and that their borrowings from classical sculpture 'were not haphazard' (Gombrich (1977), pp. 19–20). Compare, too, Gombrich's observation that 'Even Dutch genre paintings that appear to mirror life in all its bustle and variety will turn out to be created from a

limited number of types and gestures . . . There is no neutral naturalism. The artist, no less than the writer, needs a vocabulary before he can embark on a "copy" of reality' (Gombrich (1977), p. 75).

10 Gombrich (1977), p. 72.

11 Gombrich (1977), p. 76. In the Preface to the second edition of *Art and Illusion*, Gombrich helpfully clarifies his position by identifying the opposite view to the one he defends: 'It would be a state of affairs in which every person wielding a brush could always achieve fidelity to nature. The mere desire to preserve the likeness of a beloved person or of a beautiful view would then suffice for the artist to "copy what he sees" ' (Gombrich (1977), p. xi).

12 See Gombrich (1977), p. 123 and Gombrich (1982), p. 11.

13 Gombrich (1977), p. 3.

14 Gombrich (1982), p. 21. See, too, Gombrich (1977), p. 125.

15 Gombrich (1982), p. 23. Gombrich makes a similar observation in relation to the development of Greek naturalism: 'as soon as the Greeks looked at the Egyptian figure type from the aspect of an art which wants to "convince", it undoubtedly raised the question why it looks convincing . . . it was the Greeks who taught us to ask "*How* does he stand?" or even "Why does he stand like that?" ' (Gombrich (1977), p. 114).

16 Gombrich (1982), p. 27.

17 Gombrich (1977), p. 29.

18 Gombrich (1977), p. 246.

19 Lopes contends that the failure to satisfy what he calls the 'diversity constraint' is sufficient reason to reject Gombrich's illusion theory. See Lopes (1996), p. 39.

20 Gombrich (1973), p. 180.

21 Gombrich (1977), p. 233.

22 Goodman (1976), p. 35.

23 Gombrich (1973), p. 206.

24 Wittgenstein (1958), p. 193.

25 See Budd (1987), pp. 1–2: 'The independent philosophical importance of the concept of noticing an aspect is due to its location at a crucial point in our concept of mind . . . this point . . . is the juncture of the sensory and the intellectual.'

26 Wittgenstein, (1958), p. 193.

27 Gombrich (1977), p. 198.

28 Gombrich (1977), p. 198.

29 Gombrich (1977), p. 5.

30 Clark (1960), pp. 36–7.

31 Gombrich (1977), p. 211.

32 See Wollheim (1961), pp. 277–80; Podro (1993), pp. 44–6; Budd (1992), pp. 263–4; Lopes (1996), p. 41.

33 Gombrich (1977), p. 24.

34 This argument is made in Wollheim (1961), pp. 279–80.

35 Adorno (1997), p. 101.

36 *Las Meniñas* has given rise to a rich philosophical debate. See, for example, the first chapter of Foucault (1994) and Searle (1980).

37 See, in particular, Podro (1987), Podro (1993) and Podro (1998).

38 Wollheim (1987), p. 21. See, too, Wollheim (1965), pp. 27–30. For a valuable collection of responses to Wollheim's work, see Gerwen (2001) and Wollheim's 'A reply to the contributors' in the same volume (Wollheim (2001)).

39 Wollheim (1980), p. 217.

40 Wollheim (1980), p. 15.

41 Wollheim (1987), p. 21.

42 Wollheim (1987), p. 62. Wollheim claims that some abstract paintings, such as Barnett Newman's *Vir Heroicus Sublimis* (1950–51, Museum of Modern Art, New York), cancel out this effect and hence are non-representational. I return to this issue in the final section of this chapter and again in Chapter 6.

43 Wollheim (1987), p. 46.

44 Wollheim (1987), p. 48. Gombrich pursues similar historical speculations in Gombrich (1977), p. 91.

45 Wollheim (1987), p. 48. See, too, Wollheim (1980), p. 205.

46 Wollheim (1987), p. 22.

47 Podro (2004), p. 217. For incisive criticism of Wollheim's claim that there is a 'standard of correctness' for each painting that is set by the intentions of the artist, see Hyman (2006), pp. 136–9.

48 Wollheim (1987), p. 46.

49 Wollheim (1961), p. 277.

50 Wollheim (1980), p. 216.

51 I am thinking here of Malcolm Budd's suggestion that 'An alternation in the spectator's visual attention would seem to be sufficient for the recognition of and consequent admiration for the artist's artistry' (Budd, (1992), p. 267). Budd argues that since it is possible to admire the 'how' of representation by alternating between surface and subject, aesthetic appreciation cannot be used to show that twofoldness is essential to the experience of depiction.

52 Lopes (1996), p. 48.

53 Levinson (1998), pp. 228–9.

54 See Nanay (2005), p. 249.

55 Wollheim (1980), p. 213.

56 Wollheim (1980), p. 218.

57 See Wollheim (1980), p. 217 and Gombrich (1997), pp. 24–5.

58 Wollheim (1987), p. 62.

59 See, for example, Lopes (1996), p. 49: 'the existence of *trompel'oeil* pictures – pictures, experiences of which are experiences of their subjects,

but which typically preclude experiences of their design properties – is incompatible not only with strong twofoldness but also with the hope that pictures always have a distinctive phenomenology.'

60 Lopes (1996), p. 50.
61 Lopes (1996), p. 50. Cf., too, Lopes's claim that 'In truth, experiences of pictures may or may not be twofold. They can be arranged along a spectrum, with twofoldness at one pole and illusionism at the other' (Lopes (1996), p. 176).
62 Cf. Wollheim (2001), pp. 244–5.
63 Hyman (2006), p. 132.
64 Goodman (1976), p. 35.
65 See Lopes (1996), p. 3.
66 Kandinsky (1982), Vol. 1, p. 197. The quotation is from Kandinsky's *Concerning the Spiritual in Art*, which was first published in German in late 1911.

4 RESEMBLANCE AND DENOTATION

1 Kahnweiler (1971), p. 57. Originally published as *Mes galeries et mes peintres. Entretiens avec Francis Crémieux* (Paris: Gallimard, 1961), this citation, p. 80.
2 See Neil Cox, *Cubism* (London: Phaidon, 2000), p. 43.
3 Bois (1987), p. 74. The recent interest in Kahnweiler's interpretation of Cubism is largely due to Bois's reconstruction of his views. I discuss Bois's position in more detail below.
4 Plato, *Cratylus*, 383a–384d, in Plato (1989), p. 422.
5 The first three books of Augustine's treatise *On Christian Doctrine* [*De Doctrina Christiana*] were published in 397 AD. At the start of the second book, where the discussion of natural and conventional signs is to be found, he is primarily concerned with problems of biblical hermeneutics, that is to say, with the interpretation of scripture.
6 Augustine (1971), p. 636 (book II, chap. 1).
7 Augustine (1971), p. 637 (book II, chap. 2).
8 Peirce developed his theory of signs over a period stretching from 1866 through to his death in 1914, during which he frequently modified and revised his ideas. For a helpful overview, see Short (2004).
9 Peirce (1955), p. 102.
10 Peirce (1955), p. 105. According to Peirce, 'it is a familiar fact that there are such representations as icons. Every picture (however conventional its method) is essentially a representation of that kind. So is every diagram,

even though there be no sensuous resemblance between it and its object, but only an analogy between the relation of parts of each' (Peirce (1955), p. 105).

11 Peirce (1955), p. 102.
12 Peirce (1955), p. 102.
13 Peirce (1955), p. 112.
14 Peirce (1955), p. 114.
15 Bryson (1991), p. 65.
16 Bryson (1991), p. 65.
17 Krauss, (1992), p. 273. For criticism of the semiotic approach as 'cryptoformalism' see Leighten (1994).
18 Bryson (1991), p. 62.
19 See, Goodman and Elgin (1988), p. 4.
20 Hyman (2006), p. 164. Hyman claims that *Languages of Art* 'contains the only serious attempt to explain precisely what system of conventions a general theory of depiction must postulate, if it is committed to these popular ideas' (Hyman (2006), p. 164).
21 Goodman (1976), p. xii.
22 Goodman (1976), p. 231.
23 Goodman (1976), pp. 3–4.
24 Goodman (1976), p. 5.
25 Lopes (1996), p. 57.
26 Budd, (1993), p. 156.
27 See, in particular, 'Representation re-presented' in Goodman and Elgin (1988), pp. 121–31. For Goodman's description of the resemblance theory as a 'dogma', see p. 121.
28 For an analysis of the different 'routes of reference', see Goodman (1984), pp. 55–71.
29 I do not discuss Goodman's theory of fictional representational. Goodman holds that pictures that represent fictional objects, such as a unicorn, have 'null denotation'. To avoid hypostatizing a realm of non-existent objects, he employs the one-place predicate 'unicorn-picture' rather than the usual 'picture of a unicorn'. Pictures that have a generic subject – and thus do not represent a particular person, thing or scene – have multiple denotation. See Goodman (1976), pp. 21–6.
30 Goodman (1976), p. xi.
31 Goodman (1976), p. 156.
32 Goodman (1976), p. 143.
33 Goodman and Elgin (1988), p. 125; see, too, Goodman (1976), pp. 135–7. Goodman specifies the finite differentiation requirement as follows: 'For every two characters K and K' and every mark m that does not actually

belong to both, determination either that m does not belong to K or that m does not belong to K' is theoretically possible' (Goodman (1976), pp. 135–6).

34 Goodman (1976), p. 152.

35 It is, of course, possible to produce a pitch intermediate between two semi-tones on a non-keyed instrument such as a violin or through the human voice. But since the system for denoting pitch in Western music is syntactically and semantically disjoint and differentiated it allows only for determinate pitches. A different system – such as that developed by some twentieth-century composers – is needed to denote pitches intermediate between half-tone intervals.

36 Goodman (1976), p. 185.

37 Goodman (1976), p. 231.

38 Goodman (1976), p. 35.

39 Goodman (1976), p. 226.

40 Goodman (1976), p. 230.

41 Goodman (1976), p. 228.

42 Goodman (1976), p. 47; see, too, Goodman and Elgin (1988), p. 93, where Goodman claims that 'The terms "convention" and "conventional" are flagrantly and intricately ambiguous. On the one hand, the conventional is the ordinary, the usual, the traditional, the orthodox as against the novel, the deviant, the unexpected, the heterodox. On the other hand, the conventional is the artificial, the invented, the optional, as against the natural, the funda-mental, the mandatory.'

43 See Goodman (1976), pp. 58–9: 'Labelling seems to be free in a way that exemplification is not. I can let anything denote red things, but I cannot let anything be a sample of redness.' Examples of reference through exempli-fication include using a tailor's swatch to refer to certain properties of a fabric such as its colour, texture and pattern (but not, for example, its size), and a chip of paint on a sample card to refer to a specific colour. Goodman claims that 'The swatch exemplifies only those properties that it both has and refers to' (Goodman (1976), p. 53). By contrast, denotational refer-ence does not require that the sign possesses or instantiates the proper-ties to which it refers. For an ingenious attempt to rectify Goodman's theory by showing that pictures combine these two forms of reference, see Arrell (1987).

44 The anecdote is retold in Gulyga (1985), p. 73.

45 Peirce (1995), p. 112.

46 See Goodman (1976), p. 41.

47 Goodman (1976), p. 38.

48 Danto (1981), pp. 72–3.

49 Goodman (1976), p. 231.

50 Goodman (1976), pp. 41–2.

51 Goodman (1976), pp. 252–3. Goodman characterizes syntactic and semantic density and repleteness as 'symptoms of the aesthetic' rather than as criteria for identifying aesthetic experience: 'A symptom is neither a necessary nor a sufficient condition for, but merely tends in conjunction with other such symptoms to be present in, aesthetic experience' (Goodman (1976), p. 252).

52 Hyman (2006), p. 161 and p. 167.

53 Goodman and Elgin (1988), p. 110. An important exception is Dominic Lopes, who observes that 'Goodman's symbol theory is not a convention theory of depiction. Conventions are rules, and Goodman is sceptical about pictorial practices (or any symbolic practices) being rule-governed. What is habitual resists codification.' Lopes (1996), p. 65. See, too, Lopes (2000). I discuss Lopes's views below.

54 Goodman (1984), p. 57.

55 Goodman (1984), p. 10.

56 Lopes (2000), p. 227. Cf. Goodman's observation that 'Routes of reference are quite distinct from roots of reference. I am concerned here with the various relationships that may obtain between a term or other sign or symbol and what it refers to, not with how such relationships are established' (Goodman (1984), p. 55).

57 Goodman (1976), p. 43.

58 Lopes (2000). Cf., too, his observation in Lopes (1996), p. 57: 'Nothing in the symbol model rules out pictures being correlated with, and standing for, their subjects because they resemble them or provide for illusionistic experiences of them or enable us to see things in them . . . A theory of depiction may, without inconsistency, explain pictures as both symbolic and perceptual'.

59 Goodman and Elgin (1988), p. 115.

60 Goodman and Elgin (1988), p. 112. In Goodman (1970), he points out 'any two things have exactly as many properties in common as any other two' and 'comparative judgments of similarity often require not merely a selection of relevant properties but a weighting of their relative importance'. Thus, for example, the determination of which two pieces of baggage at an airport are alike 'depends not only on what properties they share, but upon who makes the comparison, and when'. A spectator might select: size, shape, colour, material, and so on; a passenger: destination and ownership; and the ground crew: weight. Goodman concludes that 'similarity is relative and variable, as undependable as indispensable. Clear enough when closely defined by context and circumstance in ordinary discourse, it is hopelessly ambiguous when torn lose' (Goodman (1970), pp. 443–5).

61 Goodman (1960a), p. 28.

62 Goodman (1976), p. 10.

63 For a good overview, see Valberg (2005); current research is published in the journal *Visual Cognition*.

64 Gombrich (1977), p. 78.

65 For a conventionalist interpretation of Gombrich's early writings – and the accusation that he subsequently went back on his own insights – see Krieger (1984). For Gombrich's reply, see Gombrich (1984).

66 Key passages are to be found in Gombrich (1977), pp. x–xi, pp. 77–8, p. 121, pp. 211–17, and p. 252. As well as the reply to Krieger cited above, Gombrich explicitly distinguishes his position from conventionalism in 'Standards of truth: the arrested image and the moving eye' and 'Image and code: scope and limits of conventionalism in pictorial representation', both reprinted in Gombrich (1982). For further clarification of Gombrich's position and his criticisms of what he takes to be Goodman's conventionalism, see Gombrich (1972).

67 See, Gombrich (1982), p. 281: 'Perspective is the necessary tool, if you want to adopt what I now like to call the "eye-witness principle", in other words, if you want to map precisely what anyone could see from a given point, or, for that matter, what the camera could record.'

68 Gombrich (1977), pp. 33–4.

69 Gombrich (1982), p. 271. Gombrich's subjectivist starting point does not rule out the identification of objective properties such as outline shape, occlusion and gradation from light to shade that can be observed in the motif and deployed by the artist. However, since there is never a one-to-one correspondence between the marks on the canvas and what they stand for or represent, these features must be compressed, accommodated, and re-cast within the medium of representation. Gombrich insists even a photograph 'is not a replica of what is seen but a transformation which has to be re-translated to yield up the required information' (Gombrich (1982), p. 282). For a sophisticated defence of objectivism that acknowledges that 'the basic principles of pictorial art reveal how exiguous the relationship between the marks on a picture's surface and the kinds of objects they depict can be', see Hyman (2006), p. 141.

70 I take the term 'object-presenting experiences' from Lopes (2000). It usefully avoids many of the problems that beset Gombrich's illusion theory of representation. As Lopes observes, to have an object presenting experience is to see in a picture the scene it represents, but 'such an experience need not and usually will not dispose one to believe one is seeing the scene represented'. See Lopes (2000), p. 228. (fn. 18, p. 231).

71 Goodman maintains that 'Realism is relative, determined by the system of representation standard for a given culture or person at a given time' (Goodman (1976), p. 37).

72 Gombrich (1982), p. 19.

73 Goodman (1976), p. 3.

74 Goodman (1978), p. 102.

75 Goodman (1984), p. 5 and p. 6.

76 Cf. Goodman's observation that 'Practice palls; and a new mode of representation may be so fresh and forceful as to achieve what amounts to a revelation' (Goodman (1984), p 127).

77 Apollinaire, *The Cubist Painters* (1912), translated in Harrison and Wood (2003), p. 189.

78 Rivière, 'Present tendencies in painting' (1912), translated in Harrison and Wood (2003), p. 190.

79 The higher truth revealed by Cubism was generally taken to be the object's underlying 'essence' or 'form', but it was also identified with the notion of a 'fourth dimension' and even X-ray photography. For a good discussion of these various theories, see Antliff and Leighten (2001), especially chapter two 'Philosophies of time and space'.

80 Kahnweiler (1949), unpaginated.

81 Kahnweiler (1949), unpaginated. Picasso is reported by Leo Stein as saying 'A head . . . was a matter of eyes, nose, mouth, which could be distributed in any way you like – the head remained the head.' Cited in Bois (1987), p. 90.

82 See, for example, Picasso's *Guitar, Sheet Music and Glass* (1912, McNay Art Museum, San Antonio), which combines a cutting from a newspaper containing the words 'Le Jou' and 'La bataille c'est engagé' with sheet music, *faux bois*, coloured paper and a schematic charcoal drawing of a glass.

83 Bois (1987), p. 74 and p. 90.

84 Krauss (1998), p. 27. Krauss first presented her interpretation of *Violin* in Krauss (1992).

85 Krauss (1998), pp. 27–8.

86 Krauss (1998), pp. 27–8.

87 Krauss (1992), p. 264.

88 Braque employed this device in two paintings: *Violin and Palette* (1909, Guggenheim Museum, New York) and *Violin and Pitcher* (1910, Öffentliche Kunstsammlung Basel).

89 Greenberg, (1958), p. 62.

90 Bois takes up the term 'relative motivation' from Saussure in order to correct 'the vulgar notion of the arbitrariness of the sign, which often simply remains the conventionalist view'. He acknowledges that Picasso reduced his 'plastic system' to a 'handful of signs, none referring univocally to a referent' but insists that 'the "system of values" governing Picasso's art . . . remained figurative. This creates the "relative motivation" of his signs, the

syntax of which the discovery of "Negro" art had liberated' (Bois (1987), pp. 89–90).

5 PICTORIAL STYLE

1 Alberti (1972), p. 99.
2 See Lopes (1996), p. 3.
3 Wollheim (1987), p. 73.
4 See Podro (1993), p. 47, and Podro (1998), pp. 6–17.
5 Goodman (1976), pp. 252–3.
6 Goodman (1960a), p. 29. Goodman seeks to distinguish his position – the view that 'there are many ways the world is, and every true description captures one of them' – from the position of the mystic or the obscurantist, who believes 'there is some way the world is and that this way is not captured by any description' (Goodman (1960a), p. 31).
7 The concept of style is conspicuously absent from *Languages of Art*. Goodman takes up the topic in a later essay, 'The status of style', which is reprinted as chapter 2 of Goodman (1978). A central theme of this book is that acknowledgement of the plurality of worlds does not imply that 'all right alternatives are equally good for every or indeed for any purpose' (Goodman (1978), p. 21).
8 See Sauerländer (1983), p. 254.
9 In book XII of his *Institutiones Oratoriae* [Education of an Orator], Quintilian (c. 35–c.100) draws a parallel between various forms of oratory and the stylistic strengths of specific painters and sculptors, including Zeuxis and Parrhasius (who are praised for their attention to light and shadow and the treatment of line).
10 Gombrich (1977), p. 3.
11 Winckelmann (2006).
12 Hegel (1975), p. 14. For a discussion of Hegel's ideas, see Gaiger (2002a) and Gaiger (2006).
13 Gombrich (1967), p. 28.
14 Gombrich (1963), p. 81. I discuss Gombrich's argument below.
15 Wölfflin (1986), p. 231. Wölfflin's book *Klassische Kunst* was first published in German in 1899.
16 The term 'Romanesque', for example, was coined in the early nineteenth century to describe pre-Gothic Western European art and architecture that revealed a knowledge of classical Roman buildings and monuments.
17 Alpers (1979), p. 139.

18 Ackermann (1962), p. 232. See, too, Schapiro (1994), pp. 51–102 and Gombrich (1967).

19 Ackermann (1962), p. 228.

20 Alpers (1979), p. 137.

21 The following sections rework material originally presented in Gaiger (2002b).

22 Wollheim (1987), p. 9. Wollheim goes on to observe 'given the small progress that art history has made in explaining the visual arts, I am inclined to think that the belief that there is such a feature is itself something that needs historical explanation: it is an historical accident'.

23 Wollheim first presented his ideas on style in the Power Lecture at the University of Sydney in 1972. His two major articles on the subject are Wollheim (1979) and Wollheim (1995). He also discusses pictorial style in Wollheim (1987), pp. 25ff.

24 Wollheim (1979), p. 189.

25 Wollheim (1979), pp. 199–200.

26 Wollheim (1995), p. 38.

27 Wollheim (1979), p. 194.

28 Wollheim (1987), p. 27.

29 Wollheim (1995), pp. 46–7.

30 Wollheim (1995), p. 38.

31 Wollheim (1979), p. 190.

32 See, Wollheim (1987), p. 26, and Wollheim (1995), pp. 47–8.

33 James D. Carney has argued that art historians 'follow what W.V. Quine has called the principle of minimum mutilation. They begin with a provisional set of beliefs, those held by the highly regarded historians and other individuals, though they anticipate augmentations and revisions in light of good reasons.' See, Carney (1991), p. 15.

34 Wollheim (1979), p. 195.

35 See Chapter 3 above, pp. 55–6.

36 Goodman (1978), p. 38. See, too, Goodman (1976), pp. 99–112.

37 I am referring, of course, to Leonardo's fresco *The Last Supper* of c. 1495–97, in the Refectory of S. Maria delle Grazie, Milan. Giotto's fresco of the same subject in the Scrovegni Chapel dates from c. 1305.

38 Panofsky (1939). For an excellent discussion of Panofsky's argument, see Robinson (1981). Robinson concludes 'if we cannot link a painting to other paintings in history, then neither the art critic nor the art historian can decipher it' (Robinson (1981) p. 14).

39 Panofsky, (1939), pp. 59–60.

40 Wölfflin (1950), p. vii.

41 Wölfflin maintained an extensive correspondence with Burckhardt (Gantner, 1948), and succeeded to his chair in Basel in 1893. In a lecture delivered in 1930, Wölfflin acknowledged that his own ideas had, to a certain extent, been anticipated by the older historian: 'one can find evidence in several places for his view that art history is never simply co-extensive with cultural history, but follows its own laws, which we must try to formulate exactly' (Wölfflin (1941), p. 154).

42 Burckhardt (1995). For an analysis of the Hegelian elements of Burckhardt's theory of history, see Gombrich (1967).

43 Wölfflin reiterated his position in a late essay that offers a concise summary of his views: 'There is in art an inner development of form. No matter how valuable it may be to relate the never-ceasing changes of form to the changing conditions of the artist's environment, and no matter how indispensable the character of the artist and the intellectual and social structure of the age may be to explaining the physiognomy of the artwork, it should not be overlooked that art, or rather the formative imagination (*bildnerische Form-phantasie*) in its most general possibilities possesses a life and development of its own' (Wölfflin (1941), p. 8).

44 Wölfflin (1950), p. 13; translation modified.

45 Wölfflin (1950), p. 12.

46 Wölfflin (1950), p. 12.

47 In the sixth edition of *Principles of Art History*, which was published in 1922, Wölfflin replaced the original foreword. In a defence of his views, first published in the journal *Kunstchronik* in 1920, he clarified his approach as follows: 'What I offer is not a new art history that is intended to take the place of the old: it is merely an attempt to look at the subject from a different perspective in order to discover guidelines for the writing of history that can guarantee a degree of certainty' (Wölfflin (1920), p. 16).

48 Wölfflin (1950), p. 11 (translation modified).

49 Wölfflin (1933), p. 277.

50 See, for example, Wölfflin (1950), p. vii, p. 16 and p. 226.

51 Here I consider Wölfflin's ideas exclusively as they relate to painting. However, it is important to note that he also deploys his five categories in relation to architecture, a non-mimetic art form.

52 Wölfflin (1950), p. 227. The German term, translated here as 'adventitious' is *aufgerafft*, which might also be translated as 'cobbled or gathered together'.

53 Wölfflin (1950), p. 17 and pp. 231–3.

54 For discussion of Riegl's work, see Podro (1982) and Iverson (1993).

55 Eckl (1993) and (1996), and Wiesing (1997).

56 Wölfflin (1950), p. 227. As Eckl notes, it is unclear from the text whether Wölfflin is drawing a comparison with Kant's 'forms of intuition' (time

and space) or with his 'categories of the understanding' (causality, unity, plurality, etc.).

57 Eckl (1993), p. 31.
58 Wiesing (1997), p. 44.
59 Wiesing (1997), p. 66.
60 Wiesing (1997), p. 66.
61 Wiesing (1997), p. 83.
62 Wölfflin (1950), p. 21.
63 Wölfflin (1950), p. 18.
64 Wölfflin (1950), p. 19.
65 Wölfflin (1950), p. 124.
66 Wölfflin (1950), p. 124.
67 Wölfflin (1950), p. 126.
68 Wölfflin (1950), p. 198.
69 Wölfflin (1950), p. 87 and pp. 197–8. See, too, Puttfarken (2000), pp. 30–1.
70 Wölfflin (1950), p. 208.
71 Eckl (1993), p. 42.
72 This observation was made by Edgar Wind back in 1925: 'the purely optical, deprived of everything haptic, i.e., of all formal limits, would be as amorphous as mere light', whilst 'the purely haptic, deprived of all optical determination, would be completely abstract, a geometric figure' (Wind (1925), p. 449). See, too, Panofsky (1964), p. 52.
73 Wiesing (1997), p. 97.
74 Wiesing (1997), p. 98.
75 Wiesing (1997), pp. 95–6 and p. 97.
76 Wollheim (1995), p. 46 and Wollheim (1987), p. 26.
77 Wollheim (1987), p. 26.
78 Wölfflin (1950), p. 30. Thus, for example, Grünewald's style appears painterly in comparison with that of Dürer, but when his work is placed alongside that of Rembrandt its overall linear quality becomes evident. Wölfflin goes on to observe that 'Grünewald is certainly more painterly than Dürer, but beside Rembrandt he is recognisable as an artist of the sixteenth century, that is to say, a man of the silhouette.'
79 See Gombrich (1963).
80 Wölfflin (1950), p. ix and p. 11.
81 Gombrich (1963), p. 92.
82 Gombrich (1963), p. 83.
83 Gombrich (1963), pp. 95–6.
84 Wölfflin (1950), p. 18.
85 Wölfflin (1950), p. 28.
86 Wölfflin (1950), p. 29.

6 MODERNISM AND THE AVANT-GARDE

1 Maurice Denis, 'Definition of neo-traditionism', translated in Harrison et al. (1998), p. 863; Henri Matisse, 'Notes of Painter', translated in Harrison and Wood (2003), p. 70; Bell (1987), p. 25.
2 Variants of formalism in relation to other arts, especially music, were developed earlier. For a discussion of these issues, see Hamilton (2007). I address the claim that the roots of formalism can be traced back to Kant's *Critique of Judgment* (1790) in Gaiger (2002a).
3 The catalogue to the first Post-Impressionist Exhibition was written by Desmond McCarthy, based on notes by Roger Fry. See Falkenheim (1980), p. 16.
4 Fry (1937), p. 195.
5 See Falkenheim (1980), pp. 15–32.
6 Bell (1987), p. 7.
7 Bell (1987), p. 8.
8 Bell (1987), p. 18.
9 Bell (1987), p. 26.
10 Fry (1937), p. 238.
11 Fry (1937), p. 241. Fry's *Vision and Design*, originally published in 1920, gathers together a selection of his essays over the previous two decades.
12 Fry (1937), p. 241.
13 Fry (1937), p. 241 and p. 242. It is interesting to note that Fry's position gradually hardened into formalism. This is vividly revealed by the note added in *Vision and Design* to his 1901 essay on Giotto. Fry observes that when he wrote the essay he had assumed 'the value of the form for us is bound up with recognition of the dramatic idea', but he now believes that it is possible 'by a more searching analysis of our experience in front of a work of art to disentangle our reaction to pure form from our reaction to its implied associated ideas'. See Fry (1937), p. 112.
14 Denis's essay was originally published in 1907 in *L'Occident*. Fry's translation, together with his 'Introductory note', is reprinted in Harrison and Wood (2003), pp. 39–46. Twenty-one paintings by Cézanne were included in the first Post-Impressionist Exhibition.
15 Fry, 'Introductory note', in Harrison and Wood (2003), p. 40.
16 Bell (1922), p. 11.
17 Fry (1927), p. 78.
18 Cézanne, letter to Bernard, 15 April 1904, translated in Harrison and Wood (2003), p. 33.
19 Fry (1937), p. 19.
20 Bell (1987), p. 44 and Fry (1937), p. 234. Bell devotes a section of *Art* to 'The classical renaissance and its diseases'.

21 Bell (1987), p. 44. Bell maintains that 'a good Post-Impressionist picture is good for precisely the same reasons that any other picture is good. The essential quality in art is permanent'. *Ibid.* p. 41.

22 Wölfflin's *Principles of Art History* was not published until 1915, but Fry was familiar with his earlier writings, including *Classic Art.* He reviewed the fourth German edition of *Principles of Art History* for the *Burlington Magazine* in 1921. For a discussion of Fry's indebtedness to the ideas of Wölfflin and other German art historians, see Falkenheim (1980) and Maginnis (1996).

23 Puttfarken (2000), p. 45. See, too, Wollheim (1995), p. 45.

24 This claim only applies to representational painting and sculpture, not to architecture, which is a non-representational art form. See Wölfflin (1950), pp. 62–3.

25 This point is made by Lucian Krukowski in Kelly (1998), Vol. 2, pp. 213–14.

26 See Budd (1995), pp. 54–5.

27 Wölfflin (1950), p. 211. Compare Budd's observation 'Formalism neglects depicted movement, depicted force and resistance, depicted energy and lassitude, and other features that are obviously relevant to a picture's unity, balance, harmoniousness, or impressive organisation' (Budd (1995), p. 56).

28 Budd (1995), p. 50.

29 Zangwill (2001), p. 55.

30 Zangwill (2001), pp. 58–9. Zangwill develops his account of moderate formalism by drawing on Kant's distinction between free and adherent beauty in the *Critique of Judgment* (§16). See Kant (2000), pp. 114–16.

31 Bell (1987), p. 27.

32 Zangwill (2001), p. 66.

33 Fry (1937), p. 244.

34 Bell (1987), p. 44.

35 Fry (1937), p. 196. Cf. Fry's observation that artists who pursue full abstraction 'may or may not be successful in their attempt. It is too early to be dogmatic on the point, which can only be decided when our sensibilities to abstract forms have been more practiced than they are at present'.

36 Fry (1937) contains essays on both of these topics, pp. 76–87 and pp. 91–9.

37 Bell (1987), p. xv.

38 See, for example, Hyman (2006), p. 110 and pp. 206–7. Budd (1995) does not discuss Greenberg. An exception is Zangwill (2001), p. 66.

39 Greenberg (1939), p. 7. For a discussion of Greenberg's ideas in relation to Kant, see Gaiger (1999).

40 The quotation is taken from Walter Benjamin's 'Theses on the philosophy of history' (1940) as cited in Gibson (1996), p. 159. Relevant sections from Saint-Simon's *Opinions Litteraires* of 1825 are translated in Harrison et al. (1998), pp. 37–41.

41 Greenberg (1939), p. 7.
42 Greenberg (1939), p. 6.
43 Greenberg (1939), p. 8.
44 Greenberg (1939), p. 9.
45 Greenberg (1940), p. 37.
46 Lessing's *Laocoon* was published in 1766. Relevant extracts are translated in Harrison et al. (2000), pp. 477–86.
47 Greenberg (1940), p. 27.
48 Greenberg (1940), p. 27 and p. 29.
49 Greenberg (1960a), p. 86.
50 Greenberg (1951), pp. 85–6.
51 Greenberg (1951), p. 89.
52 Greenberg (1940), p. 34.
53 Greenberg (1948b), p. 260.
54 Greenberg (1948b), p. 261.
55 Greenberg (1958), p. 63.
56 Budd (1995), p. 51. Evidence in support of Budd's argument can be found in the writings of Bell and Fry, both of whom clearly state that they do not intend pictures to be seen as two-dimensional patterns. Bell observes 'Pictures which would be insignificant if we saw them as flat patterns are profoundly moving because, in fact, we see them as related planes' (Bell (1987), p. 27), while Fry holds 'It is doubtful whether a purely flat surface, without suggestions of significant value, can arouse any profound emotion' (Fry (1926), p. 26).
57 Budd (1995), p. 51.
58 Budd (1995), p. 58.
59 Greenberg (1960a), p. 90.
60 Greenberg (1960a), p. 85.
61 Greenberg (1954), p. 189.
62 Greenberg (1960a), p. 87.
63 Greenberg (1945), p. 5.
64 Greenberg (1944), p. 203.
65 Greenberg (1944), p. 204.
66 Greenberg (1947), p. 166.
67 Greenberg (1947), p. 166.
68 Greenberg (1946), p. 75.
69 Pollock's remark is cited in Wood (2004), p. 164. Rosenberg's interpretation of abstract painting is developed in his essay 'The American action painters' (1952), reprinted in Harrison and Wood (2003), pp. 589–92. Greenberg points out that Rosenberg's theory of 'action painting' cannot explain 'why the painted left-overs of "action", which were devoid of

anything but autobiographical meaning in the eyes of their own makers, should be exhibited by them and looked at and even acquired by others'. See Greenberg (1962b), p. 136.

70 Greenberg (1955), p. 217.

71 Greenberg (1941), p. 65.

72 Greenberg (1952), p. 105.

73 Greenberg (1948a), p. 222.

74 Greenberg (1948a), p. 223.

75 Greenberg (1948a), p. 225.

76 For an insightful and comprehensively illustrated account of the activities of the neo-avant-garde, see Wood (2004), pp. 271–313.

77 Greenberg (1960a), p. 86.

78 See, for example, his essay 'Counter-avant-garde' of 1971, reprinted in Greenberg (2003) pp. 5–18.

79 Greenberg (1940), p. 37.

80 Greenberg (1960a), p. 91.

81 Greenberg addressed this issue directly in a note added to the 1978 reprinting of 'Modernist painting': 'There have been some further constructions of what I wrote that go over into preposterousness: That I regard flatness and the inclosing of flatness not just as the limiting conditions of pictorial art, but as criteria of aesthetic significance; that the further a work advances the self-definition of art, the better that work is bound to be.' See Greenberg (1960a), p. 94.

82 Fried (1966), p. 99.

83 See Morozova (2005).

84 Greenberg (1960b), p. 97.

85 Rosenberg, cited in Morozova (2005), p. 26.

86 Greenberg (1962a), p. 131.

87 The first interpretation is put forward by Michael Fried in his 'Three American painters' of 1965, reprinted in Fried (1998), pp. 213–65, and the second by Donald Judd in his 'Specific objects', published the same year (relevant extracts from Judd's essay are reprinted in Harrison and Wood (2003), pp. 824–8). For illustrations of Stella's Aluminium Paintings *in situ*, and a critical discussion of the issues surrounding the exhibition, see Day and Riding (2004).

88 Greenberg (1960a), p. 90.

89 Although Delaroche's words are frequently cited, there is no identifiable source for the attribution.

90 Cabanne (1971), p. 93.

91 Rodchenko made this claim retrospectively in his 'Working with Mayakovsky' of 1935. His remarks are cited in Buchloh (1986), p. 44.

92 Asger Jorn, 'Detourned painting' (1959), translated in Harrison and Wood (2003), p. 708.

93 See Foster (2007), p. 16 and Rugoff (2007), pp. 10–17.

94 Richter (1995), pp. 72–3.

95 See Richter (1995), pp. 31, 66, 73 and 93.

96 Richter (1995), p. 66.

97 Rugoff (2007), p. 14.

98 Richter (1995), p. 37.

99 See Richter's interview with Benjamin Buchloh in 1986, reprinted in Harrison and Wood (2003), pp. 1147–57.

100 Pursuing this line of interpretation, Paul B. Jaskot has argued that the dog that commands the centre of the painting is 'a resonance or trace of one of *the* brutal symbols of the SS and other Nazi perpetrators, that is, the German shepherd, or police dog'. See Jaskot (2005), p. 474.

101 These issues are considered in greater detail in Gaiger (2004) and Storr (2002).

102 Rugoff (2007), p. 16.

103 See Foster (2003) and Gaiger (2004) for a discussion of Richter's simultaneous exploration of different modes of painting.

104 I owe this point to Foster (2007), p. 16.

Bibliography

Ackermann, J. S. (1962), 'A theory of style', *The Journal of Aesthetics and Art Criticism*, Vol. 20, pp. 227–37.

Adorno, T. W. (1997), *Aesthetic Theory*, trans. R. Hullot-Kentor, London: Athlone Press.

Alberti, L. B. (1972), *On Painting and Sculpture. The Latin texts of 'De pictura' and 'De statua'*, ed. and trans. Cecil Grayson, London: Phaidon.

Alpers, S. (1979), 'Style is what you make it: the visual arts once again', in Lang (1987), pp. 137–62.

Antliff M. and Leighten, P. (2001), *Cubism and Culture*, London: Thames & Hudson.

Arrell, D. (1987), 'What Goodman should have said about representation', *The Journal of Aesthetics and Art Criticism*, Vol. 46, No. 1, pp. 41–9.

Augustine (1971), *On Christian Doctrine*, trans. J.F. Shaw, Chicago: William Benton.

Baxandall, M. (1988), *Painting and Experience in Fifteenth Century Italy*, Oxford: Oxford University Press.

Bell, C. (1922), *Since Cézanne*, London: Chatto and Windus.

— (1987), *Art*, ed. J.B. Bullen, Oxford: Oxford University Press.

Bois,Y. -A. (1987), 'Kahnweiler's lesson', reprinted in Bois (1993), pp. 65–97.

— (1993), *Painting as Model*, Cambridge, Mass. and London: MIT Press.

Bryson, N. (1991), 'Semiology and visual interpretation', in Bryson et al. (1991), pp. 61–73.

Bryson, N., Holly, M.A., Moxey, K., eds (1991), *Visual Theory: Painting and Interpretation*, Cambridge: Polity Press.

Buchloh, B. (1986), 'Primary colours for the second time: a paradigm repetition of the neo-avant-garde', *October*, Vol. 37, pp. 41–52.

Budd, M. (1987), 'Wittgenstein on seeing aspects', *Mind*, Vol. 96, No. 381, pp. 1–17.

— (1992), 'On looking at a picture', in Hopkins and Savile (1992), pp. 257–79.

— (1993), 'How pictures look', in Knowles and Skorupski (1993), pp. 154–75.

— (1995), *Values of Art: Pictures, Poetry and Music*, London: Penguin.

Burckhardt, J. (1995), *The Civilization of the Renaissance in Italy*, trans. S.G.C. Middlemore, London: Phaidon.

Cabanne, P. (1971), *Interviews with Marcel Duchamp*, trans. Ron Padgett, New York: Da Capo Press.

Carney, J. D. (1991), 'Individual style', *Journal of Aesthetics and Art Criticism*,

Vol. 49, No. 1, pp. 15–22.

Clark, K. (1960), *Looking at Pictures*, London: John Murray.

Cooper, D., ed. (1992), *A Companion to Aesthetics*, Oxford: Blackwell.

Cox, N. (2000), *Cubism*, London: Phaidon.

Danto, A. (1981), *The Transfiguration of the Commonplace: A Philosophy of Art*, Cambridge, Mass. and London: Harvard University Press.

— (1997), *After the End of Art: Contemporary Art and the Pale of History*, Princeton: Princeton University Press.

Day, G. and Riding, C. (2004), 'The critical terrain of "High Modernism"' in Wood (2004), pp. 188–213.

Deligiorgi, K. (2006), *Hegel: New Directions*, Chesham: Acumen.

Dickie, G. (1992), entry on 'definition of "art"', in Cooper (1992), pp. 109–13.

Duchamp, M. (1989), *The Writings of Marcel Duchamp*, ed. M. Sanouillet and E. Peterson, New York: Da Capo Press.

Eck, C., McAllister, J. and de Vall, R. eds. (1995), *The Question of Style in Philosophy and the Arts*, Cambridge: Cambridge University Press.

Eckl, A. (1993), 'Zum Problem der kategorialen Funktion von Wölfflins "Kunstgeschichtlichen Grundbegriffen". Erläuterungen an einem Beispiel ihrer Anwendung', *Zeitschrift für Ästhetik und Allgemeine Kunstwissenschaft*, Vol. 38, pp. 29–52.

— (1996), *Kategorien der Anschauung: Zur transzendentalphilosophische Bedeutung von Heinrich Wölfflins 'Kunstgeschichtlichen Grundbegriffen'*, Munich: Wilhelm Fink.

Falkenheim, J. (1980), *Roger Fry and the Beginnings of Formalist Art Criticism*, Michigan: Ann Arbor.

Foster, H. (2003), 'Semblance according to Gerhard Richter', *Raritan*, Vol. 23, No. 3, pp. 159–77.

— (2007), 'At the Hayward', *London Review of Books*, 1 November 2007, p. 16.

Foucault, M. (1994), *The Order of Things: An Archaeology of the Human Sciences*, New York: Random House.

Fried, M. (1966), 'Frank Stella's new painting', reprinted with minor alterations as 'Shape as form: Frank Stella's irregular polygons', in Fried (1998), pp. 77–99.

— (1998), *Art and Objecthood: Essays and Reviews*, Chicago and London: The University of Chicago Press.

Fry, R. (1926), *Transformations: Critical and Speculative Essays on Art*, London: Chatto and Windus.

— (1927), *Cézanne: A Study of His Development*, London: L. & V. Woolf.

— (1937), *Vision and Design*, Harmondsworth: Penguin.

Gaiger, J. (1999), 'Constraints and conventions: Kant and Greenberg on aesthetic judgment', *The British Journal of Aesthetics*, Vol. 39, No. 4, pp. 376–91.

— (2002a), 'The aesthetics of Kant and Hegel', in Smith and Wilde (2002), pp. 127–38.

— (2002b), 'The analysis of pictorial style, *The British Journal of Aesthetics*, Vol. 42, No. 1, pp. 20–36.

— ed. (2003), *Frameworks for Modern Art,* New Haven and London: Yale University Press.

— (2004), 'Post-conceptual painting: Gerhard Richter's extended leave-taking', in Perry and Wood (2004), pp. 88–135.

— (2006), 'Catching up with history: Hegel and abstract painting', in Deligiorgi (2006), pp. 159–76.

Gantner, J. (1948), *Jacob Burckhardt und Heinrich Wölfflin: Briefwechsel und andere Dokumente ihrer Begegnung, 1882–1897,* Basel: Benno Schwaabe.

Gerwen, R. van, ed. (2001), *Richard Wollheim on the Art of Painting: Art as Representation and Expression,* Cambridge: Cambridge University Press.

Gibson, A. (1996), 'Avant-garde' in Nelson and Shiff (1996), pp. 156–69.

Gilmore, J. (2000), *The Life of a Style: Beginnings and Endings in the Narrative History of Art,* Ithaca and London: Cornell University Press.

Gombrich, E. H. (1963), 'Norm and form: the stylistic categories of art history and their origin in renaissance ideals', reprinted in Gombrich (1966), pp. 81–98.

— (1966), *Norm and Form: Studies in the Art of the Renaissance,* London: Phaidon.

— (1967), 'In search of cultural history', reprinted in Gombrich (1979), pp. 24–59.

— (1972), 'The "What" and the "How": perspective representation and the phenomenal world', in Rudner and Scheffler (1972), pp. 129–49.

— (1973), 'Illusion and art', in R.L. Gregory and E.H. Gombrich (1973), pp. 193–243.

— (1977), *Art and Illusion: A Study in the Psychology of Pictorial Representation,* fifth edition, London: Phaidon.

— (1979), *Ideals and Idols: Essays on Value and History in Art,* Oxford: Phaidon.

— (1982), *The Image and the Eye: Further Studies in the Psychology of Pictorial Representation,* London: Phaidon.

— (1984), 'Representation and misrepresentation', *Critical Inquiry,* Vol. 11, No. 2, pp. 195–201.

Goodman, N. (1960a), 'The way the world is', reprinted in Goodman (1972), pp. 24–32.

— (1960b), 'Review of Gombrich's *Art and Illusion*', *Journal of Philosophy,* Vol. 57, pp. 595–9, reprinted in Goodman (1972), pp. 141–6.

— (1970), 'Seven strictures on similarity', reprinted in Goodman (1972), pp. 437–46.

BIBLIOGRAPHY

— (1972), *Problems and Projects*, Indianapolis and New York: Bobbs-Merrill.

— (1976), *Languages of Art: An Approach to the Theory of Symbols*, second edition, Indianapolis: Hackett.

— (1978), *Ways of Worldmaking*, Indianapolis: Hackett.

— (1984), *Of Mind and Other Matters*, Cambridge, Mass. and London: Harvard University Press.

Goodman, N. and Elgin, C.Z. (1988), *Reconceptions in Philosophy and Other Arts and Sciences*, London: Routledge.

Greenberg, C. (1939), 'Avant-garde and kitsch', reprinted in Greenberg (1986/1993), Vol. 1, pp. 5–22.

— (1940), 'Towards a newer Laocoon', reprinted in Greenberg (1986/1993), Vol. 1, pp. 23–41.

— (1941), 'Review of exhibitions of Joan Miró, Fernand Léger and Wassily Kandinsky', reprinted in Greenberg (1986/1993), Vol. 1, pp. 62–5.

— (1944), 'Abstract art', reprinted in Greenberg (1986/1993), Vol. 1, pp. 199–204.

— (1945), 'Obituary and review of an exhibition of Kandinsky', reprinted in Greenberg (1986/1993), Vol. 2, pp. 3–6.

— (1946), 'Review of exhibitions of the American abstract artists, Jaques Lipchitz and Jackson Pollock', reprinted in Greenberg (1986/1993), Vol. 2, pp. 72–5.

— (1947). 'The present prospects of American painting and sculpture', reprinted in Greenberg (1986/1993), Vol. 2, pp. 160–70.

— (1948a), 'The crisis of the easel picture', reprinted in Greenberg (1986/1993), Vol. 2, pp. 221–5.

— (1948b), 'Review of the exhibition *Collage*', reprinted in Greenberg (1986/1993), Vol. 2, pp. 259–63.

— (1951), 'Cézanne and the unity of modern art', reprinted in Greenberg (1986/1993), Vol. 3, pp. 82–91.

— (1952), 'Feeling is all', reprinted in Greenberg (1986/1993), Vol. 3, pp. 99–106.

— (1954), 'Abstract and representational', reprinted in Greenberg (1986/1993), Vol. 3, pp. 186–93.

— (1955), ' "American-type" painting', reprinted in Greenberg (1986/1993), Vol. 3, pp. 217–35.

— (1958), 'The pasted paper revolution', reprinted in Greenberg (1986/1993), Vol. 4, pp. 61–6.

— (1960a), 'Modernist painting', reprinted in Greenberg (1986/1993), Vol. 4, pp. 85–93.

— (1960b), 'Louis and Noland', reprinted in Greenberg (1986/1993), Vol. 4, pp. 94–100.

— (1962a), 'After abstract expressionism', reprinted in Greenberg (1986/1993), Vol. 4, pp. 121–34.

— (1962b), 'How art writing earns its bad name', reprinted in Greenberg (1986/1993), Vol. 4, pp. 135–44.

— (1986/1993), *The Collected Essays and Criticism*, 4 vols, ed. J. O'Brian, Chicago and London: The University of Chicago Press.

— (2003), *Late Writings*, ed. R.C.Morgan, Minneapolis and London: University of Minnesota Press.

Gregory, R. L. and Gombrich, E.H. (1973), *Illusion in Nature and Art*, London: Duckworth.

Gulyga, A. (1985), *Immanuel Kant*, trans. from Russian into German by S. Bielfeldt, Frankfurt am Main: Suhrkamp.

Halliwell, S. (2002), *The Aesthetics of Mimesis: Ancient Texts and Modern Problems*, Princeton: Princeton University Press.

Hamilton, A. (2007), *Aesthetics and Music*, London and New York: Continuum.

Harrison, A., ed. (1987), *Philosophy and the Visual Arts: Seeing and Abstracting*, Dordrecht: D. Reidel.

Harrison, C. (2003), 'Abstract art: reading Barnett Newman's *Eve*', in Gaiger (2003), pp. 105–51.

Harrison, C. and Wood, P. eds (2003), *Art in Theory: 1900–2000. An Anthology of Changing Ideas*, Malden and Oxford: Blackwell.

Harrison, C., Wood, P. and Gaiger, J., eds (1998), *Art in Theory: 1815–1900. An Anthology of Changing Ideas*, Malden and Oxford: Blackwell.

— eds (2000), *Art in Theory: 1648–1815. An Anthology of Changing Ideas*, Malden and Oxford: Blackwell.

Hegel, G. W. F. (1975), *Aesthetics: Lectures on Fine Art*, trans. T.M. Knox, 2 vols, Oxford: Clarendon Press.

Hopkins, J. (1998), *Picture, Image and Experience*, Cambridge: Cambridge University Press.

Hopkins, J. and Savile, A. (1992), *Psychoanalysis, Mind and Art: Perspectives on Richard Wollheim*, Malden and Oxford: Blackwell.

Hyman, J. (2006), *The Objective Eye: Color, Form and Reality in the Theory of Art*, Chicago: The University of Chicago Press.

Ijseeling, S. (1997), *Mimesis: On Appearing and Being*, trans. H. Ijsseling and J. Bloechl, Kampen: Kok Pharos.

Iverson, M. (1993), *Alois Riegl: Art History and Theory,* Cambridge, MA: MIT Press.

Kahnweiler, D. H. (1949), *The Sculptures of Picasso*, trans. A.B. Sylvester, London: Rodney Phillips & Co.

— (1971), *My Galleries and Painters*, interviews with F. Crémieux, trans. H.Weaver, London: Thames & Hudson.

Kandinsky, W. (1982), *Kandinsky: Complete Writings on Art*, ed. K.C. Lindsay and P. Vergo, 2 vols, London: Faber & Faber.

Janaway, C, (1995), *Images of Excellence: Plato's Critique of the Arts*, Oxford: Clarendon Press.

Jaskot, P. B. (2005), 'Gerhard Richter and Alolf Eichenmann', *Oxford Art Journal*, Vol. 28, No. 3, pp. 457–78.

Jay, P. (1981), *The Greek Anthology: Selections*, Harmondsworth: Penguin.

Kant, I. (2000), *Critique of the Power of Judgment*, trans. P. Guyer and E. Matthews, Cambridge: Cambridge University Press.

Kelly, M. (1998), *Encylopedia of Aesthetics*, 4 vols, Oxford: Oxford University Press.

Kemal, S. and Gaskell, I. eds (1993), *Explanation and Value in the Arts*, Cambridge: Cambridge University Press.

Knowles D. and Skorupski, J., eds (1993), *Virtue and Taste: Essays on Politics, Ethics and Aesthetics*, Oxford and Cambridge, MA: Blackwell.

Krauss, R. (1992), 'The motivation of the sign', in Zelevanksy (1992), pp. 261–86.

— (1998), *The Picasso Papers*, New York: Farrar, Strauss and Giroux.

Krieger, M. (1984), 'The ambiguities of representation and illusion: an E. H. Gombrich retrospective', *Critical Inquiry*, Vol. 11, No. 2, pp. 181–94.

Kristeller, P. O. (1951), 'The modern system of the arts: a study in the history of aesthetics I', *Journal of the History of Ideas*, Vol. 12, pp. 496–527.

— (1952), 'The modern system of the arts: a study in the history of aesthetics II', *Journal of the History of Ideas*, Vol. 13, pp. 17–46.

Lang, B., ed., (1987), *The Concept of Style*, expanded and revised edition, Cambridge: Cambridge University Press.

Leighten, P. (1994), 'Cubist anachronisms, cryptoformalism, and business-as-usual in New York', *Oxford Art Journal*, Vol. 17, No. 2, pp. 91–102.

Levinson, J. (1998), 'Wollheim on pictorial representation', *Journal of Aesthetics and Art Criticism*, Vol. 56, No. 3, pp. 227–33.

Lewis, W. (1982), *Blasting and Bombadeering*, London: John Calder.

Lopes, D. (1996), *Understanding Pictures*, Oxford: Clarendon Press.

— (2000), 'From *Languages of Art* to Art in Mind', *The Journal of Aesthetics and Art Criticism*, Vol. 58, No. 3, pp. 227–31.

— (2005), *Sight and Sensibility: Evaluating Pictures*, Oxford: Clarendon Press.

Maginnis, H. (1996), 'Reflections on formalism: the post-impressionists and the early Italians', *Art History*, Vol. 19, No. 2, pp. 191–207.

Misak, C., ed. (2004), *The Cambridge Companion to Peirce*, Cambridge: Cambridge University Press.

Morozova, E. (2005), *American art criticism and the crisis of art history writing*, PhD dissertation, The Open University.

Mortensen, P. (1997), *Art in the Social Order: The Making of the Modern Concept of Art*, Albany: State University of New York Press.

Munro, T. (1967), *The Arts and their Representations*, revised edition, Cleveland: Case Western Reserve Press.

Nanay, B. (2005), 'Is twofoldness necessary for representational seeing?', *British Journal of Aesthetics*, Vol. 45, No. 3, pp. 248–57.

Nelson, R. S. and Shiff, R. (1996), *Critical Terms for Art History*, Chicago and London: The University of Chicago Press.

Newman, B. (1990), *Selected Writings and Interviews*, ed. J.P. O'Neill, New York: Alfred A. Knopf.

Panofksy, E. (1939), 'Iconography and iconology: an introduction to the study of renaissance art', reprinted in Panofsky (1993), pp. 51–81.

— (1964), *Aufsätze zu Grundfragen der Kunstwissenschaft*, ed. Hariolf Oberer and Egon Verheyen, Berlin: Bruno Hessling.

— (1993), *Meaning in the Visual Arts*, Harmondsworth: Penguin.

Peacocke, C. (1987), 'Depiction', *Philosophical Review*, Vol. 96, No. 3, pp. 383–410.

Peirce, C. S. (1955), *Philosophical Writings*, ed. Justus Buchler, New York: Dover.

Perry, G. and Wood, P., eds (2004), *Themes in Contemporary Art*, New Haven and London: Yale University Press.

Piles, R. de (1993), *L'Idée du Peintre parfait*, ed. Xavier Carrère, Paris: Gallimard.

Plato (1989), *The Collected Dialogues*, ed. E. Hamilton and H. Cairns, Princeton: Princeton University Press.

Pliny (1857), *The Natural History of Pliny*, trans. J. Bostock and H.T. Riley, London: Henry G. Bohn.

Podro, M. (1982), *The Critical Historians of Art*, New Haven and London: Yale University Press.

— (1987), 'Depiction and the Golden Calf', in Harrison (1987), pp. 3–22.

— (1993), 'Fiction and reality in painting', in S. Kemal and I. Gaskell (1993), pp. 43–54.

— (1998), *Depiction*, New Haven and London: Yale University Press.

— (2004), 'On Richard Wollheim', *British Journal of Aesthetics*, Vol. 44, No. 3, pp. 213–25.

Pollitt, J. J. (1974), *The Ancient View of Greek Art: Criticism, History, Terminology*, New Haven and London: Yale University Press.

— (1990), *The Art of Ancient Greece: Sources and Documents*, Cambridge: Cambridge University Press.

Puttfarken, T. (2000), *The Discovery of Pictorial Composition: Theories of Visual Order in Painting, 1400–1800*, New Haven and London: Yale University Press.

Reynolds, J. (1997), *Discourses on Art*, ed. R.R. Wark, New Haven and London: Yale University Press.

BIBLIOGRAPHY

Richter, G. (1995), *The Daily Practice of Painting: Writings and Interviews. 1962–1993*, trans. D. Britt, London: Thames & Hudson.

Robinson, J. M. (1981), 'Style and significance in art history and criticism', *The Journal of Aesthetics and Art Criticism*, Vol. 40, No. 1, pp. 5–14.

— (2000), '*Languages of Art* at the turn of the century', *Journal of Aesthetics and Art Criticism*, Vol. 58, No. 3, pp. 213–18.

Rudner R. and Scheffler, I., eds (1972), *Logic and Art: Essays in Honour of Nelson Goodman*, Indianapolis: Bobbs-Merrill.

Rugoff, R. (2007), *The Painting of Modern Life*, ex. cat., London: Hayward Publishing.

Sauerländer, W. (1983), 'From stilus to style: reflections on the fate of a notion', *Art History*, Vol. 6, No. 3, pp. 253–70.

Schapiro, M. (1994), *Theory and Philosophy of Art: Style, Artist and Society*, New York: Georges Brazillier.

Schier, F. (1986), *Deeper into Pictures*, Cambridge: Cambridge University Press.

Searle, J. R. (1980), 'Las Meninas and the paradoxes of pictorial representation', *Critical Inquiry*, Vol. 6, No. 3, pp. 477–88.

Sheehan, J. J. (2000), *Museums in the German Art World: From the End of the Old Regime to the Rise of Modernism*, Oxford and New York: Oxford University Press.

Shiner, L. (2001), *The Invention of Art: A Cultural History*, Chicago and London: The University of Chicago Press.

Short, T. L. (2004), 'The development of Peirce's Theory of Signs' in Misak, pp. 214–40.

Smith P. and Wilde, C. eds (2002), *A Companion to Art Theory*, Malden and Oxford: Blackwell.

Sörbom, G. (1966), *Mimesis and Art: Studies in the Origin and Early Development of an Aesthetic Vocabulary*, Stockholm: Svenska Bokförlaget.

Storr, R. (2002), *Gerhard Richter: Forty Years of Painting*, ex. cat., New York: Museum of Modern Art.

Valberg, A. (2005), *Light, Vision, Colour*, London: John Wiley.

Vasari, G. (1987), *The Lives of the Artists*, trans. George Bull, London: Penguin.

Weitz, M. (1956), 'The role of theory in aesthetics', *The Journal of Aesthetics and Art Criticism*, Vol. 15, pp. 27–35.

Wiesing, L. (1997), *Die Sichtbarkeit des Bildes: Geschichte und Perspektiven der formalen Ästhetik*, Hamburg: Rowohlt.

Winckelmann, J. J. (2006), *History of the Art of Antiquity*, trans. H.F. Malgrave, Los Angeles: Getty Research Institute.

Wind, E. (1925), 'Zur Systematik der künstlerischen Probleme', in *Zeitschrift für Ästhetik und Allgemeine Kunstwissenschaft*, Vol. 18, pp. 438–86.

BIBLIOGRAPHY

Wittgenstein, L. (1958), *Philosophical Investigations*, trans. E.A. Anscomebe, second edition, Malden and Oxford: Blackwell.

Wölfflin, H. (1920), 'In eigener Sache', in Wölfflin (1941), pp. 15–18.

— (1930), 'Jacob Burckhardt und die systematische Kunstgeschichte', in Wölfflin (1941), pp. 147–55.

— (1933), 'Eine Revision von 1933 als Nachwort', in Wölfflin (1991), pp. 276–82.

— (1941), *Gedanken zur Kunstgeschichte: Gedrucktes und Ungedrucktes*, second edition, Basel: Benno Schwabe.

— (1950), *Principles of Art History: The Problem of the Development of Style in Later Art*, trans. M.D. Hottinger, New York: Dover.

— (1986), *Classic Art: An Introduction to the High Renaissance*, trans. P. Murray and L. Murray, Oxford: Phaidon.

— (1991), *Kunstgeschichtliche Grundbegriffe. Das Problem der Stilentwicklung in der neueren Kunst*, eighteenth edition, Basel: Schwabe & Co.

Wollheim, R. (1961), 'Reflections on *Art and Illusion*', reprinted in Wollheim (1973), pp. 261–89.

— (1965), 'On drawing an object', reprinted in Wollheim (1973), pp. 3–30.

— (1973), *On Art and the Mind: Essays and Lectures*, London: Allen Lane.

— (1979), 'Pictorial style: two views', in Lang (1987), pp. 183–202.

— (1980), *Art and its Objects*, second edition with six supplementary essays, Cambridge: Cambridge University Press.

— (1987), *Painting as an Art*, London: Thames & Hudson.

— (1995), 'Style in painting' in Eck et al. (1995), pp. 37–49.

— (2001), 'A reply to the contributors', in Gerwen (2001), pp. 241–61.

Wood, P., ed. (2004), *Varieties of Modernism*, Newhaven and London: Yale University Press.

Zangwill, N. (2001), *The Metaphysics of Beauty*, Ithaca and London: Cornell University Press.

Zelevanksy, L., ed. (1992), *Picasso and Braque: A Symposium*, New York: Museum of Modern Art.

Index